Momoyama Genre Painting

Volume 17
THE HEIBONSHA SURVEY OF JAPANESE ART

For a list of the entire series see end of book

CONSULTING EDITORS

Momoyama Genre Painting

by YUZO YAMANE

translated by John M. Shields

New York · WEATHERHILL/HEIBONSHA · Tokyo

This book was originally published in Japanese by Heibonsha under
the title *Momoyama no Fuzokuga* in the Nihon no Bijutsu series.

A full glossary-index covering the entire series will be published
when the series is complete.

First English Edition, 1973

*Jointly published by John Weatherhill, Inc., 149 Madison Avenue, New York,
New York 10016, with editorial offices at 7-6-13 Roppongi, Minato-ku, Tokyo
106, and Heibonsha, Tokyo. Copyright © 1967, 1973, by Heibonsha; all rights
reserved. Printed in Japan.*

Library of Congress Cataloging in Publication Data: Yamane, Yūzō, 1919– /
Momoyama genre painting./(The Heibonsha survey of Japanese art
[17]/Translation of Momoyama no fūzokuga./1. Genre painting, Japa-
nese. 2. Japan—History—Azuchi-Momoyama period, 1568–1603. I.
Title. II. Series./ND1452.J3Y3513/754′.0952/72–92099/ISBN 0–8348–
1012–3

Contents

Momoyama Genre Painting

The Nature of Momoyama Genre Painting

GENRE PAINTINGS IN NAGOYA CASTLE On April 11, 1615, Tokugawa Ieyasu,* founder of the Tokugawa shogunate, arrived in Nagoya in preparation for the so-called summer siege of Osaka Castle. Two days later he proceeded to Nagoya Castle to congratulate its lord, Ieyasu's ninth son, Yoshinao, on his marriage, which had taken place the day before. Another reason for his visit, however, was to inspect Nagoya Castle. On Ieyasu's orders, the daimyos had started building the castle in 1610. It was intended both as a residence for Yoshinao and as a strategic strongpoint to balance against the Toyotomi family's Osaka Castle. The five-story donjon was completed in 1613, after which work was started on the Hommaru Compound (the principal compound of the castle). This was finally completed only some two or three months before Ieyasu's visit to Nagoya.

On entering the Goten (master's residence) in the Hommaru Compound, Ieyasu first passes through a vestibule made up of two rooms. Everything here, from the tokonoma (alcove) wall to the *fusuma* (opaque sliding partitions) and the skirting

* The names of all premodern Japanese in this book are given, as in this case, in Japanese style (surname first); those of all modern (post-1868) Japanese are given in Western style (surname last).

of the *shoji* (translucent sliding partitions), is decorated with the "tiger-and-bamboo" theme executed in gorgeous colors on a ground of gold. Next to this is the spacious *omote shoin,* or front reception suite, where Yoshinao's wedding ceremony had taken place. This consists of a reception chamber with anterooms, and a bedchamber. With the exception of the last, these rooms are decorated with *kachoga* (literally, "bird-and-flower paintings") featuring mainly pine, cherry, and other trees. They are in the *kompeki* style, characterized by brilliant colors on a ground of gold or silver foil, and invest the rooms with a dazzling beauty. To the northwest, connected to the *omote shoin* by a corridor, is the Taimensho reception suite, where Ieyasu will meet Yoshinao. We can imagine the ex-shogun (he had named his son Hidetada as successor in 1605, but continued to hold power until his death in 1616) surveying his surroundings with an air of obvious ease. He might well do so. On the termination of the winter siege of Osaka Castle in January of that year, Ieyasu had filled in both the outer and inner moats, and had destroyed the outer ramparts of the castle, leaving it all but defenseless. His victory in the forthcoming summer siege was sealed.

We notice that the paintings embellishing the walls, partitions, and doors of the Taimensho are

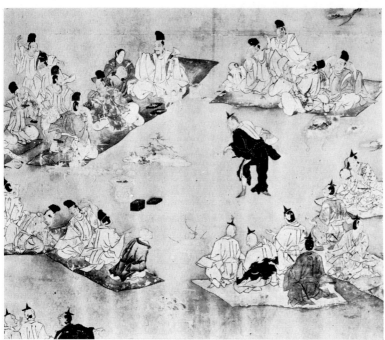

1. *Court nobles' drinking party; detail from a genre painting mounted on a tokonoma wall; Kano school. Colors on paper; 1614. Formerly in Nagoya Castle. Lost in fire.*

2 *(opposite page, left). Rice-planting dance; detail from a genre painting on* fusuma; *Kano school. Colors on paper; 1614. Nagoya Castle.* ▷

3 *(opposite page, right). Bathhouse; detail from a genre painting on* shoji; *Kano school. Colors on paper; 1614. Nagoya Castle.* ▷

not in the *kompeki* style of the vestibule and *omote shoin*. Instead, we find a detailed depiction in color of all kinds of customs and manners of the day. The painting on the wall of the tokonoma in the dais room (Fig. 1), for example, shows a group of court nobles enjoying themselves at a drinking party with Mount Atago in the background. The participants are seen to be already in various stages of intoxication, and one has proceeded to the center of the gathering to do a dance. Perhaps Ieyasu, who did not have much of an artist's eye, found in the depiction a reason to take up the slack in the ethics of the court. To the right, the wall behind the *chigaidana* (shelves adjoining the tokonoma alcove) is decorated with scenes of cormorant fishing on the Katsura River. Next to this, in the wall on the right, is the *chodaigamae* (four *fusuma* panels in a heavy, elaborate framework, behind which is the bedchamber). The *chodaigamae* is decorated with paintings of scenes like horse racing at the Kamo Shrine with spectators (Fig. 8) or samurai engaging in trials of strength. Part of the charm of the

paintings is the beautiful clothes of the watching women and the excitement on the faces of the men. Among the spectators we also notice some Europeans. Continuing, we have four *fusuma* paintings with scenes showing northeast Kyoto from the Takano district down to the Yoshida Shrine, including a large rendering of a rice-planting dance (Fig. 2). The four *shoji* panels of the decorative reading-bay (*tsukeshoin;* literally, "annexed study"), and two *shoji* dividing the Taimensho suite from the corridor outside, have scenes showing carpenters, plasterers, dry-goods dealers, and a bathhouse (Fig. 3) painted on their skirting. The bathhouse girls are seen busily attending to their customers.

While the raised dais room of the Taimensho suite has scenes of famous places in Kyoto, providing a healthy sprinkling of scenes from shrine activities and bustling streets, the paintings of the second room depict famous places in and around Sakai, Sumiyoshi, and Naniwa (the present-day Osaka region), and events of interest. The paintings

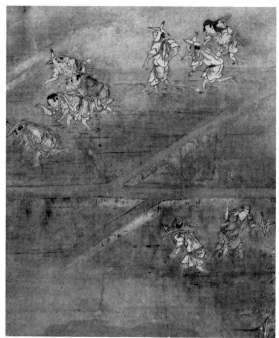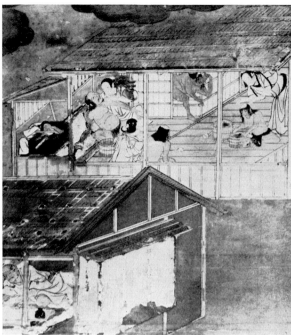

cover three sides of the room, decorating eight *fusuma* and the lower parts of four *shoji*. The focus is especially on battledore and shuttlecock (*oibane*), Japanese polo (*dakyu*), wrestling (*sumo*; Fig. 6), tug of war (Fig. 7), and other such games. The tug-of-war painting is particularly amusing for the seriousness of the grown men in it.

The total width of the paintings on the walls, *fusuma*, and *shoji* of the two chambers of the Taimensho suite comes to over forty-three meters. They give the effect of a panoramic display of famous places and scenic spots in the Kyoto-Osaka area. But the artist is more interested in life than natural settings. People from every background and social level—high, low, rich, poor, monk, and layman—are colorfully captured at work and play, in festivals and similar events. The portrayal presents one with a large slice of life delineated in beautiful colors with a light touch. It reflects, in fact, the emergence of the lower classes in the Momoyama period (1568–1603). First and foremost come the ordinary folk of the day, but basking together with

them in the good life are the noblemen, the samurai, and the monks. What Ieyasu felt as he viewed all this—at a time when he was weighing the move to a more rigid feudal system—we can only conjecture. Suffice it to say that such painting was indeed worthy of the Momoyama period, with its glorification of the here-and-now.

Had Ieyasu asked a member of his entourage as to the themes of the paintings in the Taimensho, he would have been told that they show famous places in the Kyoto-Osaka vicinity. *Meisho-e* (paintings of famous places), along with *tsukinami-e* (depictions of social customs and events associated with the months of the year), and *shiki-e* (scenes of the four seasons) were originally three thematic types of the *yamato-e* painting tradition, that is, Japanese-theme painting that began to appear in the ninth century (Heian period). However, the famous places are in fact merely a device for unifying the various scenes into a grand composition— the real theme is ordinary life in its various aspects. These are genre paintings (*fuzokuga*; literally,

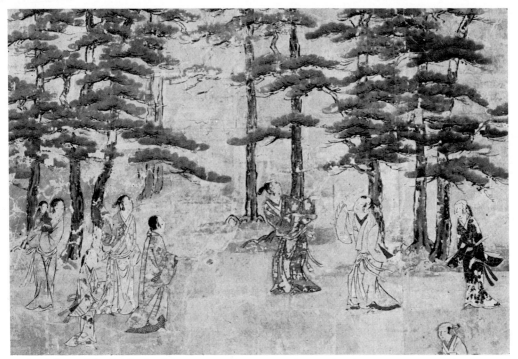

4. *Battledore and shuttlecock; detail from a genre painting mounted on a wall; Kano school. Colors on paper, 249 ×*
378 cm. First half of seventeenth century. Emman-in, Shiga Prefecture.

"paintings of manners and customs"), and the paintings of the Taimensho of Nagoya Castle are considered to be a collection of many genre paintings with famous places of the Kyoto and Osaka regions for a background.

POSITION OF GENRE IN MOMOYAMA PAINTING

Genre work of this sort saw its peak in and around the Momoyama period. Indeed, aside from what we find at Nagoya Castle, there are only two or three other extant examples of genre *shohekiga* (Figs. 4, 5), that is, paintings on walls, doors, and partitions. On the other hand, genre art on folding screens (*byobu*) is quite voluminous. Much is also extant in fan form, in picture albums (*gacho*), and on scrolls (*makimono*). But the latter do not compare with the folding-screen variety either

in quality or quantity. Genre painting on hanging scrolls (*kakefuku*) made its debut only later, in the second quarter of the seventeenth century. Hence we can say that Momoyama genre painting followed the trend of the times, mainly evolving in the large-surface media of walls, *fusuma*, *shoji*, and folding screens.

The type of painting that flourished most in the Momoyama period was *kachoga*, broadly including also tiger-and-bamboo painting and other animal depictions (*soju-zu*), flowering-tree paintings without birds (*kaboku-zu*), and flowering-plant paintings (*soka-zu*). Next came genre painting, followed by depictions of figures from Chinese history. Paintings of Chinese historical and legendary figures on walls, partitions, and doors outstrip genre in volume, but fall considerably behind if we take the genre work on folding screens into account.

5. *Peddlers; detail from a genre painting mounted on a wall; Kano school. Colors on paper, 249 × 378 cm. First half of seventeenth century. Emman-in, Shiga Prefecture.*

As we shall subsequently see, these two types—*kachoga* and genre painting—developed independently of each other from the middle to the latter part of the Muromachi period (1336–1568). Both are rather realistic and hence easily understood. It was because of this realism that they were the great favorites of the samurai class and *machishu* (the newly risen merchant elite), who were the mainstays of the Momoyama period. Their themes quickly caught on, and the two types of painting developed precisely for the humanist, realistic note they struck, which suited well the spirit of the age. However, that the decor of the vestibule, *omote shoin* suite, and Taimensho suite of a castle completed in 1615 should be limited purely to *kachoga* and genre paintings is rather interesting.

I should like to remark here that the genre and *kachoga* work found in the master's residence of the Hommaru Compound of Nagoya Castle is from the brush of the famous Kano school of painting, led by Kano Sadanobu (1597–1623). That Kano painters of the time did not turn out genre works simply because they were ordered to do so is clear from the fact that half the Momoyama genre extant is obviously in the Kano style. This proves that Kano painters must have undertaken it also on their own initiative.

Momoyama genre painting, then, was the most significant product of the period next to *kachoga*. I should like to underline the close relationship that existed between the two types in their origin, development, and the following they generated among painters and patrons. I can point out the obvious: in the master's residence of Nagoya Castle, it is the *kachoga* group that occupies the more or less public spaces, that is, the vestibule and

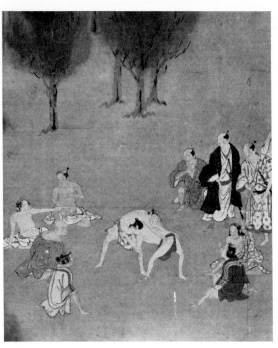

6. Sumo *wrestling; detail from a genre painting on* fusuma; *Kano school. Colors on paper; 1614. Nagoya Castle.*

8. *Horse racing at Kamo Shrine; detail from a genre painting on a* chodaigamae; *Kano school. Colors on paper; 1614. Formerly in Nagoya Castle. Lost in fire.* ▷

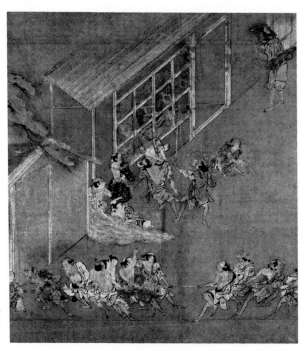

7. *Tug of war; detail from a genre painting on* fusuma; *Kano school. Colors on paper; 1614. Nagoya Castle.*

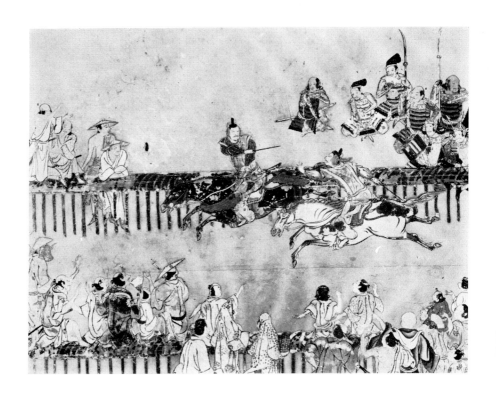

omote shoin reception suite. The genre work, on the other hand, is relegated to places slightly more private in nature, such as the Taimensho reception suite. This tells us that the function of the two types of painting is not at all the same.

Some scholars have said that the *kachoga* among the Momoyama *shoheiga* (paintings on partitions, doors, and folding screens) were for the samurai class what genre painting was for the commoners. I feel that to say this or to stress only the fact that Momoyama genre painting was the forerunner of ukiyo-e paintings and woodblock prints—the art of the Edo-period merchant class—and call it early ukiyo-e is too much like interpreting the Momoyama period from the point of view of the Edo period. Likewise, it is a rash generalization to attribute the large number of anonymous genre paintings to an artist's hesitation to affix his name out of shame, or because such works were mainly by the *machi-eshi* (literally, "town painters"—that

is, painters accessible to the public at large and not in the service of the court or samurai class). Attribution, after all, has also been a problem with many Momoyama-period *kachoga*. The reason is that most genre and *kachoga* work is on folding screens and *fusuma*. When the level of genre studies reaches that of studies in *kachoga*, we should be able to attribute many more works. There is no doubt that anonymous town painters did genre work; and it should be valued as fine art whenever worthy of the term. (*Kachoga* work by town painters should not be overlooked either, if it is good.)

At all events, as we move into our discussion of genre painting, I hope to put into relief its relationship, similarities, and dissimilarities with *kachoga*, while reaching back to sift through its origins and development. Along with this, I should like to pursue the new direction genre took as the Momoyama period edged into the Edo period (1603–1868), touching briefly upon ukiyo-e in the process.

CHAPTER TWO

———— • ————

The Rise of Genre Painting

THE YAMATO-E TRADITION Japanese genre may be generally defined as painting that has *as its theme* the manners, customs, recreational activities, and other aspects of the lives of people of all classes. Given this, it is easy to see that a painting does not belong to the genre category simply because it happens to include something from real life.

The problem is that deciding the theme of a painting is liable to be highly subjective. The definition is thus extremely difficult to apply. For example, Japanese genre painting in a broad sense may be traced back as far as *yamato-e,* which depict Japanese things and events as opposed to *kara-e,* which depict Chinese things and events. But, in a narrower sense, we might even say that the Momoyama period itself had few genre paintings; that is, in the strict sense of having customs and manners *as a theme.*

This book steers a middle course. I maintain that genre painting grew out of *yamato-e* around the beginning of the sixteenth century as the Muromachi period drew to its close, and that it developed as an important type of painting on a par with *kachoga* in Momoyama times. I will first of all try to cover the rather sudden emergence of genre painting, and a balanced viewpoint necessitates that we familiarize ourselves with the tradition of genre depiction within *yamato-e* painting.

The mansions of the Heian nobility were decorated with partitions and screens painted with scenes of the four seasons (*shiki-e*), depictions of social customs and events associated with the months of the year (*tsukinami-e*), and also paintings of famous places romanticized in poetry (*meisho-e*). Only the focus of attention is seen to differ; otherwise all present the beholder with beautiful scenery and birds and flowers, depicted naturally and with considerable warmth. The distinctive feature is the aim to capture that indefinable moment when man and nature meld into one.

Chinese painting was already divided in the T'ang period (618–907) into the three separate categories of landscape, bird-and-flower, and figure painting. And in the Sung dynasty (960–1279), all artists assiduously pursued the ideals and kinds of beauty particular to each field. Japanese painting moved from the *kara-e,* which was under the strong influence of T'ang painting, to the *yamato-e* style, developing in the direction of combining the landscape, bird-and-flower, and figure types of painting. The reason why seasonal painting, *tsukinami-e,* and famous-place painting tended to converge in Japan may be found in their intimate relationship with *waka* court poetry both as to conception and form. It was the *entente cordiale* between man and nature, the attempt to catch the pulse of the seasons and their changes, that mattered most in *waka* poetry. This is why painting may show something of the life and customs of the nobility, while the priorities remain with reproducing the feel of a season. The depiction of contemporary

9. Yuna *(Bathhouse Girls). Hanging scroll; colors on paper, 72.6 × 80.3 cm. First half of seventeenth century. Atami Art Museum, Shizuoka Prefecture.*

10. *Kyoto festival scene showing floats and portable shrines be-ing carried in procession. Detail from* Rakuchu Rakugai Zu *(Scenes In and Around Kyoto), by Kano Eitoku. Pair of sixfold screens; colors and gold on paper; each screen, 159.5 × 364 cm. About 1570. Uesugi Collection, Yamagata Prefecture.*

11. *Transplanting Rice. Girls transplanting seedlings ac-companied by* dengaku *music and dance. One of several paintings of manners and customs of the months* (tsukinami fuzoku) *mounted on single eightfold screen; colors on paper, 61.7 × 41.7 cm. Mid-sixteenth century. Tokyo National Museum.* ▷

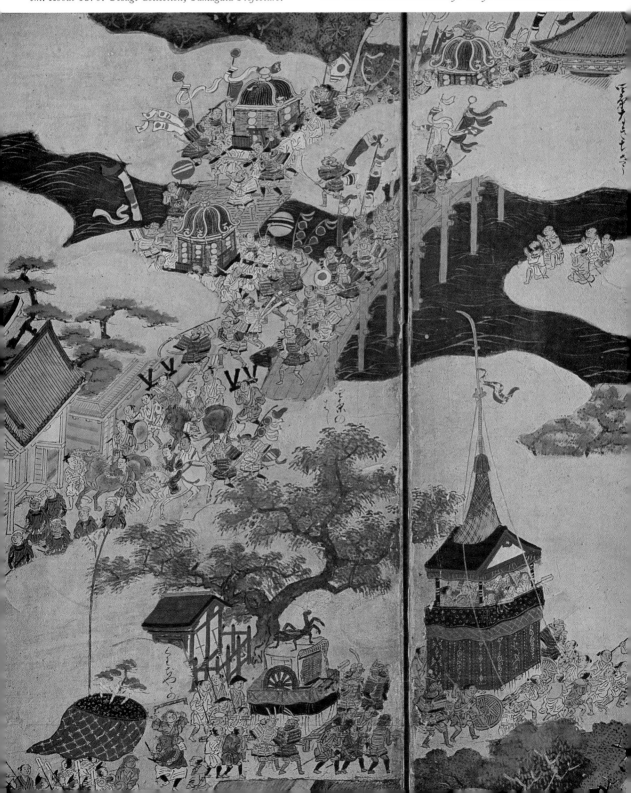

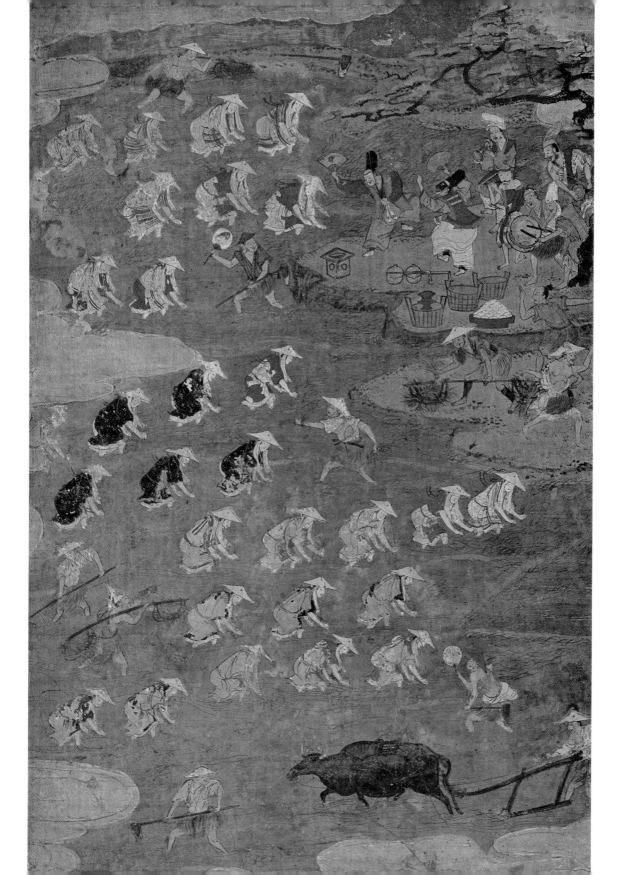

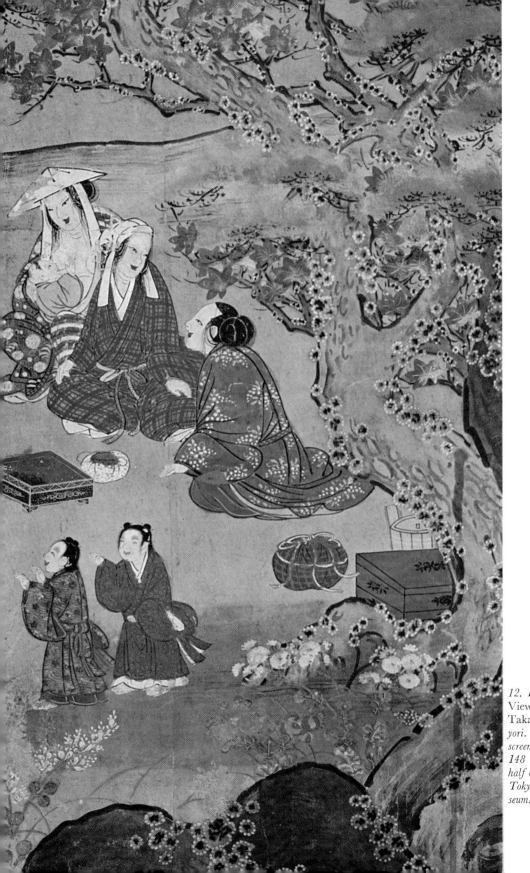

12. *Detail from* Maple Viewing at Mount Takao, *by Kano Hideyori. Single sixfold screen; colors on paper, 148 × 364 cm. Second half of sixteenth century. Tokyo National Museum.*

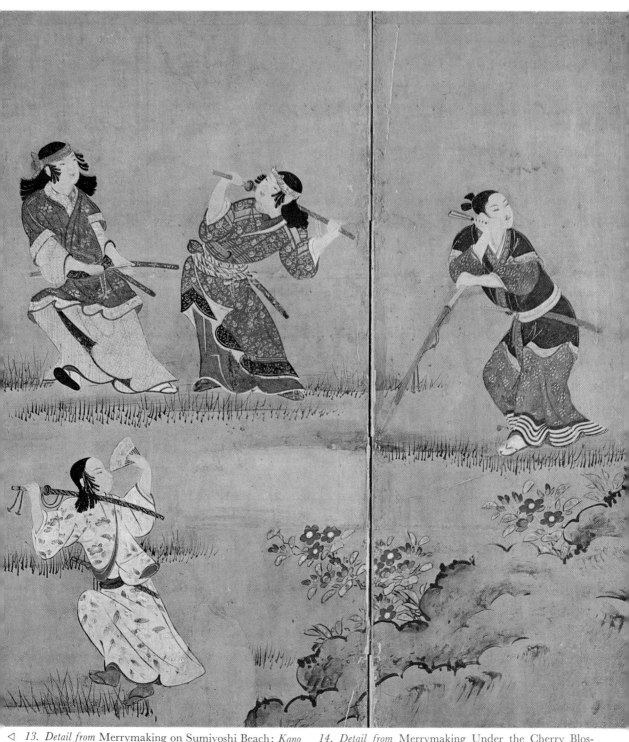

◁ 13. Detail from Merrymaking on Sumiyoshi Beach; *Kano school. Colors and gold on paper, mounted on tokonoma wall; overall size, 249 × 378 cm. About 1620. Emman-in, Shiga Prefecture.*

14. *Detail from* Merrymaking Under the Cherry Blossoms, *by Kano Naganobu. Pair of sixfold screens; colors on paper; each screen, 148.5 × 356 cm. Early seventeenth century. Cultural Properties Protection Commission, Tokyo.*

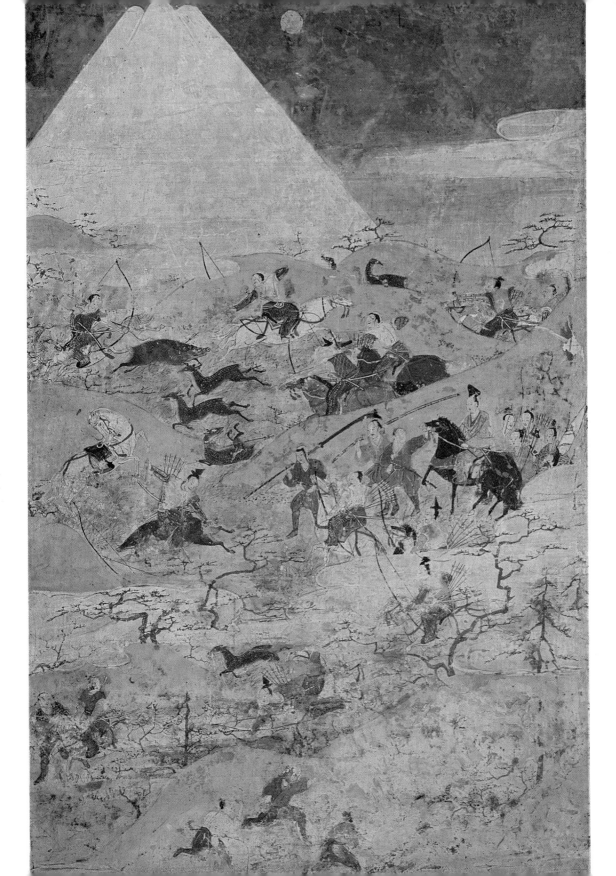

16. *Three panels of landscape screen. Colors on silk; each panel, 110.9 × 36.9 cm. First half of thirteenth century. Jingo-ji, Kyoto.*

customs occupies only a small part of the paintings, which are executed in considerable detail. (See Fig. 16.) Because of this they would have to be termed landscape painting (*fukeiga*) or seasonal-scenery painting (*keibutsuga*).

Quite a number of *shoheiga* (paintings on partitions, doors, and folding screens), containing many genre elements, of course, would be of this kind. A generous sprinkling of nobility and even peasantry are depicted therein, but the fact remains, unless you were to photograph and enlarge only the small sections in which such appear, you could not, at least in my estimation, describe them as genuine genre. Just as *kachoga* did not exist as a separate entity at this time, neither, it would seem, did genre.

A stream of seasonal, *tsukinami-e,* and famous-place paintings in the *yamato-e* style decorated the interiors of the Kamakura period (1185–1336). As we will note a bit later, a sharp turnabout occurred in the fourteenth century. Nevertheless, the tradition as such, in one form or another, extended on up into Muromachi and Momoyama times.

While *shoheiga* was closely associated with *waka* poetry, scroll painting had developed as illustrations of romances and popular tales. Thus Japanese life and customs figured frequently in picture scrolls, and the role played by the depiction of manners and customs was much more important than in the *shoheiga.*

The end of the Heian period produced the *Genji Monogatari Emaki* (Tale of Genji Picture Scroll), which depicts the lives and customs of the nobility, going beyond the illustrative to reveal something of the mentality of the times. Then came *Shigi-san Engi Emaki* (Scroll of Legends of Shigi-san Temple)

◁ 15. Grand Hunt at Mount Fuji. *One of several miscellaneous paintings of manners and customs of the months* (tsukinami fuzoku) *mounted on a single eightfold screen; colors on paper, 61.7 × 39.8 cm. Mid-sixteenth century. Tokyo National Museum.*

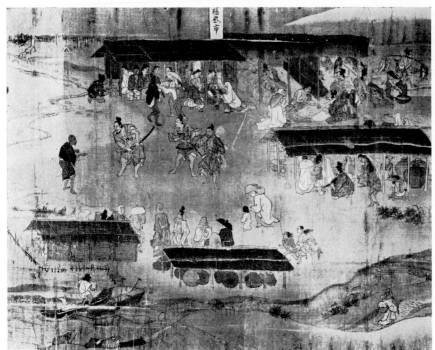

18. *Detail from the* Scroll ▷ of Frolicking Animals and People. *Handscroll; ink on paper; height, 30.9 cm. First half of thirteenth century. Kozan-ji, Kyoto.*

and *Ban Dainagon Emaki* (Story of the Courtier Ban Dainagon Picture Scroll). The paintings drew largely on people and the bustle of everyday life, and obviously artists were very much taken with the customs of commoners. Such portrayal reached the high-water mark in the following Kamakura times with the biographical scrolls of the new Buddhist-sect founders. In particular there is the *Ippen Shonin Eden* (Pictorial Life of Saint Ippen) scroll (Fig. 17) of 1299. These paintings show landscapes of various regions and we can see every class of common people—even beggars. The treatment of both landscapes and figures is extremely realistic.

The purpose of these scrolls, however, was to illustrate tales or narratives, the history of Buddhist temples or Shinto shrines, and the lives of the founders of new Buddhist sects. It was not to depict manners and customs, and the role of the life of the people is marginal in these scrolls.

When you really think about it, the painting of ordinary life—that is, the pure and simple portrayal of everyday existence (precisely what we have been defining as genre)—is easier said than done. Although artists' interest in the subject may have grown considerably, traditional themes always exert a surprisingly powerful influence.

Among scrolls there are paintings like those in the *Choju Jimbutsu Giga* (Scroll of Frolicking Animals and People; Fig. 18) which appear to have as their theme the manners and customs of the people. Certainly in this scroll the figures of priests and laymen absorbed in various competitive activities are shown very realistically, without any background, using only *sumi* ink. It is called a cartoon (*giga*) because of the abbreviated, sketch-like treatment and the humorous way of showing the weak overcoming the strong. From this we see that there was a cartoon tradition deriving from *yamato-e* painting. And it is a fascinating comment

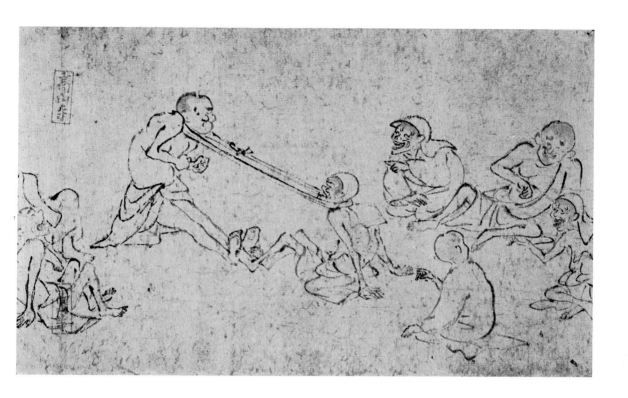

on the subject that the most serious attempt to depict ordinary people was in caricature, although this genre was not part of the mainstream.

For small painting other than on scrolls, we have the underpainting on sutra fans of the late Heian period, such as the one showing the storefront of a fishmonger (Fig. 19), considered to be a genre painting. Such fan illustrations were perhaps never consciously executed as genre, either because originally many were simply miniature versions of partition and screen paintings or portions lifted from them or scrolls. But the emergence of fans with what were in fact genre themes, and the ready access to them among people other than courtiers, are significant.

I think all of this boils down to the fact that the *yamato-e* of the Heian and Kamakura periods was not yet true genre painting. Still, in comparison to the heavily religious art of medieval Europe, which rarely descended to motifs from the secular, work-aday world, Japanese art has a rather rich tradition of painting including motifs from the fabric of daily life.

THE INFLUENCE OF KANGA About the last quarter of the fourteenth century a second Chinese style of painting, known as *kanga*, began to hold sway. *Kanga* was strongly influenced by the Chinese abstract landscape paintings of the Sung (960–1279) and Yuan (1280–1368) periods, and is to be distinguished from *kara-e*, which is the work of Japanese painters in T'ang-period (618–907) or earlier styles. The fourteenth century saw a sort of dialogue between traditional *yamato-e* and *kanga*, but in the fifteenth century, under the powerful patronage of the military class, *kanga* emerged as the undisputed protagonist of Japanese painting. *Yamato-e* were still produced in great numbers, but they did not exhibit as much artistic progress as *kanga*. This is

not to say there were only old breezes blowing, for there were fresh things happening in the field of *shoheiga*.

Between the fourteenth and fifteenth centuries, scroll painting gradually lost its trademarks: a fluid line and skillful composition. It had regressed to something little more than pictorial explanation, its fate sealed the earlier by encounter with *kanga* and the latter's severity of line and composition. If the scroll had anything new to offer, it was in subject matter. Compared with Kamakura times, the life of the common people figured more prominently. An example of the many fairy-tale-like illustrated scrolls is the *Story of Fukutomi* scroll (Fig. 20). The main theme is an old man who strikes it rich with his uncanny ability to break wind at will. This is a rather new development, to say the least, and reflects something of the social and economic emergence at the time of the common man and his culture.

If this was the state of things with the scroll,

shoheiga, stereotyped and outdistanced by the popular scroll during the Kamakura period, saw a revival. This tendency can be seen from the screens depicted in the picture scrolls. It is noteworthy that landscapes of the *hamamatsu* (beach with pines) and "sun and moon landscape" types, and *kachoga* like the "autumn grasses" paintings, both of a larger size than hitherto, have become more numerous. The scene is first cleared of human activity, then enlarged in size, leaving us with what might be called close-ups of the *kachoga* elements in the original landscapes. This had already been happening in applied-art designs, but in painting it was indeed a breakthrough when you realize the subsidiary, explicative role painting had come to play to literature or the lyric view of nature then prevailing. We can probably see here the stimulus of the Sung-Yuan style, in which landscape, people, and flower-and-bird paintings belonged to separate categories, or of the new *kanga* style, which was influenced by Sung-Yuan style. Where-

20. *Detail from the* Story of Fukutomi. *Handscroll; colors on paper; height, 31.2 cm. Fifteenth century. Shumpo-in, Kyoto.*

◁ 19. *Fishmonger's store. Underpainting on a sutra fan; colors on paper,*
 27.4 × 57.8 cm. Second half of twelfth century. Shitenno-ji, Osaka.

as former *shoheiga* had had a bird's-eye-view approach to composition, letting the eye drift from one detail to another, now the subject matter was enlarged, brought much closer, and perspective broadened to make a whole. This again reflects the influence of Sung-Yuan painting and *kanga*. (The appearance of *yamato-e* on the larger surfaces of partitions, sliding doors, and screens was to invite a similar move on the part of the seasonal landscape and seasonal bird-and-flower types of *kanga* painting. *Yamato-e*, in turn, would be affected by the *kanga* compositional approach.)

This is the story, then, of how *yamato-e* on partitions and screens met a new wave of *kanga* and came away completely renewed both as to themes and composition. In the fifteenth century we see the dawn of *kachoga* on gold screens; in the sixteenth century, *yamato-e* bird-and-flower painting in turn stimulated *kanga*-style *kachoga*, paving the way for the gorgeous *kompeki*-style *kachoga* screen-and-partition paintings of the Momoyama period.

Muromachi *yamato-e*, therefore, found its new lease on life not in the scroll medium, but in that of screen-and-partition painting.

RAKUCHU RAKUGAI ZU SCREENS Along with the appearance of landscapes and *kachoga* in *yamato-e* on screens and partitions, another factor deserving attention here is the rise of the important new screen-painting genre known as *Rakuchu Rakugai Zu* (literally, "Scenes In and Around Kyoto"). Indeed, the theory is gaining credence that this type of painting is the immediate progenitor or even an early form of Momoyama genre painting.

The earliest extant example of a *Rakuchu Rakugai Zu* we find in the pair of sixfold screens formerly in the Machida Collection (Figs. 28, 39). They embrace in a single perspective the famous places in and around Kyoto, the great shrines and temples, the Imperial Palace, the mansions of noblemen and warriors, and the shops of merchants. In

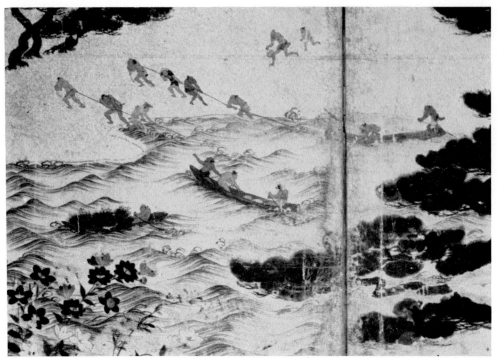

21. *Detail from* Hamamatsu *(Beach with Pines). Pair of sixfold screens; colors and gold on paper; each screen, 106 × 312.5 cm. Mid-sixteenth century. Agency for Cultural Affairs, Tokyo. Formerly in the Kumita Collection.*

between is a generous sampling of the life of the times, the various classes of people, and their detailed customs and manners. The screens are indebted, of course, to the famous-place paintings, but the lyrical treatment of the routine collection of renowned sites has disappeared; it is no longer the much-romanticized Kyoto of the *waka*. Instead we have a meticulous picture of the famous places and bustling streets just as they were—so accurate in fact that it dates itself: the Machida screens show the Kyoto of about 1525. Depicted are the same kinds of activities that we see in the seasonal or *tsukinami-e* paintings we discussed earlier, but here all these elements are meant to heighten the realism and add to the picture of the city. The *Rakuchu Rakugai Zu* thus assimilates many traditional *yamato-e* ingredients from the seasonal,

tsukinami-e, and famous-place paintings, but the viewpoint is entirely new and different. The perspective was grounded in the current craving to recreate Kyoto. This is why all the carnivals, the activity, the fun are relayed so realistically and openly. The same motivation was behind the emphasis on genre elements to be seen.

When did these new and quite distinctive paintings of scenes in and around Kyoto appear? In the Machida screens we sense a fixed form of arrangement in the background, which means a pattern of some sort probably existed before 1525, although we are not certain exactly when. But we have some records and a supposed copy that are suggestive. In the *Sanetaka-Ko Ki* (the diary of Sanjonishi Sanetaka) there is an entry for December 23, 1506, alluding to a pair of screens painted for Asakura

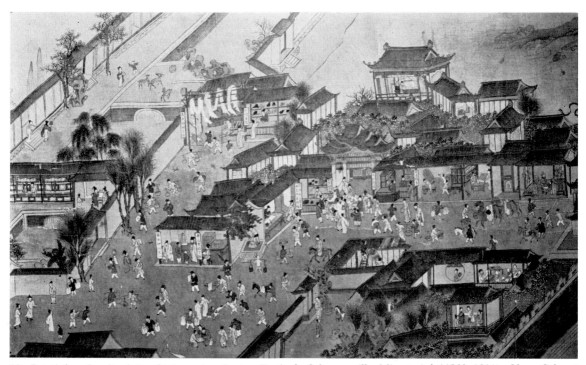

22. *Detail from* Scroll of the Ch'ing-ming Spring Festival. *Colors on silk. Ming period (1368–1644). Okura Cultural Foundation, Tokyo.*

Sadakage, lord of the province of Echizen (modern Fukui Prefecture), by Tosa Mitsunobu (?–1522) of the famous Tosa school of *yamato-e* painting. The screens are described as "a new kind of picture . . . of the city of Kyoto," and reputed to be "very highly valued." In other words, Mitsunobu's painting on the Kyoto theme was new in its day. The copy mentioned above is of one of a pair of sixfold screens by Tosa Mitsunobu, at one time in the possession of the second Tokugawa shogun Hidetada (ruled 1605–23), depicting monthly festivals at shrines in Kyoto. (This copy is at present in the Tokyo National Museum.) Although called a *Rakuchu Rakugai Zu*, it differs from usual paintings of the kind: the arrangement of the scenes is not clear, and the famous places and residences shown are not identifiable. The main focus is on monthly festivals and other regular events of the Kyoto year. I would deem it the precursor of the *Rakuchu Rakugai Zu* paintings of Kyoto. It is interesting to note that the copy has been attributed to Tosa Mitsunobu, who also painted the original screens. These two sources thus provide cogent evidence that *Rakuchu Rakugai Zu* screens originated in the early sixteenth century in association with this leading name in *yamato-e*.

How did this type of screen painting come about? Why the desire to capture so realistically the famous places and customs of Kyoto in particular in one panoramic sweep on a pair of sixfold screens? What lay behind the realistic illustration of life and manners or the ordered treatment of the composition as a whole?

Kyoto was in a shambles after the Onin Civil

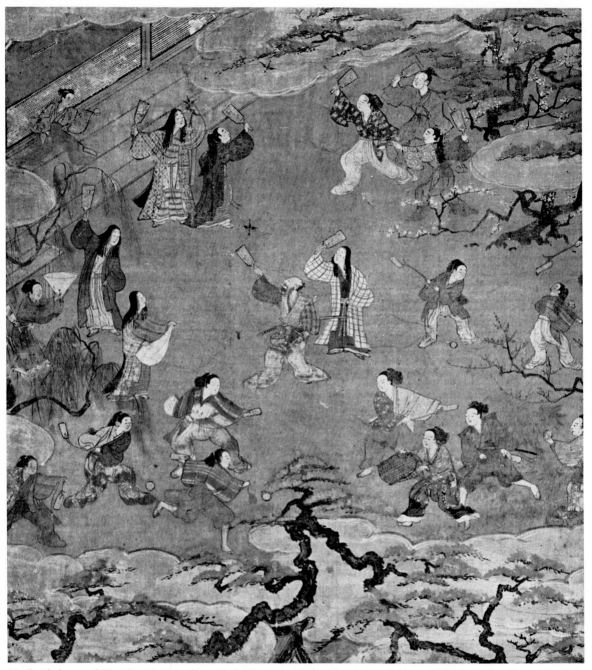

23. Battledore and Shuttlecock. *One of several miscellaneous paintings of manners and customs of the months* (tsukinami fuzoku) *mounted on a single eightfold screen. Half panel; colors on paper; size of whole panel, 61.7 × 41.7 cm. Mid-sixteenth century. Tokyo National Museum.*

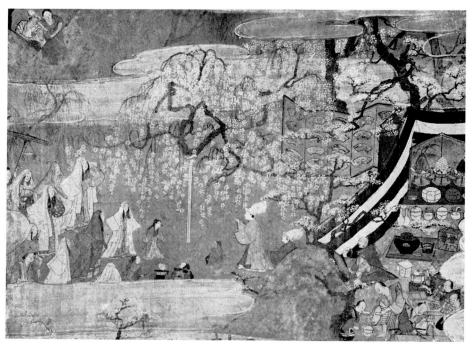

24. Cherry-Blossom Viewing. *One of several miscellaneous paintings of manners and customs of the months* (tsukinami fuzoku) *mounted on a single eightfold screen. Half panel; colors on paper; size of whole panel, 61.7 × 42.2 cm. Mid-sixteenth century. Tokyo National Museum.*

War (1467–77), and raising it from the ruins was the great achievement of the *machishu* (merchant elite), whose wealth and power were based on profits derived from money lending. The old capital, it was said, had been completely reborn from a political into a commercial entity. The Gion Festival, suspended during the war, was revived in 1500 mainly by the *machishu*, and its floats, symbolic of the prosperity of the *machishu*, were becoming more magnificent with every year. It was a scene from this festival that was depicted on a grand scale in the screen reproduction by Tosa Mitsunobu that we mentioned above. The festival also figures prominently in the Machida screens. The wish to have the new Kyoto represented and to "have their picture taken" alongside it, as it were, would seem to be natural for the *machishu*. After all, their tremendous energy had rebuilt the city from its ashes. Such aspirations are the usual explanation for the origin of the *Rakuchu Rakugai Zu* genre.

Recently, however, in probing for the fundamental compositional motif in early screenwork depicting Kyoto, such as seen in the Machida screens, studies have brought to light another underlying intent. (See Chapter Seven.) The new theory suggests that the principal compositional elements are the Imperial Palace, the shogun's residence, and the residence of the governor general, Hosokawa. The prominence accorded not only to the emperor and shogun, but also to Hosokawa, alerts us to the key role the latter played in the Kyoto polity in the aftermath of the Onin War. Seen in this new light, the early *Rakuchu Rakugai Zu* screens would amount to much more than paintings of the capital. They were specifically contrived

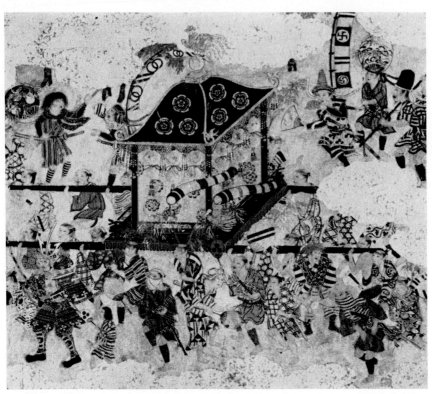

25. *Festival procession. Leaf from* Customs of the Twelve Months of the Year, *by Tosa Mitsuyoshi. Picture album; colors on paper, 32.7 × 28 cm. Early seventeenth century. Yamaguchi Collection, Kanagawa Prefecture.*

to impress the viewer with the image of a Kyoto very much under the thumb of the warrior class, using Hosokawa as its symbol of authority. This view takes us rather far from the earlier interpretation in terms of a nascent *machishu* wishing for equal billing with the city of Kyoto, now gloriously reborn.

When we consider that the pair of screens by Mitsunobu described above as "a new kind of picture" was commissioned by the daimyo Asakura Sadakage, and that Mitsunobu was at the time an official painter of the shogunate, there seems to be no doubt that the new theory is right about the objectives of these screens.

This does not mean that we can dismiss the role

of the *machishu* merchant elite in such depictions. Nor can we ignore the wishes made felt in these paintings.

An analogy suggests itself. While allowing the energies of the Kyoto *machishu* a certain degree of freedom, Governor General Hosokawa and *shugo* daimyo (the so-called protector daimyo) like Asakura made use of these energies to further the ends of the samurai class. In the same way, whereas individual parts of the *Rakuchu Rakugai Zu* screens showed lively depictions of customs and manners, they had an ordered overall composition consonant with the aim of the warrior class to emphasize its importance in society. I think, then, that we must acknowledge a double intention at work in the

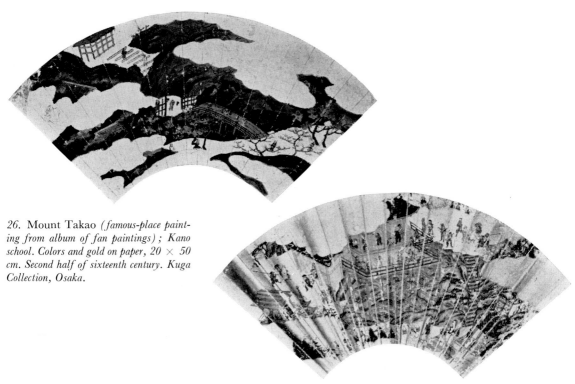

26. Mount Takao (*famous-place painting from album of fan paintings*); *Kano school. Colors and gold on paper, 20 × 50 cm. Second half of sixteenth century. Kuga Collection, Osaka.*

27. Kiyomizu Temple; *Tosa school. Fan painting; colors and gold on paper, 18.6 × 48.2 cm. Mid-sixteenth century. Tokyo National Museum.*

genesis of the *Rakuchu Rakugai Zu* genre: the irrepressible love of the *machishu* for a Kyoto once dead and now beautifully brought back to life, and the barely disguised aim of the military class to gain firm control over Kyoto.

PAVING THE WAY FOR GENRE

Next we must look for the reasons behind the masterly detail and superb unity of the whole to be found on these screens. Before the screen versions, it is true, there were *Rakuchu Rakugai Zu* on fans (Figs. 26, 27). These were only depictions of famous places, however, and people occupied very little space. The depiction of social customs was extremely stereotyped, and *Rakuchu Rakugai Zu* screen paintings were certainly much more than mere conglomerations of such fan paintings.

Here, we should call to mind that *yamato-e* had found a new path in the *shoheiga* (partition, door, and screen painting) medium. The *yamato-e* artists who pioneered the new landscape and *kachoga* screen painting, especially the mainstream represented by Tosa Mitsunobu, must have been most enthusiastic about screenwork of this *Rakuchu Rakugai Zu* type. Thus, an excellent tradition from the Kamakura period, portraying its customs and life, now sprang to life not within the smaller surfaces of scroll and fan, but in the screen medium, where it was to gravitate in the direction of genuine genre

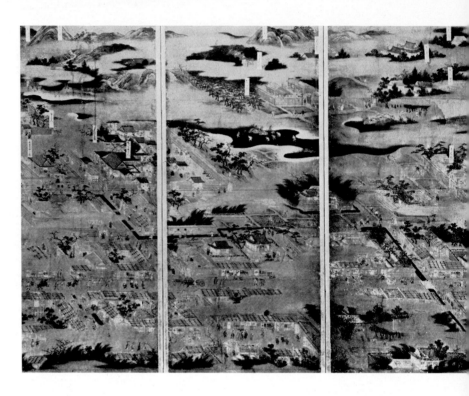

art. Earlier we saw how *kanga* landscapes and *kachoga* stimulated the rise of these genres in *yamato-e* and influenced their composition techniques. What about the Kyoto screens? We know that *kanga* about this time abounded in depictions of famous Chinese sages, hermits, demigods, and other well-known figures, historical and otherwise; scant place was accorded contemporary life. The likelihood, therefore, that *kanga* affected the development of *Rakuchu Rakugai Zu* is slim, except for Chang Che-tuan's *Ch'ing-ming shang-ho t'u* (Scroll of the Ch'ing-ming Spring Festival), a genre painting of the Sung dynasty. The scene is an overview of bustling Pien-ching, a town in South China. We see a realistic treatment of rows of shops and people flocking in front of plays or performances —not a far cry from our *Rakuchu Rakugai Zu*. In China, many paintings based on this scroll and bearing its name, but with other towns, seasons, and people, were produced. (Figure 22 shows a Ming-period version.) Some of them may well have reached Japan in the Muromachi period, perhaps to influence our *Rakuchu Rakugai Zu*. But this is a problem for future studies.

Recently, attention has been drawn to the remarkable depth of perspective to be found in the Machida Kyoto screens. Close examination, some scholars say, reveals the composition to be a bird's-eye view as if from a tall tower that provides a point of unified perspective. The resulting overview effect has no parallel in Japanese art up to this time, it is maintained; which means Japan may indeed have picked it up from China. This, too, suggests many lines of investigation, but again, we must leave this to forthcoming research. In any event, at this juncture, whether there was any

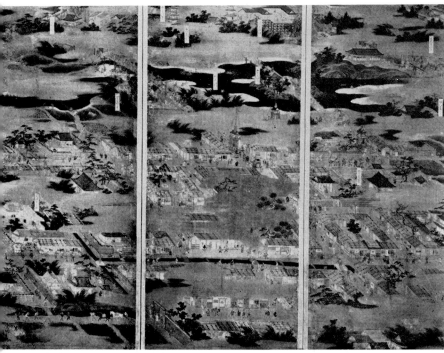

28. Rakuchu Rakugai Zu *(Scenes In and Around Kyoto). One of a pair of sixfold screens; colors on paper; each screen, 138 × 348.5 cm. First half of sixteenth century. Agency for Cultural Affairs, Tokyo. Formerly in the Machida Collection.*

direct influence exercised by Sung-Yuan painting or *kanga* on either the rise or compositional techniques of *Rakuchu Rakugai Zu* is necessarily a matter of guesswork.

If you take the kind of technical proficiency that turned out the Machida screens, combine it with the drive and initiative that gave birth to the *Rakuchu Rakugai Zu* screens of the famous-place variety, and apply them in the *tsukinami-e* tradition—you end up with painting like the *tsukinami-e* genre screens at the Tokyo National Museum (Figs. 11, 15, 23, 24, 63, 95).

The lyrical treatment of earlier paintings of social customs and events associated with the months of the year (*tsukinami-e*) is notably absent. Rather, realistic depiction of life, customs, and manners predominates.

This kind of work nonetheless continues to ex-press the deep-rooted bond between man and nature in the *yamato-e* tradition. In the recently uncovered *Hamamatsu* (Beach with Pines) screens formerly belonging to the Kumita family (Figs. 21, 34), in addition to fishermen, quite normal for landscapes, a party of mounted samurai with attendants is worked into the picture. The handling of this genre element is skillful. But the important point here is that while giving the willows, flowers and grasses, birds, and similar details of the foreground a graceful, *kachoga*-like treatment, this *yamato-e* artist has at the same time made an effort to recombine the three components of landscape, bird-and-flower motifs, and genre elements into a single unified composition. It seems that the arrival of the Kano school on the scene is what was needed to push Japanese painting one step further in the direction of true genre.

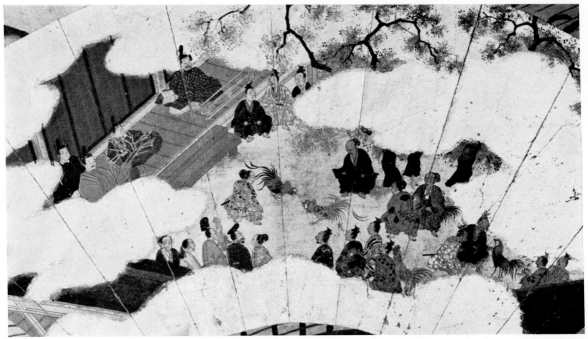

29. *Detail of cockfight; from a set of fan paintings of customs and manners of the months bearing the seal of Kano Motonobu. Mounted on a pair of sixfold screens; colors and gold on paper; each screen, 150.5 × 357.5 cm. Mid-sixteenth century. Koen-ji, Kyoto.*

THE KANO SCHOOL The genre paintings in Nagoya Castle we noted to be the work of the Kano school, which was also responsible for most other Momoyama genre painting. Despite this, the prevalent opinion is that the Kano school was a pawn, only producing genre to order. This misunderstanding arises from the assumption that what is true of painters of the Kano school after the prolific Tan'yu (1602–74), who were so immersed in academic *kanga* under the shogunate, is equally true of Kano artists before him. *Honchogashi* (History of Japanese Painting), written by Kano Eino (1634–1700), the grandson of Kano Sanraku, states that the Kano school "combines the Chinese and Japanese styles," the *kanga* and the *yamato-e*. This confluence is commonly traced either to the marriage of Kano Motonobu (1476–1559) to Tosa Mitsunobu's

daughter, or to the adoption of *yamato-e* coloring into *kanga*. But it would be more correct to reach back even further, for since the time of its founder Kano Masanobu (1434–1530) until the time of Tan'yu, the Kano school had been deliberately fusing the spirit and techniques of the Chinese and Japanese styles. This is the correct estimation and it would hold for the field where *yamato-e* is supreme —the depiction of contemporary customs. Thus I would argue that well before Tan'yu, through having seriously taken up themes of contemporary life along with *kachoga*, the Kano school played a central role in the rise of genre painting.

Kano Masanobu followed in the footsteps of Shubun, the famous fifteenth-century painter, and his disciple Sotan (1413–81). Masanobu painted under samurai patronage and so naturally is given a niche in the *kanga* tradition. But works definitely

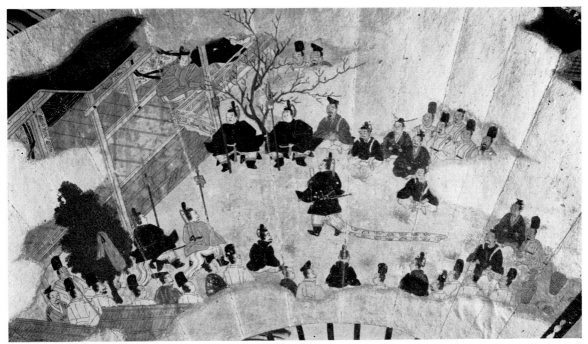

30. Detail of imperial banquet; from a set of fan paintings of customs and manners of the months bearing the seal of Kano Motonobu. Mounted on a pair of sixfold screens; colors and gold on paper; each screen, 150.5 × 357.5 cm. Mid-sixteenth century. Koen-ji, Kyoto.

attributed to him unexpectedly reveal the greater part of his output to be portraiture in the *yamato-e* style, such as the painting of Yoshihisa (Shogun Ashikaga Yoshimasa's son) in armor or the portrait of Yoshimasa's wife, Hino Tomiko. Another interesting point is a reference to the important painters of the day in the *Jinson Ki* (Annals of Jinson) describing Masanobu as "Kano, a Tosa disciple." It is not clear whether he studied *kanga* first and then *yamato-e,* or vice versa. What is certain is that he shuttled between the fields of Chinese and Japanese painting. This departure from the ordinary may have something to do with the fact that Masanobu was an adherent of the Hokke (Lotus) sect founded by Nichiren (1222–82) and not a Zen monk like most *kanga* artists. He was free, and as an aspiring professional he undertook the study of both *kanga* and *yamato-e.* I want to

stress this point in particular, for it is my personal conviction that Masanobu and the Kano school developed a third style distinct from both *kanga* and *yamato-e.*

Kano Motonobu, Masanobu's son, moved in much wider artistic and social circles than his father, and it was Motonobu who further strengthened the foundations of the Kano school. He, too, apparently became a shogunate artist, but it was wartime, when no one could sit peaceably in power. Relying on his protean talents, Motonobu managed nicely through the kaleidoscopic leadership changes, maintaining smooth relations with the imperial court and nobility while working for Zen temples and the Hongan-ji of Ishiyama. Despite the fact that the Hongan-ji sect was at odds with the Hokke sect his father had belonged to, Motonobu was to find in it the greatest patron of his later years. This

31. Detail from Scroll of the History of Seiryo-ji Temple. *Handscroll; colors on paper; height, 34.8 cm.; 1515. Seiryo-ji, Kyoto.*

32. Detail from Cherry-Blossom Viewing at ▷ Daigo. *Single sixfold screen; colors on paper, 141 × 324 cm. Early seventeenth century.*

reveals him for the practical person he was; he was strong-willed, very much his own man as to life style. He once painted a votive picture donated by the *machishu* of Sakai to the Itsukushima Shrine near Hiroshima, and he also had his disciples do countless fan paintings for the fanmakers of Kyoto. This capacity to meet a wide spectrum of demands for his art from every sector of society developed the range and easy versatility of Motonobu's brush.

Motonobu did not limit himself to mastering the current themes and techniques of *kanga* and *yama-to-e*. (We have some of his scrolls and portraits of famous poets.) His peculiar Kano blend of Chinese and Japanese techniques revitalized the then ane- mic *yamato-e*, and as seen in the *kachoga* on the sliding doors of the Reiun-in, a subtemple of Myoshin-ji in Kyoto, he obviously succeeded in "japanizing" the *kanga* style. This double feat is a

tribute to his personal dynamism, prodigious talent, and especially his passionate feeling for real life. Since we know from records that he was already painting *kachoga* on gold screens, we can say that Motonobu paved the way for the magnifi- cent decorative style of painting, a synthesis of the *yamato-e* and *kanga* styles, that was to flower at the hands of his grandson Kano Eitoku (1543–90).

HIDEYORI'S MAPLE VIEWING AT MOUNT TAKAO

What, then, was Moto- nobu's particular con- tribution to the evolution of genre painting? Ex- tant works clearly attributable to him are few, so our answer would have to be that "his second son, Hideyori, painted *Maple Viewing at Mount Takao.*" Let us look at a few of Motonobu's depictions of genre themes. *Seiryo-ji Engi Emaki* (Scroll of the

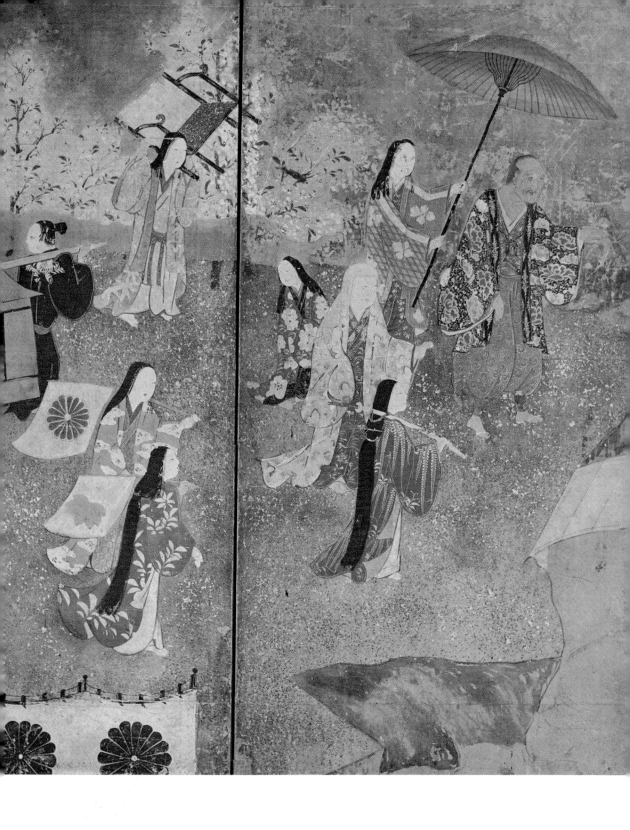

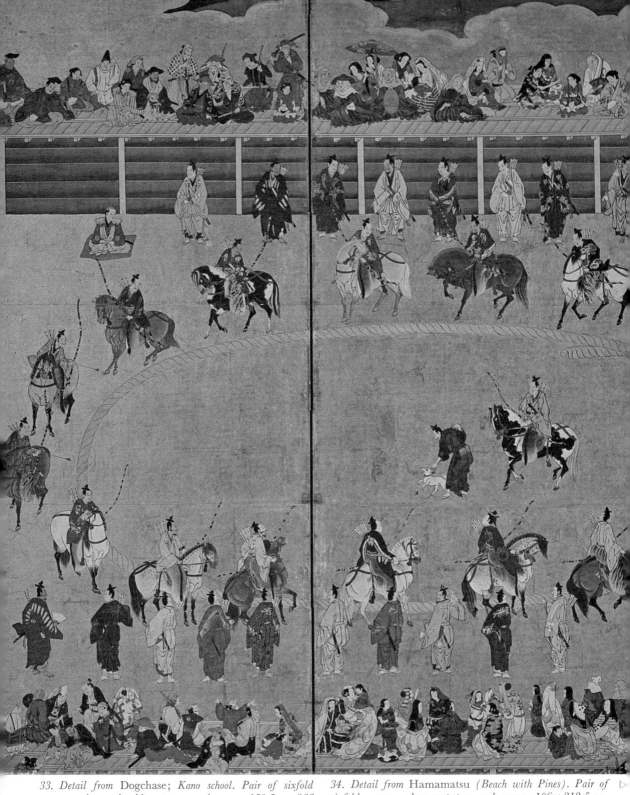

33. *Detail from* Dogchase; *Kano school. Pair of sixfold screens; colors and gold on paper; each screen, 153.5 × 366 cm. First half of seventeenth century. Tokyo National Museum.*

34. *Detail from* Hamamatsu *(Beach with Pines). Pair of sixfold screens; colors on paper; each screen, 106 × 312.5 cm. Mid-sixteenth century. Agency for Cultural Affairs, Tokyo. Formerly in the Kumita Collection.* ▷

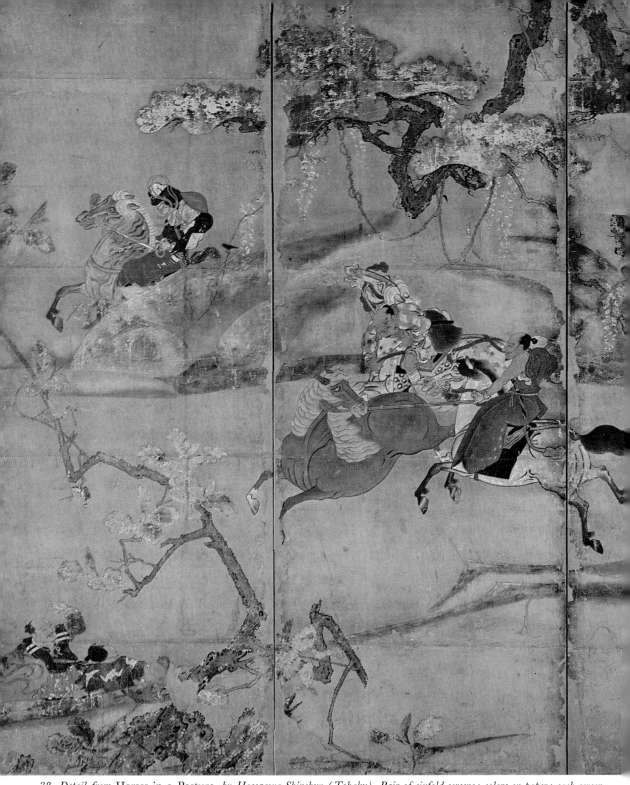

38. *Detail from* Horses in a Pasture, *by Hasegawa Shinshun (Tohaku). Pair of sixfold screens; colors on paper; each screen, 157.5 × 343 cm. About 1570. Tokyo National Museum.*

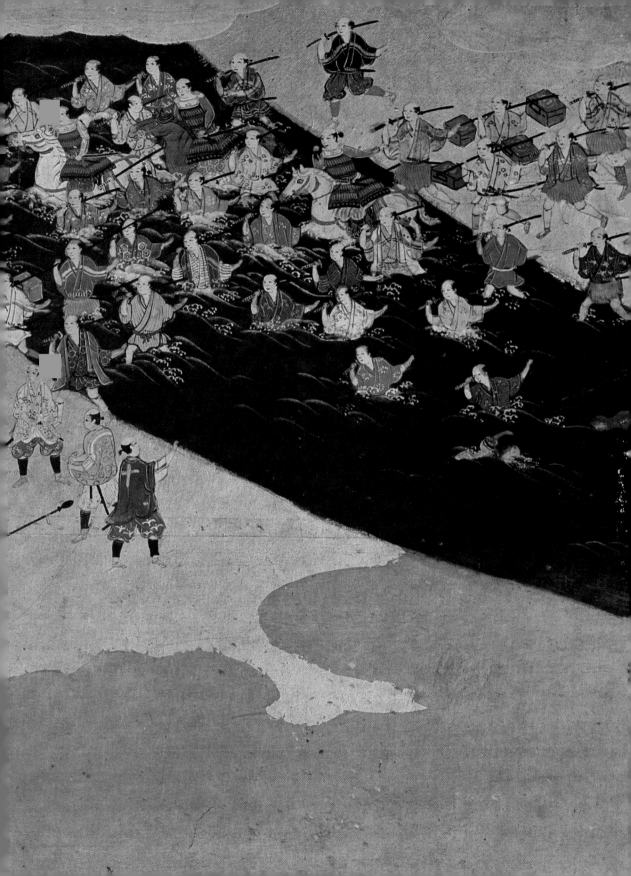

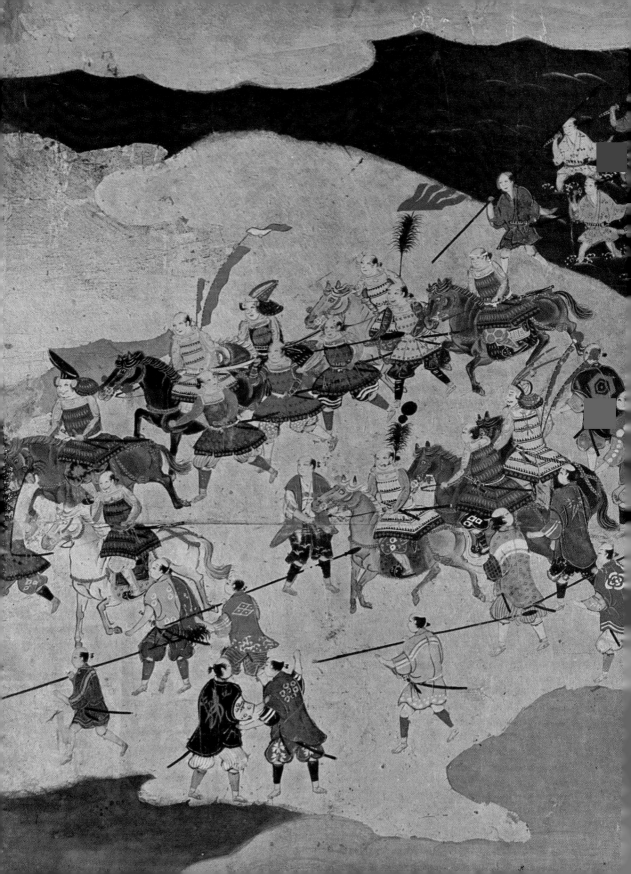

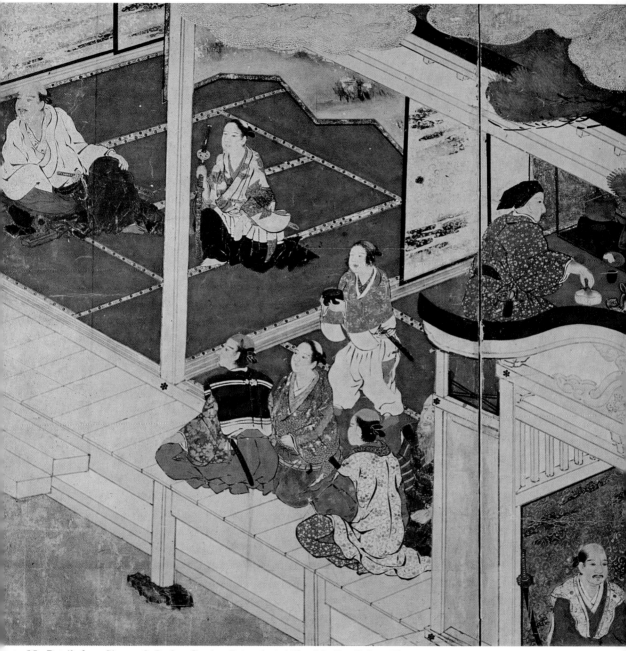

◁ *35. Detail from* Siege of Osaka Castle. *Pair of sixfold screens; colors and gold on paper; each screen, 150 × 361 cm. First half of seventeenth century. Osaka Castle.*

36. Detail from Horse Training and Stable; *Kano school. Pair of sixfold screens; colors and gold on paper; each screen, 155 × 354 cm. Early seventeenth century. Taga Shrine, Shiga Prefecture.*

37 (overleaf). Detail from Battle of Sekigahara; *Tosa school. Pair of ▷ eightfold screens; colors and gold on paper; each screen, 194 × 594 cm. Early seventeenth century. Maeda Collection, Osaka.*

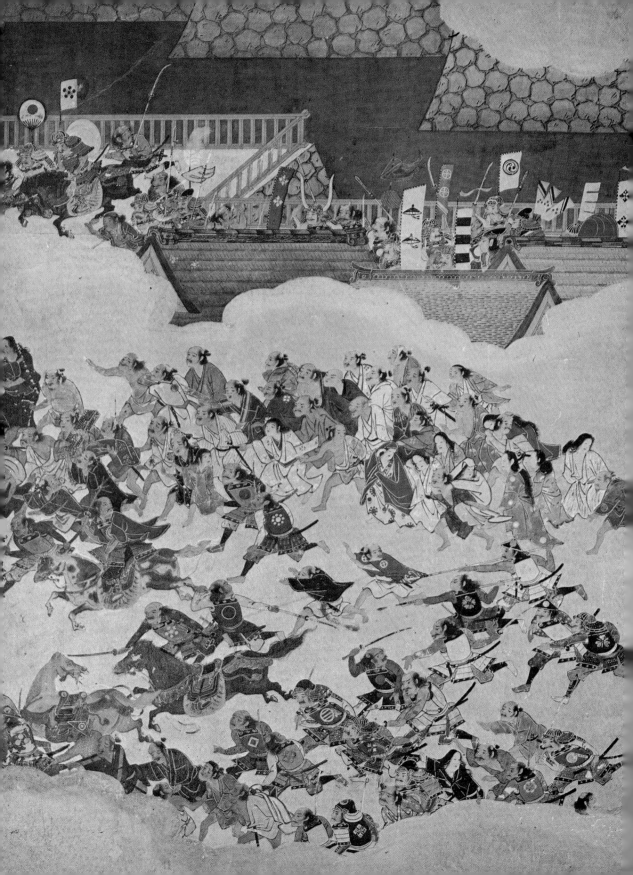

39. *Detail from* Rakuchu Rakugai Zu *(Scenes In and Around Kyoto). Pair of sixfold screens; colors on paper; each screen, 138 × 348.5 cm. First half of sixteenth century. Agency for Cultural Affairs, Tokyo. Formerly in the Machida Collection.*

History of Seiryo-ji Temple; Fig. 31), dated 1515 in the colophon, has been traditionally attributed to Motonobu. It is a matter of historical record that Motonobu did paint a scroll of the history of Kurama Temple only two years prior to this, in 1513; and from the *kanga*-like treatment of trees, the rough-hewn rocks, and the line of the Chinese garments in the Seiryo-ji scroll, I think we can more or less take the attribution at face value. The portrayal of manners and customs shows outstanding vitality and movement compared to the *yamato-e* of the day. It is manifestly the work of someone skilled in *kanga*. However, the line tends to be obtrusive. But this is completely overcome in the large-figure votive painting of Figure 40, which is signed by Kano Motonobu and datable from the writing as prior to 1539. On balance, it makes sense to say that it was from Motonobu that the

Kano school mastered methods suited to the candid expression of life and manners.

Recently, a pair of sixfold screens of the Kyoto *tsukinami-e* genre-painting type has been discovered and is now at Koen-ji temple in Kyoto. One of them has twenty-four fan paintings fixed to the gold ground of the screen as if floating down a stream. All but one show scenes of gala shrine festivities and myriad Kyoto events against the background of the seasons. Each bears the seal of Motonobu, but in view of his fanmaker connections, it is thought they are, rather, products of his pupils. Be that as it may, we should note that Motonobu and his circle were producing many fans with scenes of Kyoto life on gold, and Hideyori's *Maple Viewing at Mount Takao* was an almost inevitable development.

This renowned sixfold screen (Figs. 12, 41, 42),

40. Sacred Horses, *by Kano Motonobu. Votive paintings; colors on wood; each painting, 85 × 77 cm. First half of sixteenth century. Kamo Shrine, Hyogo Prefecture.*

41. Maple Viewing at Mount Takao, *by Kano Hideyori. Single six-fold screen; colors on paper, 148 × 364 cm. Second half of sixteenth century. Tokyo National Museum.*

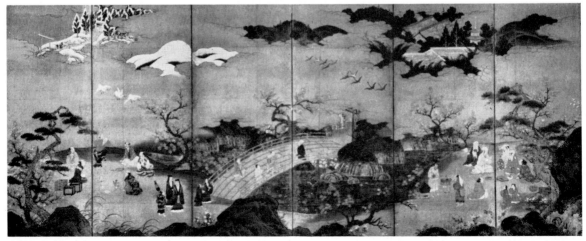

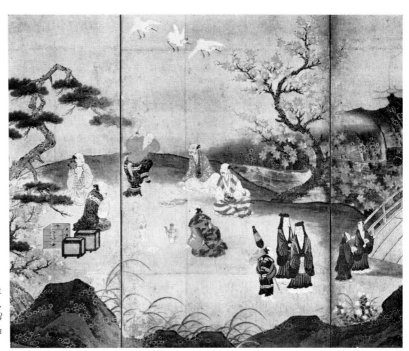

42. *Detail from* Maple Viewing at
Mount Takao, *by Kano Hideyori.
Sixfold screen; colors on paper, 148
× 364 cm. Second half of sixteenth
century. Tokyo National Museum.*

originally one of a pair, captures the crimson of
autumn leaves surrounding the Takao Jingo-ji
temple, with snow-capped Mount Atago in the
distance. In the foreground flows the Kiyotaki
River, lined with maple trees in lovely autumn
foliage. Enjoying the scene we see samurai, monks,
and women. It is not difficult to surmise that the
other, no longer extant, screen of the pair must
have shown people enjoying the Higashiyama
environs of Kyoto as spring gave way to summer.
This screen should actually be placed in the
seasonal and famous-place categories of genre
painting. But since it is not typical of these, it
could be described as a large-scale treatment of
customs and manners. Genre themes had not held
a very prominent place up to this time, but now
the artist obviously lays store by people, ushering
them generously into the foreground. The figures
and faces of the women and children are especially
charming, obviously brimming over with the gen-

uine joy at being alive in this world that was so
characteristic of the period.

The maples and mountain are handled in
yamato-e style, the pine trees and rocks in the *kanga*
way, amounting to a delightful aesthetic compro-
mise between the two. Arranging large figures on
a screen like this was not something we find in the
yamato-e repertory. In Kano Motonobu, the Kano
school had attempted it on the *fusuma* at the Daisen-
in, a subtemple of Daitoku-ji, Kyoto, depicting
figures from Chinese history, but it was probably
Hideyori who first used large figures for Japanese
genre themes. I think we can safely venture to say
that it was only Kano-school artists who would
have been sufficiently equipped to draft and ex-
ecute this kind of painting. And, of course, credit
is due to Motonobu, for with him painting really
launched into life as it is. In any case, Hideyori's
Maple Viewing at Mount Takao represents the largest
landmark in the sudden rise of genre painting.

CHAPTER THREE

Kano Eitoku's
Contribution to Genre

THE UESUGI SCREENS From the *Uesugi Nempu* (Chronicle of the Uesugi Family) and other sources, we know that in 1574 a pair of *Rakuchu Rakugai Zu* folding screens painted by Kano Eitoku (1543–90) was presented by the military leader Oda Nobunaga (1534–82) to Uesugi Kenshin (1530–78), daimyo of Echigo (present-day Niigata Prefecture). The gift shows how eminently desirable Kyoto-scene genre screens were even for a daimyo in days of war. The pair of sixfold screens is still carefully preserved as a precious possession of the Uesugi family, an eloquent indication of Eitoku's early style and his interest in genre.

In the Uesugi screens (Figs. 10, 43, 44, 67) the gold ground and clouds spill across all twelve panels, and we can see many buildings and people depicted in rich color. The screens are the earliest extant example of *shoheiga* painting in the *kompeki* style. Because of the gold ground we miss the depth seen in the Machida screens (Figs. 28, 39), but in place of it, the buildings and figures stand out sharply against the brilliant background. We have moved one step further away from the lyrical, idealistic conception of painting.

The result is something incredibly richer than the Machida screens. Eitoku included over fifteen hundred people; and the execution of the different customs of the various classes, the figures, the faces, the men and women—everything is painted in utter clarity with a deft brush. A small child is seen being coaxed to relieve himself by his mother (Fig. 67). A streetwalker propositions a passerby, pulling at his kimono (Fig. 43). Details like these speak volumes for Eitoku's unerring eye and keen powers of observation; and above all, we come face to face with his tremendous love of real life. The color scheme, devised to fit the gold ground, succeeds. Eitoku's Uesugi screens have caught, as none before, that definite but indefinable, bright and bubbling life which was then typical of the roaring capital. I might be forgiven for mentioning only one slight drawback: in stepping away for perspective, you cannot help but notice how tiny the figures become. The gold ground and golden clouds are meant to give the picture unity, but the steep-sloping rooftops of temples, shrines, and other buildings somehow swallow up the whole. The effect is, therefore, somewhat diminished. It is indeed a gorgeous but in the final analysis decorative piece of painting.

To judge from the depicted residences of generals, the screens show the Kyoto of the mid-sixteenth century, somewhere between 1550 and 1565. (See Chapter Seven.) If we settle for 1562, Eitoku would have been only nineteen years old

43. Detail from Rakuchu Rakugai Zu *(Scenes In and Around Kyoto), by Kano Eitoku. Pair of sixfold screens; colors and gold on paper; each screen, 159.5 × 364 cm. About 1570. Uesugi Collection, Yamagata Prefecture.*

when he undertook the work. At first sight this would seem much too young to be true, but when you recall that he could come up with something of the caliber of the famous *kachoga fusuma* at the Juko-in, a subtemple of Daitoku-ji in Kyoto, at the age of twenty-three, the Uesugi screens quite plausibly may have been painted when he was nineteen.

Eitoku's *fusuma* painting of birds and flowers in the Juko-in, done in the manner of Motonobu's bird-and-flower *fusuma* at the Reiun-in, depicts plum trees and pines in close-up executed in brushwork of great power, giving an unprecedentedly exhilarating feeling of pulsating life. It is what the Kano *History of Japanese Painting* would describe as *taiga,* or "large" painting. On the other hand, the Uesugi screens correspond to *saiga,* or "detailed" painting, having some fifteen hundred people drawn down to their last dynamic detail. The

techniques, also, of these two paintings seem at first sight to be completely different—the *kanga* combination of *sumi* ink on gold paint of the Juko-in *fusuma,* as against the typical *yamato-e* use of brilliant colors on gold of the *Rakuchu Rakugai Zu* screens. The same Kano source attests, however, that Kano Eitoku painted "landscapes, figures, and *kachoga;* mostly *saiga* with some *taiga.*" Furthermore, there is, I feel, a freshness of sensibility and a bright, lively treatment common to these two paintings by Eitoku. In both cases, the entire surface of the work announces the arrival of a new era. The Momoyama style in painting can be said to start with these two works. And it is interesting to note that one is a *kachoga* and the other a genre painting.

I myself feel the Uesugi genre screens are the work of Kano Eitoku when he was about twenty. (Oda Nobunaga acquired the screens upon visiting Kyoto in 1568, and presented them to Uesugi

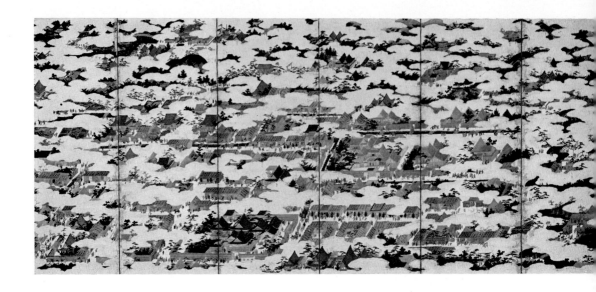

Kenshin in 1574.) But even should he have painted them in the year of their presentation, he would still have been only thirty-one. It appears certain that in his early period, he was immensely attracted to this type of genre painting and made a significant contribution to its development.

GENRE PAINTINGS IN AZUCHI CASTLE Azuchi Castle, erected in 1576, signaled the dawn of a new era in every sphere. Azuchi was intended to make the majesty of Oda Nobunaga evident. A prodigious quantity of *shohekiga* (paintings on walls, doors, and partitions) decorated the donjon and the master's residence. Most of these paintings were in the *kompeki* style of dazzling colors on gold. We know from the *Nobunaga-Ko Ki* (Chronicle of Lord Nobunaga) the subjects of all the donjon paintings and some of the paintings in the master's residence of the castle's Hommaru Compound. And we also learn that Nobunaga commissioned Kano Eitoku to do the work. He probably chose the then thirty-three-year-old Eitoku because he knew from the Uesugi screens Eitoku's powers of expression.

The paintings in the donjon show a remarkable diversity of subjects. On classifying them, by far the greatest number are seen to be bird-and-flower scenes (*kachoga* in its wider sense, including animals and the like), and then figure painting. A single landscape, *Curfew Bell of a Temple in the Distance,* is found. The idealistic Chinese landscape popular in the Muromachi period was evidently on the wane about this time. Easily comprehensible *kachoga* are everywhere, a prelude to the stream of Momoyama painting just around the corner.

Particularly worthy of note is the point that the donjon as a whole has a unified decor of paintings in the flowering-tree genre. Types include "plum trees," "pines only," "various kinds of bamboo," "rocks and various trees," and so on. Indeed, the whole of a room is decorated with paintings featuring just one kind of tree, say, pine or plum. In Eitoku's *fusuma* paintings at the Juko-in, the tradition of doing one room entirely in *kachoga* of the four seasons is still alive. But in these Azuchi Castle paintings, the birds have been removed, and the large trees, already emphasized in the Juko-in paintings, have been given their independence.

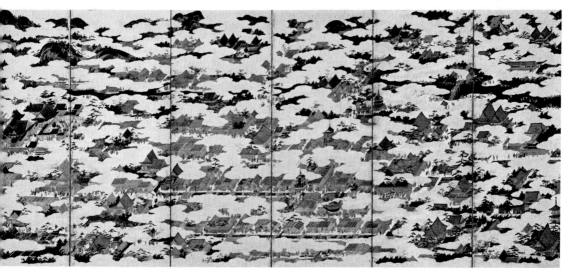

44. Rakuchu Rakugai Zu *(Scenes In and Around Kyoto)*, by Kano Eitoku. *Pair of sixfold screens; colors and gold on paper; each screen, 159.5 × 364 cm. About 1570. Uesugi Collection, Yamagata Prefecture.*

The splendid decorative effect is all the more enthralling for the techniques, which set aside *sumi* ink in favor of luxurious colors on gold. Eventually, this tendency toward more concrete subject matter was also to be seen in the development of genre painting.

The figure painting in the donjon is almost all of sages, hermits, and legendary figures of China, such as the Three Emperors and Five Rulers, Confucian scholars, the Seven Sages of the Bamboo Grove, and the Four Ancients of Mount Shang. This family of revered figures once lined court walls of Heian times, and sometimes also turns up amid the *kanga* of the Muromachi period. Nobunaga probably found them ideal to preach the Confucian ethic. But people's interest in them was probably due more to the fact that they were depictions of foreign customs and manners, as is thought to be the case with the *fusuma* paintings *Twenty-four Paragons of Filial Piety* and *Taoist Immortals* at the Nanzen-ji in Kyoto, painted by Eitoku's pupils in 1585 or 1591. In any case we have to admit the adoption of Confucian figure-painting techniques, especially the compositional approach, in evolving genre.

Are there any genre paintings to be found among the figure work in the Azuchi Castle donjon? The painting of horses in a pasture in the twenty-mat room on the north side of the third floor is taken for a *kachoga,* but it is more likely to have been a warrior genre painting in the manner of a painting of horses in a pasture (Figs. 38, 48) by Hasegawa Shinshun (later known as Tohaku; 1539–1610). (See Chapter Eight.) The latter was executed a little before 1576, the year when Azuchi Castle was constructed. There is a synthesis of Chinese and Japanese techniques, not altogether unlike Hideyori's *Maple Viewing at Mount Takao.* It is a skilled depiction of many men and horses in dynamic action. I find it hard to imagine the samurai class not being enchanted by a genre form that was so intimately related to their lives. Another warrior genre work showing horses, usually attributed to Kano Motonobu, is a pair of sixfold screens showing a stable (Fig. 49), with people sitting around in front of it enjoying backgammon and other board games. Both the line and composition are rather antiquated, suggesting a Kano product of either late Muromachi or early Momoyama times. It

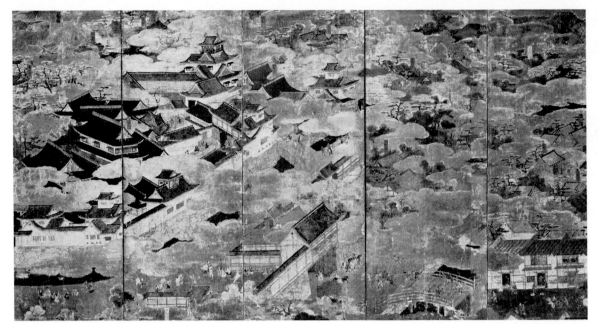

45. Juraku-dai; *Tosa school. Single sixfold screen (one panel missing) ; colors and gold on paper, 156 × 355 cm. Mitsui Collection, Tokyo.*

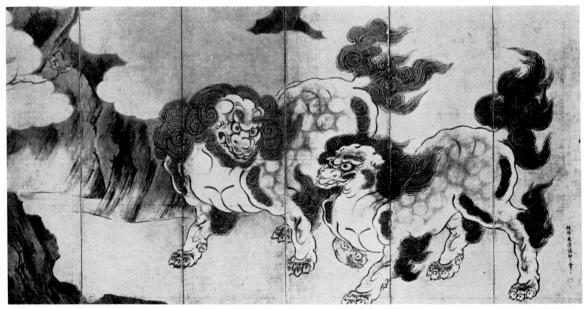

46. Chinese Lions, *by Kano Eitoku. Single sixfold screen; colors and gold on paper, 225 × 459.5 cm. Second half of sixteenth century. Imperial Household Collection.*

47. *Detail from* Juraku-dai; *Tosa school. Single sixfold screen (one panel missing); colors and gold on paper,
156 × 355 cm. Mitsui Collection, Tokyo.*

would not be out of character for Kano Eitoku to
have attempted warrior genre painting of this type,
though he would most likely have given it a differ-
ent treatment. Records say that on the fourth floor
of the donjon there was an eight-mat room dec-
orated with a garden scene and called the "Room
of the Falcon." The description suggests that this
may have been a painting depicting retainers at-
tending to falcons on their perches in the garden
of a samurai lord's residence.

For all this, there is still nothing among the
motifs of the donjon which is indisputably genre.
But for the quarters within Azuchi Castle known
as Koun-ji Goten, we have records of *shohekiga*
(partition-and-wall paintings) described as "all
kinds of pictures of all kinds of places" and "famous
places of three countries" showing "scenes of the
four quarters"—mountains and sea, the country-
side, villages, and so on. People were evidently very

interested in this kind of thing. If we take the
"three countries" to mean India, China, and
Japan, Eitoku would seem to have painted, on the
one hand, Indian and Chinese landscapes and
genre scenes based on earlier works and fancy, and
on the other, Japanese customs and famous places
in the realistic *Rakuchu Rakugai Zu* style.

Be that as it may, Azuchi Castle did have its
genre paintings, but they were all destroyed when
the castle fell in 1582. This leaves us pondering
how far Eitoku went along the road he started out
on in his early years with the *Rakuchu Rakugai Zu*
of the Uesugi screens.

It would be well to allude here to the screens
showing Azuchi Castle (sometimes called the
Azuchi Screens), which were presented in 1581 as
a farewell gift from Nobunaga to Alessandro
Valignano (1539–1606), the Visitor of the Society
of Jesus to Japan, as the latter was about to return

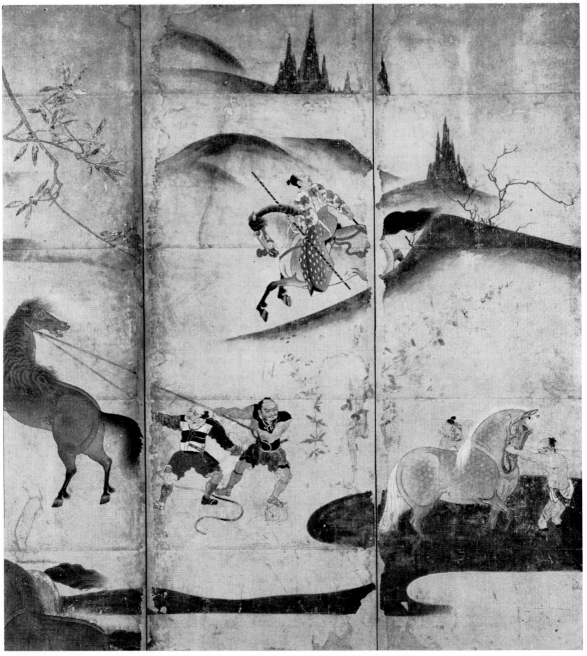

48. Detail from Horses in a Pasture, *by Hasegawa Shinshun (Tohaku). Pair of sixfold screens; colors on paper; each screen, 157.5 × 343 cm. About 1570. Tokyo National Museum.*

49. *Detail of* Stable; *Kano school. Pair of sixfold screens; colors on paper; each screen, 149.5 × 354 cm. Second half of sixteenth century. Tokyo National Museum.*

to Europe. Nobunaga had ordered Kano Eitoku, "Japan's most famous artist," to paint a pair of screens of Azuchi Castle. One side was to depict the completed castle, the other the castle town and its prosperous life, deviating not the slightest bit, as Nobunaga would have it, from the appearance it actually presented. Nobunaga's taste for realism, his penchant for putting painting to political ends, are indeed fascinating. Unfortunately the screens do not survive, but the difference in composition from the Uesugi screens is full of implications. In the Uesugi screens the Imperial Palace and the residences of the shogun and governor-general constitute the main element of the composition, but they are merely conspicuous, being scattered throughout the city spread over the two screens. By constrast, in the Azuchi screens, the magnificent castle soars up on one screen, while the bustling castle town sprawls below it on the other screen.

The difference in power between Nobunaga and the Ashikaga shoguns (the last one, Yoshiaki, was deposed by Nobunaga in 1573) is clear at a glance. The town teems with activity in both, but the point of view is not the same. The Azuchi Castle screen, we can suppose, is the realization of an ideal Nobunaga conceived while gazing at the Uesugi *Rakuchu Rakugai Zu* screens. Eitoku painted almost exclusively for Nobunaga, the man holding the reins of power. Could it be that he too came to look down on the life of townspeople from on high?

LARGE-SCALE KACHOGA Following Oda Nobunaga's death in 1582, Kano Eitoku worked for the military ruler who succeeded him, Toyotomi Hideyoshi (1536–98), giving himself over completely to painting *shohekiga* in large edifices such as Osaka Castle, Juraku-dai (Hide-

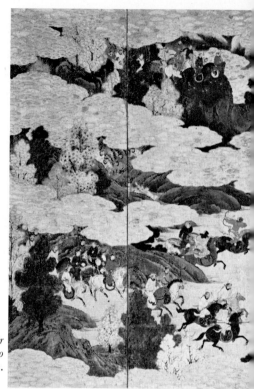

50. Tartars Hunting, *by Kano Soshu. One of a pair of sixfold screens (the other screen shows a Japanese-polo scene); colors and gold on paper, 165 × 351.6 cm. About 1600. Kumita Collection, Tokyo.*

yoshi's palace, built in 1587), and the Imperial Palace. All these paintings have been destroyed and even the themes are unknown. The Kano *History of Japanese Painting* claims that Eitoku "no longer had time for detailed work [the *saiga* mentioned earlier, and *saimitsuga*, or miniatures] so he painted mainly large-scale pictures of pines or plum trees, as much as one hundred to two hundred feet long. Figures reached a height of three to four feet. His brushwork also became broad and free-ranging."

The extant works from Eitoku's final period are his screen paintings *Kara-shishi* (Chinese Lions; Fig. 46), *Hinoki* (Cypresses), and a painting of Hsu Yu and Ch'ao Fu, two legendary Chinese sages. *Chinese Lions* is a gold screen reputed to have been Hideyoshi's gift to the Mori family. It is done in *kompeki* style and a large pair of lions, male and female, are shown walking majestically across the center. The animals strike you more for their majesty and dignified composure than their size. They aptly express Eitoku and his day in terms of the heroic and herculean. *Cypresses* is considered to have originally been a *fusuma* painting in the palace of Prince Hachijo, which was built to its grandiose dimensions by Hideyoshi in 1590. Again, in the center is a life-size cypress, the colossal branches jutting out from the great trunk to each side, giving the arrangement an overpowering note. The style of the flowering-tree paintings so numerous in Azuchi Castle has been brought to perfection. Many animal and flowering-tree paintings in the manner of these works must have adorned the chambers of Osaka Castle and Juraku-dai. I rather think that the reason for the gigantic scale of Eitoku's works in this period is not so much lack

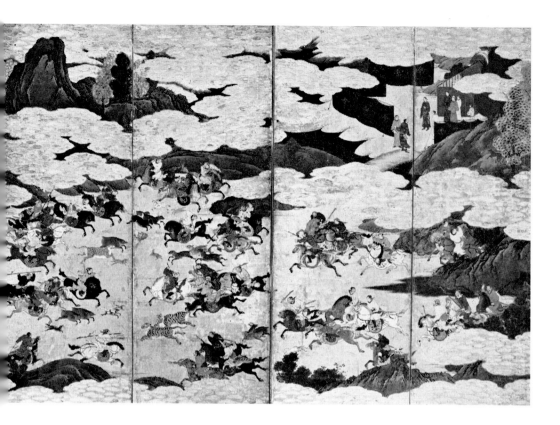

of time as the fact that their powerfully expressive impact corresponded to the generals' tastes. The size of human beings in his figure paintings must have been increased for the same reason.

The painting of Hsu Yu and Ch'ao Fu, a hanging scroll in *sumi* ink (unusual for Eitoku), impresses us for the free-flowing folds of their robes, but the figures are not all that large. Nevertheless, it would not have been out of character for Eitoku to do paintings with three- or four-foot figures in Osaka Castle or Juraku-dai, since we know that painters heavily influenced by him, such as Kaiho Yusho (1533–1615) and Kano Sanraku (1559–1635), did gold-screen genre work of Chinese figures in this size. (Yusho's *Four Accomplishments* screen and Sanraku's *King Wen and Lu Shang* and *Four Sages of Mount Shang*, forming a pair of screens at Myoshin-ji in Kyoto, are examples.)

Did Eitoku actually do genre painting of such tremendous scale and showing figures of such proportions? Sad to say, we have no record concerning genre paintings, let alone actual works, from Eitoku's later period. Because of this we must sift through the work of the group of painters who surrounded him at the time. The *Kyo Meisho Zu Semmen* (Fig. 26) is a series of fan paintings originally over sixty in number. They are thought to be the work of Eitoku's younger brother Soshu, and to date from before 1587. The people are smaller and far less active than those in the Kyoto-genre fan paintings in Koen-ji temple, Kyoto, which bear Motonobu's seal. And we have the *Juraku-dai* screen (Figs. 45, 47) of around 1590 by artists of the Tosa school, probably influenced by Eitoku's Azuchi Castle screen. Here again, the figures are few and look somewhat diminutive beside the

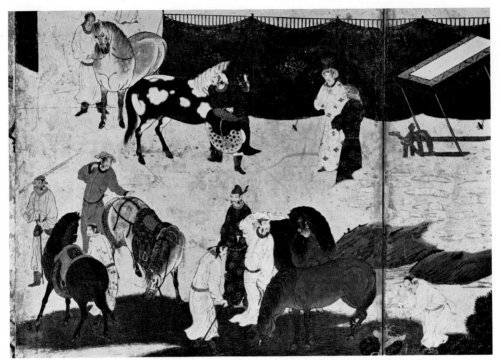

51. *Detail from* Tartars Hunting, *by Kano Soshu. One of a pair of sixfold screens (the other screen shows a Japanese-polo scene); colors and gold on paper, 165 × 351.6 cm. About 1600. Kumita Collection, Tokyo.*

Juraku-dai, which holds the center of the stage. For this reason, though the painting of customs and manners is rendered with considerable flair in the *yamato-e* style, the life of the city does not register very palpably. As genre painting, these works may be said to have taken a step backward.

Thus we may infer from the two works above that Eitoku in his later years committed himself to perfecting large-scale *kachoga* and did not exert much influence on the development of genre painting. In contrast to *kachoga*, therefore, Momoyama genre painting made few strides during the last quarter of the sixteenth century.

A HYPOTHESIS Even if we accept that, as Hideyoshi and other generals came to look down on the townspeople, so Eitoku too lost interest in paintings showing the life of the common people, the samurai class would not have

lost interest in warrior genre painting also. *Tartars Hunting* (Figs. 50, 51) by Kano Soshu (?–1601) and similar depictions of courageous warriors in foreign lands were probably popular because they struck a sympathetic chord in the hearts of Japanese warriors. And Hideyoshi could conceivably have commissioned Eitoku to depict Emperor Goyozei's visit to the Juraku-dai. No warrior genre work from the 1580s exists to support this hypothesis. However, I should like to consider here the possibility that genre paintings with large-scale warriors and similar figures were in fact painted.

Take for instance Figure 52, showing Western princes on horseback. Tradition says that this screen was once in Wakamatsu Castle in Aizu (modern Fukushima Prefecture), and it is generally dated between 1590 and 1596. Needless to say, it has a Western prototype and shows the shading of Western-style painting. But look at the astounding

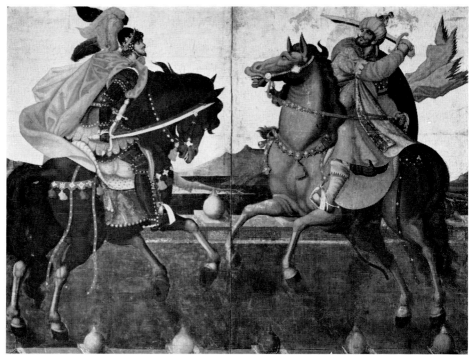

52. Detail from a single fourfold namban *screen showing mounted princes. Colors and gold on paper, 162 × 468 cm. Kobe Municipal Museum of Namban Art.*

size of the figures and horses, covering as they do the entire sweep of the screen. Indeed, a connection can be found here between Western-style painting and these enlarged figures on a gold ground. The link is the love for genre and the popularity of screen-and-partition work in Momoyama times. The fact that the prototype, a work of small format, was enlarged to such dimensions argues strongly for the prior existence of a large-figure form of genre painting in Japan.

Asahina Saburo Tugging Armor Tasses, at Kiyomizu Temple, is a picture painted in 1592 by Kyuzo (1568–93), the son of Hasegawa Tohaku (1539–1610), and is known for its gallant figures of the Japanese Hercules, Asahina Saburo, and the vengeful Soga Goro, a twelfth-century hero. The fact that it is a votive painting may explain the large size of the figures. It comes under the category of historical painting, but the work is useful as a

comparison. Another work (Fig. 152), now in the Imperial Household Collection, representing the oldest style in *namban* screen painting and datable around 1590, is provocative for its figures, which are larger than on any later *namban* screens. (The term *namban* refers to southern Europeans, principally Portuguese and Spaniards, and in connection with painting it signifies works with *namban* subject matter.) In the same vein, *Tartars Hunting*, attributed to Soshu, is sprightlier and the people are awarded ampler consideration than in the same theme as painted by his son Jinnojo.

Had Eitoku in his final days left us a legacy of warrior genre painting of the horse-training or horses-in-pasture kind, we might have come across magnificent heroes somewhat like the mounted princes of Figure 52—and my explanation of the progressive evolution of Momoyama genre art would surely have been a livelier tale.

CHAPTER FOUR

---·---

Genre Painting at Its Zenith

In *Collection of Observations on the Keicho Era* (1596–1615), by the writer Miura Joshin, is a passage with the theme of "joy to all people," in which he writes: "Truly great times, these! Indeed, great times! Even people the likes of me behold the beautiful and catch word of wonders in the good life of today. May the Buddha's Kingdom come!"

Doubtless, it was a grand time to be alive during the decade or so in the Keicho era between the battle of Sekigahara in 1600 and the summer siege of Osaka Castle in 1615. They were halcyon times for everyone, and the people intoned the praises of the gorgeous life of the age. "Even peasants handle gold and silver," reads Miura's account, indicating the burgeoning money economy. Trade was never better: foreign ships and the famed "red-seal" vessels of the shogunate shuttled to and fro on the seas. ("Red-seal" vessels, or *shuin-sen,* were Japanese ships licensed by the shogunate to sail the open seas for purposes of trade. The license carried a large red seal, hence the name.) City commerce flourished beyond anyone's dreams. The age of money and the power that came from it had dawned. The talk of the town with one and all, regardless of social standing, was the Okuni Kabuki; and the new, short-sleeved kimono known as *kosode* were the rage.

Although the hegemony of the house of Tokugawa was established at the battle of Sekigahara, Hideyoshi's son Hideyori was still in Osaka Castle, and the samurai no doubt foresaw the coming of a bloody battle between the Tokugawa and Toyotomi families. Moreover, the nobility, clergy, and common people must have sensed the gradual approach of control by the *bakufu* (military government) in Edo. But in daily life, a cheerful mood of peace prevailed. It is this peaceful spirit that is reflected in the many genre paintings of the period, and this new tendency in popular feeling duly escorted the art form to its heights. As the mood of the times changed—from the atmosphere of destruction and creation of the Tensho era (1573–92) to that of peace of the Keicho years (1596–1615)— even the military class felt the new, more settled pulse, and looked for a lower-keyed, more engaging painting form in place of Eitoku's style. As it turned out, it was Kano Mitsunobu (1565–1608) who best met the enthusiastic desire for a change, and it was he and his Kano mainstream group that were the source of most of the genre painting we have today.

KANO MITSUNOBU AND HIS GROUP
Mitsunobu was Eitoku's eldest son. Unlike the father with his formidable energies, Mitsunobu was basically mild-mannered, in the mold of a gentler, easier-going era. As Eitoku's art had tended to brilliance, Mitsunobu's developed elegance; as time went on, his work in many ways came to be the opposite of his father's in style. Turning to Mitsunobu's most representative work, the *fusuma* painting of birds and trees on gold in the Kangaku-in temple, Shiga Prefec-

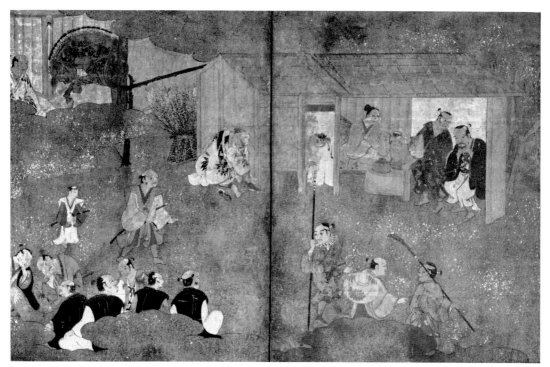

53. *Detail from* Cherry-Blossom Viewing at Daigo. *Single sixfold screen; colors on paper, 141 × 324 cm. Early seventeenth century.*

ture, we realize immediately there is none of Eitoku's adventuresome scale or form, nor the dynamic compositional flourish. The subject matter is simply lined up in a two-dimensional manner, less manipulated, and left to state its own message. As a result a warmth that is its trademark reaches out to the beholder. We also notice many *yamato-e* elements. This new style of painting was welcomed. Partly because Mitsunobu was patronized by Tokugawa Ieyasu, his style influenced many artists of the Kano school, a notable exception being Mitsunobu's adopted brother Sanraku (1559–1635), who painted for the Toyotomi family. Sanraku is noted for having been true to the Eitoku tradition, but Mitsunobu and his group adapted to the times, eventually becoming the mainstream of the Kano tradition. Around Mitsunobu were his brother Takanobu (1571–1618); a cousin, Jinnojo

Genshu; and his disciples Koi, Hayato, and Shin'e-mon, along with his uncle, Naganobu.

What kind of genre painting in particular did Mitsunobu and his group undertake? Records tell us that Mitsunobu did a genre painting in 1603 for the palace of Tokugawa Hidetada, the third son of Ieyasu. It was something on the order of a *Rakuchu Rakugai Zu* and was of "upper Kyoto and the Imperial Palace." Mitsunobu's disciples and his younger brother Takanobu produced an assemblage of famous-place paintings in colors on gold for the walls, partitions, and doors of the academy (*gakumonjo*) of the Kyoto Imperial Palace and its outbuildings upon their completion in 1614. The *Nakanoin Michimura Ki* (Chronicle of Nakanoin Michimura) states that in 1615 Mitsunobu's disciple Koi was doing genre paintings, such as a screen depicting the siege of Osaka Castle. Un-

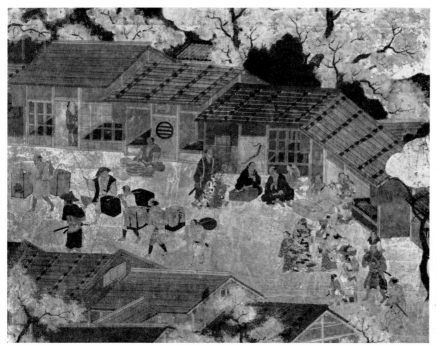

54. *Detail from* Cherry-Blossom Viewing at Yoshino; *Kano school. Pair of sixfold screens; colors and gold on paper; each screen, 155 × 363.5 cm. Early seventeenth century. Hosomi Collection, Osaka.*

fortunately, however, with the exception of Naganobu's *Merrymaking Under the Cherry Blossoms,* which I will soon refer to, we have no genre work that can definitely be attributed to Mitsunobu or his group. Nevertheless, basing our case on the decor in Nagoya Castle and Emman-in temple in Shiga Prefecture, the historical evidence points to many genre paintings from the brushes of artists gathered around Mitsunobu, and we do know the characteristics of these works.

Historical references indicate that Mitsunobu's son Sadanobu (1597–1623) was commissioned to do the paintings inside the main compound of Nagoya Castle. Sadanobu would have been only seventeen or eighteen when the work was completed in 1615, so it seems reasonable that Mitsunobu artists would have lent a hand. Who did what painting is uncertain, but it has long been thought that the same Naganobu who gave us the screen genre masterpiece *Merrymaking Under the Cherry*

Blossoms also did the Taimensho-suite genre work. But the brushwork and composition of these are quite different. The attribution ignores the fact that anyone could have painted genre if he belonged to the Kano school. I side with the art historian Tsuneo Takeda, who recently attributed it to Jinnojo Genshu. This makes more sense than insisting on Naganobu.

We can, therefore, conclude that the decorative work in the main compound of Nagoya Castle was produced by Mitsunobu's followers or relations. It is beyond doubt that these paintings constitute a collection from the Kano mainstream at the end of the Keicho era (1615).

THE OBJECTIVE POINT OF VIEW I remarked in the beginning that what I found special about the genre paintings in the two rooms of Nagoya Castle's Taimensho was not the famous-place or seasonal-landscape aspects

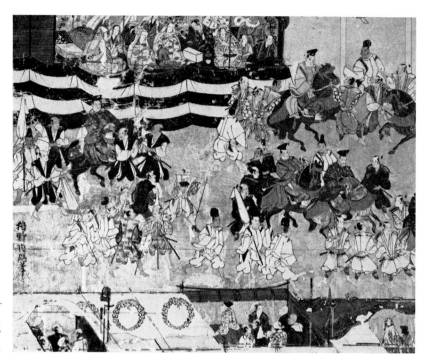

55. *Detail from* Hokoku Festival, *by Kano Naizen. Pair of sixfold screens; colors and gold on paper; each screen, 167 × 362 cm.; 1606. Hokoku Shrine, Kyoto.*

so much as the fact that they deal with people in every walk of life, capturing them faithfully. The artistic intention is showing life realistically, and the eye is as far-reaching as it is sensitive to detail. However, the handling of flowing garments, which probably began with Mitsunobu, is at times too summary, and because the people are scattered about with large spaces yawning between them, the feeling of a crowd is not communicated. Whatever intrinsic life there is seems to evaporate or is swallowed up into the background. An example would be the painting with the scene of horse racing at the Kamo Shrine (Fig. 8). One seems to be far away from the action; the impact is weakened and the message robbed of feeling thereby. Of course, this kind of general-overview composition is in line with the traditions of famous-place seasonal-landscape painting. But the depiction of customs has come a long way since. Why, we may ask, use this compositional approach? Hideyori's *Maple*

Viewing at Mount Takao of the late Muromachi period is also executed as a bird's-eye view, but its redeeming feature is that it gives greater prominence to manners and customs. On balance, however, the Kano school of the Keicho era had indeed swung over to contemporary life and had at least begun to peer in, if only with an objective, somewhat external attitude. This predisposition to take a certain distance from the subject manifests a strong desire to give the whole composition an elegant finish. The same may be said for the *kachoga* in the front reception rooms of Nagoya Castle or the tiger-and-bamboo paintings in the vestibule. The limitation of the Kano painters of the time lies precisely here.

But perhaps we are rushing too hastily to our conclusions. Let us look at some genre *shohekiga* (partition-and-wall paintings) work in the Emman-in.

In the imperial quarters (*shinden*) of the temple

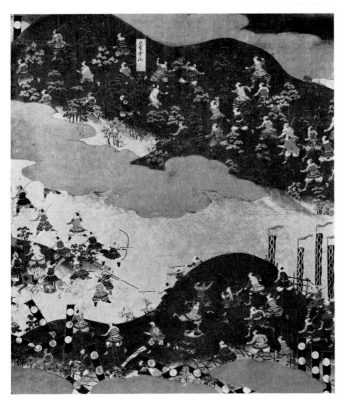

56. *Detail from* Battle of Sekigahara; *Tosa school.*
Pair of eightfold screens; colors and gold on paper;
each screen, 194 × 594 cm. Early seventeenth century.
Maeda Collection, Osaka.

57. *Detail from* Siege of Osaka Castle. *Pair of ▷*
sixfold screens; colors and gold on paper; each screen,
150 × 361 cm. First half of seventeenth century.
Osaka Castle.

we find three kinds of genre *shohekiga* in addition to *kachoga* and depictions of Chinese historical personages. The best of these are the paintings on the walls of the tokonoma and the adjoining *chigaidana* of the dais room, and those on the four *fusuma* running along the west side of the so-called Fifth Room, in the northeast section. Probably these paintings—in gorgeous colors on gold—once ringed a single room. The scenes are placed in a kind of linear compositional scheme: the Sumiyoshi Shrine at New Year's with the merchants' houses nearby, numerous people dressed in their finest, enjoying the peace of untrammeled times (Fig. 4), and peddlers hawking their wares (Fig. 5). We know from recent research that the *shinden* of the Emman-in was originally a building in a residence for imperial ladies built in 1619, and was transferred to the Emman-in grounds in 1647. More-

over, records in the possession of the Imperial Household Agency show that the partition-and-wall paintings of the original imperial ladies' residence were executed by Sadanobu and such associates as Jinnojo Genshu, Koi, Sahei, and the young Tan'yu.

This makes it certain that the genre paintings of Emman-in were done by the Sadanobu circle. The style is similar to that of the genre work of Nagoya Castle, but I do not believe the paintings to be by the same artists. There is no space to prove the point here, but I would like to make one observation. The paintings in the Emman-in are later than the Nagoya genre work and exhibit an older style of line and composition. Also, they are of a more dignified style, implying an artist of more mature years and experience than the painter or painters of the Nagoya Castle work.

The Emman-in paintings avoid the all too tidy treatment of the Nagoya Castle genre paintings and close the glaring spatial gaps in the composition. The result is that the effect of people enjoying the peace comes through more clearly. The paintings, with their colors on gold, would seem to be standard Kano style for the Keicho era. However, they do not quite overcome the rather external, distant attitude I have mentioned.

THE RICH VARIETY OF GENRE PAINTING

On carefully studying the brushwork, facial expressions, and handling of trees in the Nagoya Castle and Emman-in genre paintings, one realizes that these Kano painters and those influenced by them produced many different kinds of genre screens. We might, therefore, have a brief look at some of the finest.

First of all, we find several even among the *Rakuchu Rakugai Zu* screens: there is one belonging to the Yamaoka family, one at Shoko-ji temple, and another with the Yoshikawa family. All have a Nijo Castle scene on the left screen and a Gion Festival scene of one kind or another on the right. The Nijo Castle here is not as prominent as the *Juraku-dai* on the *Juraku-dai* screen; it is instead a most faithful attempt at portrayal of Kyoto as it was. It strikes one as a depiction of a flourishing Kyoto, her life and people, her coat of many colors, just when the Keicho era was coming to its climax.

The *Gion Festival* screens (Figs. 96, 109) are the oldest extant works representing the Gion Festival exclusively. The compositions may be viewed as enlargements of sections from *Rakuchu Rakugai Zu* paintings; indeed, this is why the festival activities are more detailed than in the latter. Still, the festi-

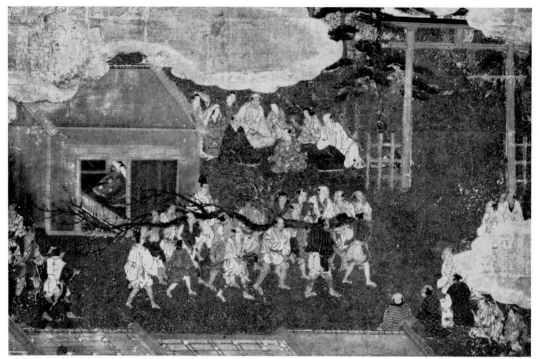

58. *Detail from* Hie-Sanno Festival; *Kano school. Pair of fourfold screens; colors and gold on paper; each screen, 168.5 × 369 cm. Early seventeenth century. Danno Horin-ji, Kyoto.*

val spirit does not exactly carry one away, a re-mark equally applicable to the *Hie-Sanno Festival* (Figs. 58, 97) in the Danno Horin-ji temple, Kyoto. This pair of fourfold screens, originally a *fusuma* painting, has a representation of the annual festival of Hie (also called Sanno) Shrine in Otsu, Shiga Prefecture. The minutely detailed execution, with its precise brushwork and rigid composition, borders on the documentary.

The *Hie-Sanno Shrine* screen (Figs. 59, 108) shows New Year's customs against the background of the shrine and is distinguished by its relatively large figures in the foreground and the beautifully dressed women. This painting and the *Rakuchu Rakugai Zu* screen of the Yoshikawa family are the work of the same artist, and genre was clearly one of his fortes.

The *Merrymaking Under the Cherry Blossoms* shown in Figures 69 and 100, the work of the same title shown in Figure 149, and *Dengaku Dance* (Figs. 70, 141; *dengaku* is a type of entertainment originally associated with rice planting) are three screens de-picting a dance in the round performed under beautifully blossoming cherry trees. The tradition is the same as Hideyori's *Maple Viewing at Mount Takao*, but now we notice a thematic develop-ment: spring is the only season shown, and the outdoor entertainments are richer in content, the tipsy men and women giving these works more of a feeling of fun. The vogue for dances in the round apparently had an attraction for artists. The *Men-zei Odori* (Tax-Exemption Dance; Fig. 60) screen is a variation on the same theme. (The dance represented in this painting is in fact a variety of *furyu*, a form of entertainment popular at the time using spectacularly colorful costumes and props.

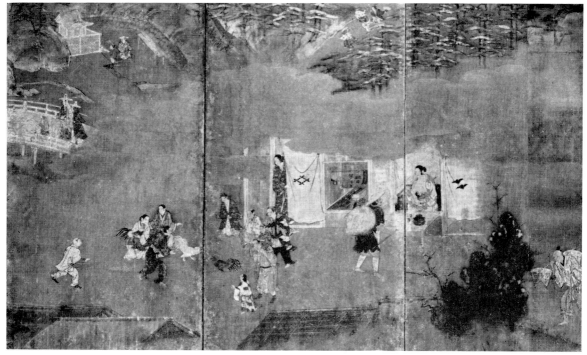

59. *Detail from* Hie-Sanno Shrine; *Kano school. Pair of sixfold screens; colors on paper; each screen, 93.2 × 275 cm. Early seventeenth century. Domoto Collection, Kyoto.*

The title *Tax-Exemption Dance* would seem to be due to a Tokugawa-period misinterpretation of the work as people dancing in joy at news of the rescinding of some tax. In the early Tokugawa period, with its strict stratification of social classes, it must have been difficult to conceive of courtiers enjoying outdoor sakè parties, betting on games like *go,* backgammon, and cards, and indulging themselves in pastimes like miniature archery, shamisen playing, and the recitation of the ballad dramas called *joruri.*) All these works, however, deal more with the environment; they show little effort to handle graphically the interest inherent in the dance itself.

There are many other examples of genre screens painted by the Kano mainstream, such as the *Horse Training and Stable* screens of Figure 117 (the right-hand screen of the pair shows a horse-training scene, the left-hand one a stable; Fig. 36 is a detail of the right-hand screen). The main Kano school of the time would seem to have put its considerable talents to work in genre painting that faithfully reflected a time of peace. The gorgeous attire, the *furyu* dances in the round, the fascinating Okuni Kabuki, the foreigners—all these endowed the manners and customs of the age with novelty. What we have yet to find, nevertheless, is an earnest attempt to represent the human being as such. The range of subject matter of these works is wide, and they have considerable value as records of contemporary life. But the touch is always light, and not much originality is to be found in the compositions. Even so, this kind of genre is an advance over the highly idealized, ethereal Chinese landscapes of the Muromachi period. Both in name and fact, we can see here the socialization of painting.

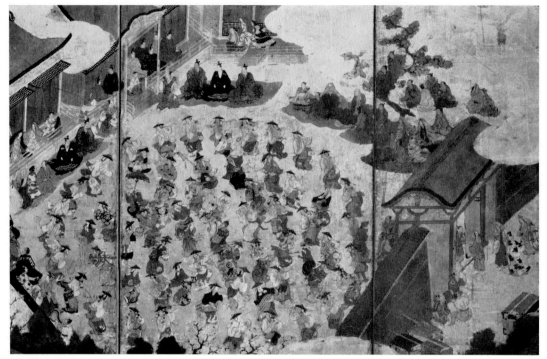

60. *Detail from* Tax-Exemption Dance. *Single sixfold screen; colors and gold on paper, 103 × 281.5 cm. Early seventeenth century. British Museum, London.*

NAGANOBU'S MERRYMAKING UNDER THE CHERRY BLOSSOMS

The most outstanding genre painting from the Kano mainstream and most significant in shaping the course of genre itself is *Merrymaking Under the Cherry Blossoms* (Figs. 14, 68) by Naganobu (1577–1654). He is said to be Eitoku's youngest brother, and he was even twelve years younger than his nephew, Mitsunobu. Naganobu is thought to have been active roughly from 1596 to 1644. This one masterpiece, which makes his name undying, is hard to date. It is believed to be from the Keicho era (1596–1615), but it could well be from the Genna era (1615–24).

The famous pair of sixfold screens shows a cherry-blossom scene. A group of men and women dance about with sword or fan in hand, while nobles, wives, and children, and their ladies-in-waiting, watch nearby. (The middle two panels of the right-hand screen, showing a part of the cherry trunk and some ladies, were lost in the great Kanto earthquake of 1923.) Naganobu has succeeded not only in depicting individuals larger than any we have come across so far; he has also turned our eyes to manners and customs by the fine detail of the composition and blaze of gorgeous garments. The brilliant effect is artfully kept within bounds by containing color through a generous use of ink. We have yet to see so conscious an effort at arranging each and every figure so carefully. Not even Hideyori's *Maple Viewing at Mount Takao* has its soft line or skillful expression of the beauty of healthy bodies. We have encountered a genuine Japanese genre painting for the first time.

That the faces are not all that expressive is probably due to the fact that noblemen and ladies

61. Detail from Sueyoshi Ship. *Votive painting; colors on wood; 1632. Kiyomizu Temple, Kyoto.*

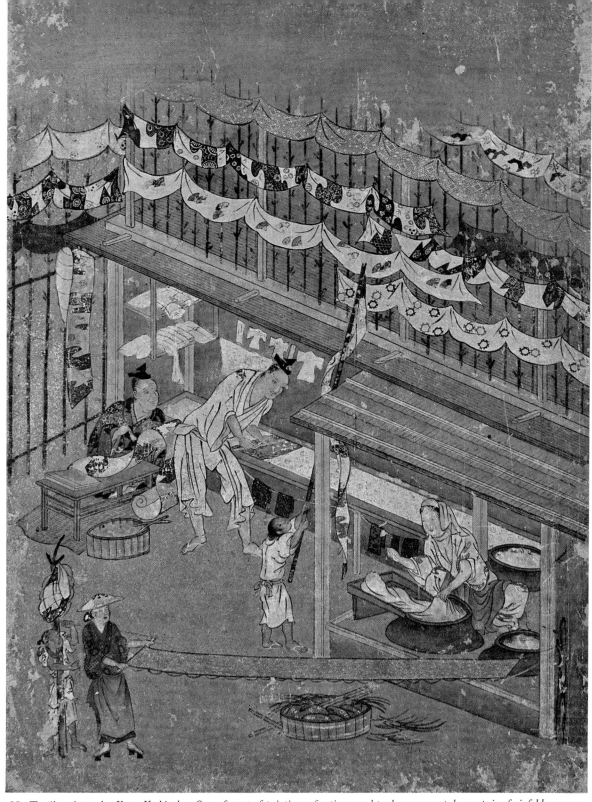

65. *Textile printer, by Kano Yoshinobu. One of a set of paintings of artisans and tradesmen mounted on a pair of sixfold screens; colors on paper, 58 × 43.8 cm. First half of seventeenth century. Kita-in, Saitama Prefecture.*

63. Draper's Store. *One of several miscellaneous paintings of manners and customs of the months* (tsukinami fuzoku) *mounted on a single eightfold screen. Half panel; colors on paper; size of whole panel, 61.7 × 41.8 cm. Mid-sixteenth century. Tokyo National Museum.*

◁ 62. Street vendor; *detail from genre painting on* fusuma. *Colors on paper, 162.5 × 141 cm.; 1614. Nagoya Castle.*

64 (overleaf). *Detail from* Rakuchu Rakugai Zu (Scenes ▷ In and Around Kyoto). *Pair of sixfold screens; colors and gold on paper; each screen, 162 × 352.5 cm. Early seventeenth century. Tokyo National Museum.*

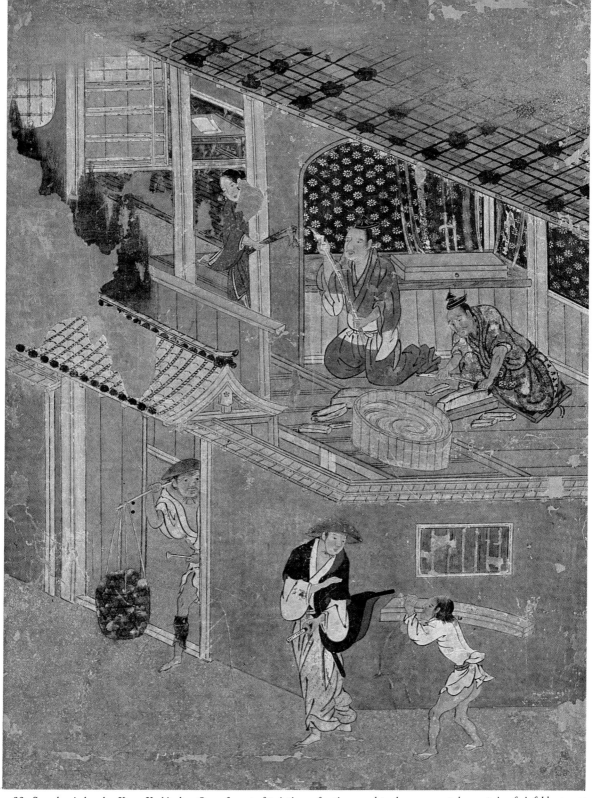

66. *Sword grinder, by Kano Yoshinobu. One of a set of paintings of artisans and tradesmen mounted on a pair of sixfold screens; colors on paper, 58 × 43.8 cm. First half of seventeenth century. Kita-in, Saitama Prefecture.*

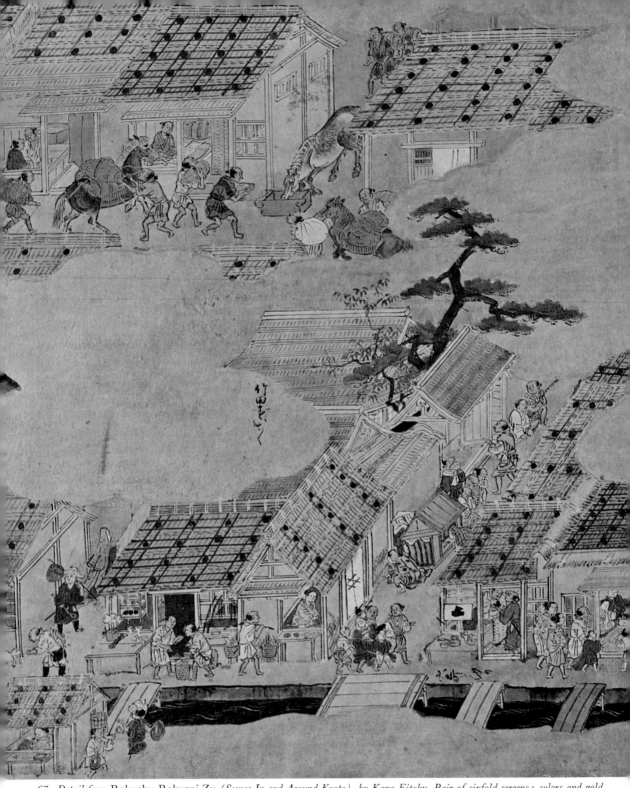

67. Detail from Rakuchu Rakugai Zu (Scenes In and Around Kyoto), by Kano Eitoku. Pair of sixfold screens; colors and gold on paper; each screen, 159.5 × 364 cm. About 1570. Uesugi Collection, Yamagata Prefecture.

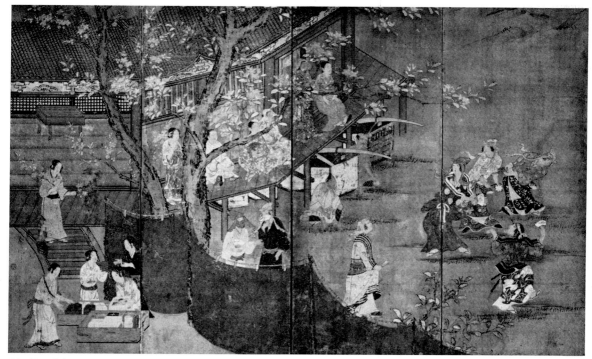

68. Detail from Merrymaking Under the Cherry Blossoms, *by Kano Naganobu. Pair of sixfold screens; colors on paper; each screen, 148.5 × 356 cm. Early seventeenth century. Cultural Properties Protection Commission, Tokyo.*

are represented here. Unlike *Maple Viewing at Mount Takao,* the dancing men and women and ladies-in-waiting are not completely absorbed in their merrymaking. The limitations of this work could be said to lie here.

Also famous are the *shokunin-zukushi* screens (Figs. 65, 66; foldout facing p. 56) by Kano Yoshinobu (1552–1640). Their fame, however, is due to the subject matter—aspects of the lives of various kinds of tradesmen. Since there are many works similar to this, and since there is a strong suggestion in these works that the style of old drawings has been adapted to the Kano style, I shall reserve further comment for Chapter Nine.

SANRAKU AND NAIZEN Sanraku, Eitoku's a-
dopted son, grew up
in the atmosphere of his adoptive father's fierce dedication and passionate temperament, and his

painting took on the same majestic, unified style. But Sanraku by nature was gentle and meticulous, taken more with the part than the whole, prone to become extremely involved with his subject matter. Since he did not make a special point of developing these characteristics, however, his own unique style did not surface until 1615 with his gold-ground *fusuma* painting *Tree Peonies* at Daikaku-ji temple, Kyoto. The composition hangs together beautifully with its steady line; the peonies and rocks are firmly balanced, and both the realistic and decorative, whole and part, are in perfect harmony. It exhibits a magnificently rich beauty. In the same vein, Sanraku's screens *King Wen and Lu Shang* and *Four Sages of Mount Shang* show his flexible line and composure in their large figures from Chinese history and legend. But now let us look at the kind of genre paintings he undertook. The *Battle of the Carriages* screen (Fig. 72), based on

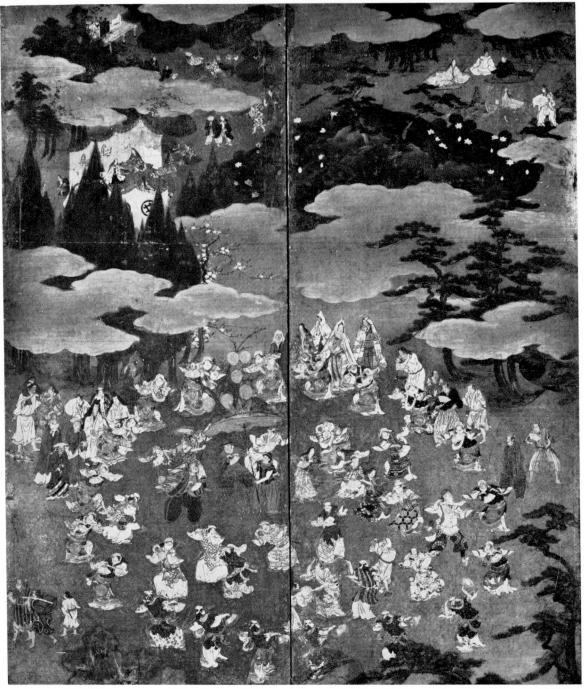

69. *Detail from* Merrymaking Under the Cherry Blossoms; *Kano school. Pair of sixfold screens; colors on paper; each screen, 149 × 352 cm. Early seventeenth century. Kobe Municipal Museum of Namban Art.*

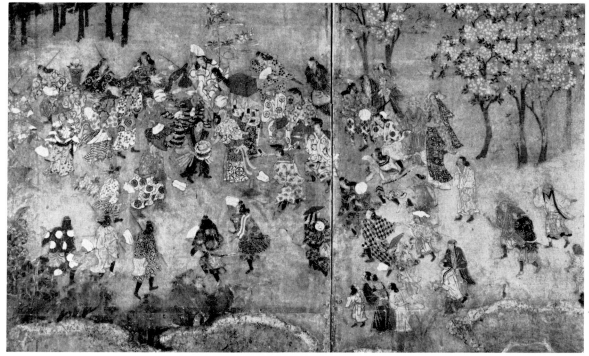

70. *Detail from* Dengaku Dance. *Single sixfold screen; colors on paper, 105 × 291 cm. First half of seventeenth century. Hosomi Collection, Osaka.*

The Tale of Genji, shows that in his time Sanraku stood second to none in mastery of *yamato-e* methods. His capacity to paint a milling crowd, a technique perfected in early Kamakura-period scrolls, is seen here; and the viewer will not miss the fact that the fashions of the spectators are all right out of the Momoyama period. In contrast to the Kano paintings of the mainstream I mentioned before, here there is movement far more real and a greater wealth of facial expressions. It was generally accepted previously that no authentic Sanraku was to be found in genre painting. But anyone with Sanraku's eye or skill, I would hazard, was bound to engross himself eventually in painting the life of the times. For example, Tsuguyoshi Doi, a leading authority on Momoyama-period painting, has recently suggested that Sanraku painted the *Dogchase* now in the Tokiwayama Library (Fig. 71).

His reasoning is based on the similarity of its treatment of manners and customs, and the handling of the trees, with that of *Battle of the Carriages*.

Warrior genre includes a wide assortment of stereotyped dogchase screens. (See pages 140–53.) The Tokiwayama Library screens are the original. They are especially outstanding for the movement and mounted archers ready for the chase. Only *Horse Training* at Daigo-ji temple (Figs. 73, 118) can touch *Dogchase* among paintings of mounted samurai. The interesting note is that while using them as a model, other warrior-painting variations (Figs. 33, 120–22) have managed to add over five hundred spectators. This makes for more in the way of genre elements, of course, but unlike the Tokiwayama Library screens, where the eye is naturally drawn to the center of the paddock, the focus in the variations is scattered. The reason is,

71. Dogchase; *Kano school. One of a pair of sixfold screens; colors and gold on paper, 152.1 × 348.4 cm. Early seventeenth century. Tokiwa-yama Library, Kanagawa Prefecture.*

I believe, that artists of the Sanraku mold borrowed the popular "general overview" compositional approach to genre painting which was used by the Kano mainstream then.

Sanraku basically wished to show in his picture the way in which a dog-chasing contest was held. (See Chapter Eight.) He felt he should incorporate the officials and a few onlooking samurai within the enclosure on the far left, and this resulted in the slightly distant perspective. But the exquisite Sanraku balancing of calm and movement on either side is superb, reminiscent of his *Battle of the Carriages,* wherein we shift from a silent file of people to the fantastic scramble of the carriage crews. At any rate, we will surely hear more of Sanraku's genre work as it is gradually uncovered.

The *Hokoku Festival* screens (Figs. 55, 98, 110) are considered standard Momoyama genre. Artist, date, and motive are known: they have the seal of Kano Naizen (1570–1616), and records show they were commissioned by Toyotomi Hideyori in 1606 and presented to Hokoku Shrine (dedicated to the deified Toyotomi Hideyoshi). Naizen is reputed to have been a disciple of Shoei (1519–92), Eitoku's father, and together with Sanraku he worked for the Toyotomi family. He was commissioned by Hideyori to make a copy of *Kagen-ji Engi* (Chronicle of Kagen-ji Temple), and appears to have been well versed in *yamato-e* techniques.

The right-hand screen of the pair shows a dedicatory performance of *dengaku* and *sarugaku* (early forms of Noh), and a great mounted procession.

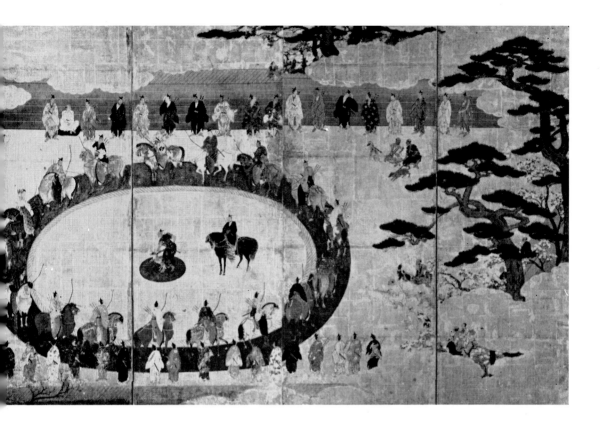

The left-hand screen shows a throng of people dancing, with the Great Buddha Hall of the shrine in the background. The artist's aim was to record faithfully for future generations the special grand festival that took place on the seventh anniversary of Hideyoshi's death. The artist's ability to control this mass of men and buildings and bring them together in an aesthetic *tour de force* is remarkable. The brushwork gives an objective picture of the vast crowd of intense people; and the exact execution of people and architecture is marvelous. Best of all, we have the superb treatment of the dance: two great rings of dancers set off against the Great Buddha Hall—all this is something we could not find in the mainstream of the Kano school. The compositional approach as a whole is probably derived from Sanraku. The line is forceful, unswerving; the forms and faces of the people have a certain stereotyped quality because of the heavy coloring and the attempt to treat them not as individuals but as members of a crowd. In fact, the stereotyped approach helps to strengthen the overall impression. All of this means that Naizen's *Hokoku Festival* screens have a compelling note not to be seen in the elegant genre work of the main Kano school.

There are two or three *namban* screens (Fig. 153) which also carry the signature and seal of Naizen. I will leave general discussion of *namban* screens to Chapter Eleven, but let me say that the type is not a separate entity outside the Momoyama genre category. The main works were from the Kano

72. Detail from Battle of the Carriages, *by Kano Sanraku. Single fourfold screen; colors and gold on paper, 174.5 × 370 cm. Early seventeenth century. Tokyo National Museum.*

genre specialists; one of them (Figs. 74, 75) is almost unmistakably Mitsunobu's, and another shows the style of Sanraku (Fig. 154). It is not as farfetched as it might seem, then, to imagine the artist of the *Hokoku Festival* painting also doing *namban* screens. Moreover, *namban* screens with Naizen's seal introduced a new type of composition and loomed large in the development of *namban*-screen genre art.

GENRE BY OTHER SCHOOLS We should devote a few remarks now to schools other than Kano during the Momoyama period. There are, for example, the *kanga* traditions of the Hasegawa, Kaiho, Unkoku, and Soga schools and the *yamato-e* tradition of the Tosa school. Let me explain their connection with genre.

The *kanga* tradition of the Muromachi period (exclusive of Kano) did not use subject matter taken from Japanese life, and did not work in the *kompeki* style. But in order to comply with the tastes of the Momoyama period, they had to take up one of these two.

Soga Chokuan, a *kanga* painter of the ultraconservative wing of the Momoyama period, leaves not a trace of genre or *kompeki* in his wake. But he did show signs of weakening. In his *Sacred Horse*, commissioned by Toyotomi Hideyori in 1610 and presented to the Kitano Temman Shrine, there is a rather perfunctory portrayal of a stableman. Possibly Chokuan was commissioned to do some genre work in his latter days.

Togan (1547–1618) of the Unkoku school, as might be expected of someone indentured to the

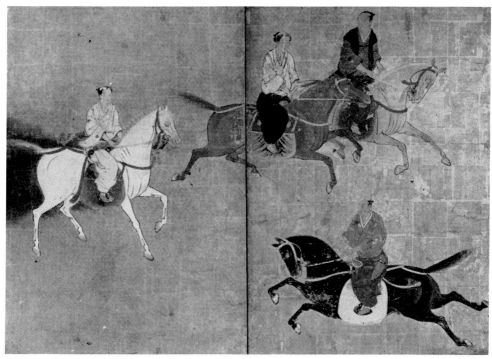

73. *Detail from* Horse Training; *Kano school. Pair of sixfold screens; colors and gold on paper; each screen 153.9 × 360.6 cm. Early seventeenth century. Daigo-ji, Kyoto.*

Sesshu ink-painting tradition, was altogether wrapped up in the *sumi* ink landscapes, birds and flowers, and figure painting of another day. Nonetheless, several *kompeki* pieces making ample use of ink are known to be his, and one genre painting is thought to be by him. The latter is the screens *Cherry-Blossom Viewing and Falconry* (Figs. 132, 138). The handling of rocks and pines makes it unequivocally Togan's. The right-hand screen (of cherry blossoms) is conspicuous for the rather subdued background set off by the colorfully attired women. Even Kano genre cannot compare for clamoring color. Togan of the Unkoku school was not so passé after all.

Yusho (1533–1615) of the Kaiho school also painted a great deal with *sumi* ink, but his work defers to and shows a mixture of the ebullience and

rich feeling of the Momoyama period. It is hard to classify him as conservative. He was preoccupied with the inner dimension of reality and this was what made him wish to go beyond both the gold medium and genre. Three *kompeki* screens we have are certainly his, two more almost surely so, and all of them show ink-work at its finest. However, no genre painting by him has as yet been found. Even had he encountered a demand for genre, perhaps the beautiful, Chinese-style women in color that we find in his screen *The Four Accomplishments* at the Tokyo National Museum would be the extent of his compromise. (Not even the Momoyama beauties of Kano genre work can challenge Yusho's style as seen in this bevy of charming women.)

Cherry-Blossom Viewing at Daigo (Figs. 32, 53), by an unknown artist, shows Yusho-like treatment

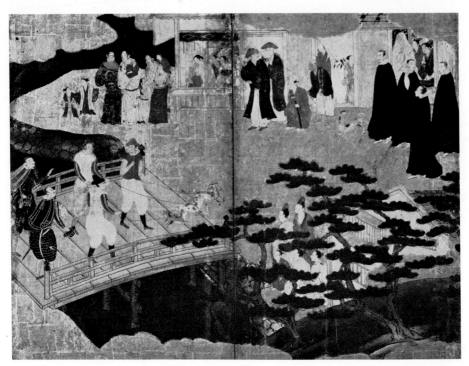

74. *Japanese onlookers watching Europeans being welcomed by missionaries; Kano school. Detail from a pair of sixfold* namban *screens; colors and gold on paper; each screen, 146 × 337 cm. Early seventeenth century. Kobayashi Collection, Tokyo.*

in the roundness of its rocks. Here and there the artist uses elements of Yusho's style, but I do not believe that Yusho's small group of students would have produced any genre painting. His son Yusetsu (1598–1677) did a *Gion Festival* (Fig. 137), which I shall discuss presently. But this painting was very much later.

After the death of Kano Eitoku, due to the talents of its founder, Tohaku, the Hasegawa school for a time assumed an importance nearly equal to that of the Kano school, producing such *kompeki*-style masterpieces as the *shoheiga* (partition and door paintings) of the Chishaku-in in Kyoto. The peculiar mixture of Chinese and Japanese techniques that was its forte made the Hasegawa school quite distinct from the Kano school. I mentioned in the section on Eitoku (see page 55) that in 1573 Tohaku (at that time using the name Shinshun) did a screen painting of horses in a pasture. *Asahina Saburo Tugging Armor Tasses*, the historical painting executed by Tohaku's son Kyuzo in 1592, is notable for its powerful treatment of the human form. Hasegawa-school genre from the Keicho era (1596–1615) is still unconfirmed but there is a good chance we will find some. Tohaku himself was somewhat disenchanted with his school and his times. He called himself Sesshu V, and moved only in conservative circles. I would be very much surprised to hear that he himself painted genre. If anyone did so, it would have been his disciples.

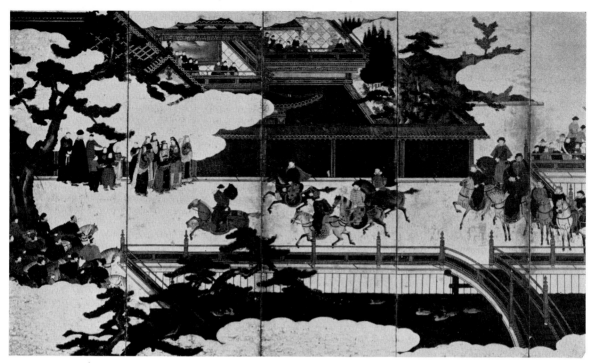

75. *Mounted foreigners; Kano school. Detail from a pair of sixfold* namban *screens; colors and gold on paper; each screen, 153.5* × *364 cm. First half of seventeenth century. Tokyo National Museum.*

The illustrious Tosa school of *yamato-e* was only treading water at that time. The leader, Tosa Mitsuyoshi (also known as Kyuyoku; 1539–1613), was counted an underling in the Kano painting studio, and did only subcontractor work. He specialized in miniatures (*saimitsuga*) using mainly classical subject matter, as in his *Tale of Genji Picture Album*. His delicate strokes and elegant color schemes refined the form. But he did not stick to the classical. An example is *Customs of the Twelve Months of the Year Picture Album* (Fig. 25), thought to be by Mitsuyoshi on stylistic grounds. One could not call it a stirring work, but the miniature aspect and its realistic kind of beauty must have pleased a certain audience. It is probable that

Mitsuyoshi painted the *Battle of Sekigahara* screens (Figs. 37, 56, 111), judging by the exquisite colors, the stylization in the arrangement of its mounted figures, and the miniature approach. For raw reportage of the violent war then in progress it does not come up to the *Siege of Osaka Castle* screens (Figs. 35, 57). Understood rather as a beautiful piece of warrior genre using a battle theme, it even becomes enjoyable.

The *yamato-e* artists of the Tosa school did not, then, contribute much to Momoyama genre painting. Genre development required a further refinement of *yamato-e* methods. This was not to be a task for the Tosa school, but a challenge for others on the fringes of *yamato-e* art.

CHAPTER FIVE

The New Wave

RAKUCHU RAKUGAI ZU
AT THE TOKYO
NATIONAL MUSEUM

The pair of *Rakuchu Rakugai Zu* screens (Figs. 64, 76, 77, 129) that was found soon after World War II and then acquired by the Tokyo National Museum was not just one more of a kind; it broke new ground. It was a path yet untrodden by the Kano or minor schools. The new note was the frank portrayal of pleasure and the unusual emotion with which the aesthetic entirety was charged.

The screens show Tokugawa Ieyasu's Nijo Castle in Kyoto on the far left, and on the far right, almost opposite, the Great Buddha Hall of the Toyotomi family's Hoko-ji temple. The center of attention and the painting's main compositional feature is a bustling street scene. The action on the old avenues is, however, much closer to us now than in former *Rakuchu Rakugai Zu*: the artist's lens zooms in, showing in sharp relief the tangled stretch from upper Kyoto at Nijo where merchants hold forth, on down the busy maze of people and hubbub toward Shichi-jo, giving us the Gion Festival, Shijo riverbed with Women's Kabuki and puppet performances, and throwing in the gay quarters of Rokujo-Misujimachi for good measure. The beholder cannot help remarking the important place the new entertainment districts of the Shijo riverbed and Rokujo-Misujimachi have. The artist—whoever he was—was not content to stay aloof, gazing on the glory of Kyoto from some safe or settled distance. He plunges us directly into the life of the town, there to catch the pulse of its people and sample their prodigious energy.

Look at the conglomeration of figures. Everyone has something infectious about him; no one is allowed to be a copy or do the humdrum. Each figure is up to something, with flailing hands or flying feet; even the people stopping along the way are shown in some dynamic pose. A painting swarming with this many people on a thousand and one errands is necessarily electric. True, the human movement is somewhat caricatured, but this is only in keeping with the traditional approach from the classic form of warrior painting, the *Heiji Monogatari Emaki*, a scroll portrayal of the Heian-period Heiji rebellion. I would see the overstatement as the artist's means to express the sheer energy of the people in the most forceful terms at his disposal.

The same could be said for the profusion of pleasure throughout. Prostitutes and their patrons embrace in broad daylight at Rokujo, within sight of everyone. The rendering is unclouded by even a glimmer of guilt or hint of scruple. Although lacking in lyrical atmosphere, these are happy, wholesome scenes never before attempted in painting. In the ukiyo-e prints that come much later all the fun is behind doors. The chances are this kind of thing actually occurred in public and the artist felt it should be painted so.

In any event, this new *Rakuchu Rakugai Zu* at the

76. *Gojo Bridge; detail from* Rakuchu Rakugai Zu *(Scenes In and Around Kyoto). Pair of sixfold screens; colors and gold on paper; each screen, 162 × 352.5 cm. Early seventeenth century. Tokyo National Museum.*

Tokyo National Museum can be dated around 1615, considering the composition and other factors, but the artist remains anonymous. The firm, sure line recalls Kano Naizen, but the candid, uncontrived quality, the raw expression, clearly outstrips that of Kano or the other schools. So now we know that back in 1615 there lived some artists who were actually like this—free as a breeze, uncluttered by inhibition—and with them came the makings of a new style of genre painting.

PASSIONATE EXPRESSION As the lively feeling I discussed above is taken further, paintings of the quality of the *Hokoku Festival* screens (Fig. 80) that belong to the Tokugawa Art Museum began to emerge. The subject is the same as Naizen's *Hokoku Festival* (Figs. 55, 98, 110), which shows the special Hokoku festival on the

seventh anniversary of the death of Hideyoshi. What differs immensely is the artistic intent of the work. Naizen's screens were an exercise in rather objective reportage, as I said earlier, and he managed to do this by maintaining the strictest fidelity throughout the execution. The screens at the Tokugawa Art Museum, on the other hand, are a pandemonium of riders galloping wildly past the Great Buddha Hall, and a frenzied *furyu* dance. The scene is intentionally exaggerated, and the festival is used in order to heighten the expression of the eruption of the crowds' energies.

The screens are obviously derivative, the subject matter being taken from the *Rakuchu Rakugai Zu* screens at Tokyo National Museum. But instead of extravagance with forms and movement, now we have extravaganza. Everything assumes unreal proportions; the clothing colors are garish, the

dress patterns gaudy, and one comes away with a strong impression of the crude or, at least, gauche. These figures, crushed and jostling one another, cover the entire picture surface and the effect is total bedlam. The intermingling of exaggerated form, color, and movement proves to be too strong a mixture. Ultimately, instead of communicating the energy of the crowds the effect is grotesque. The *Rakuchu Rakugai Zu* at Tokyo National Museum evinced raw vitality; here it is the fierce protest of the artist that stands out clearly.

It is of considerable interest that a work like this should appear in Momoyama genre painting, redolent with a sort of strong, almost un-Japanese openness. Another point that should not be overlooked is that great picture-scroll works that show the same treatment of figures and have the same expressionistic character were produced in the 1630s.

The scrolls with classic ballad-drama (*joruri*) themes (Fig. 78) are the ones that leap to mind. These are the *Yamanaka Tokiwa Scroll*, the *Tales of Horie Scroll*, and the *Lady Joruri Scroll*. All three were once taken for the work of Iwasa Matabei (1578–1650), together with many other genre paintings. (It was even thought that Matabei was the originator of ukiyo-e.) The past several decades have seen this opinion lose ground. Instead, Matabei is thought to have set up his own school of painting, combining Tosa and Kano, and also techniques from Hasegawa, Kaiho, and Unkoku; he is thought to have specialized in painting figures from Chinese and Japanese history and legend. Recently, the art historian Nobuo Tsuji has carried out detailed studies comparing these scrolls with works clearly attributable to Matabei, and notes a basic characteristic common to all of them—their expressionistic nature, manifested in the depiction of raw passions reinforced by a feeling of dark gloom. He concludes that these three scrolls and a number of genre works—including the *Hokoku Festival* screens in the Tokugawa Art Museum and a pair of screens in a private collection (Fig. 79 shows one of these, depicting horse racing at Kamo Shrine)—are, after all, by Matabei and his studio. I subscribe to the new theory, for I feel we can sense the hand of

Matabei at work in the highly emotional atmosphere of this representation of the festival.

Matabei always drew his basic materials from classical *monogatari*, or tale, literature, after which he would proceed to equip his men and women with contemporary passions, plain and open to view. It is this Matabei that I imagine as quite prepared to paint genre if the opportunity presented itself; and if he did launch into this kind of painting, I find it hard to believe that the objective approach of Kano would have been particularly appealing or fulfilling. The dark strain which pervades most of Matabei's painting may be taken for buried feelings of rebellion cast up from cruel childhood experiences. He was the illegitimate son of Araki Murashige, daimyo of Itami in Settsu Province (modern Hyogo Prefecture), and at the age of two his family was summarily killed by order of Oda Nobunaga. The latter had dispossessed Araki of his domains in 1579, and the child was forced to flee with a nurse. Often on the move, he lived in many parts of Japan and later on took his mother's surname as his own. It was the sad plight of Matabei that inspired a poem by one of his father's concubines as she lay dying that long tore at the heartstrings of all Kyoto.

All this, we can be sure, left Matabei with certain scars. I have always maintained that it took the art of Sotatsu to give us the Momoyama period in all its glory; it is Matabei who gives us the blood, sweat, and tears.

In any case, we cannot underestimate *Hokoku Festival* for its influence on later genre, for its coarse pattern of human expression, and for its exceptional forthrightness.

TOWN PAINTERS As genre painting became more and more of a vogue in the first half of the seventeenth century, a growing number of artists unattached to the Kano or any other school were eager to cash in on the boom. They are generally called *machi-eshi* (literally, "town painters"). Even now little is known about them. Some probably began as apprentices in the schools and afterward free-lanced; others developed their own style from the start, plagiarizing from

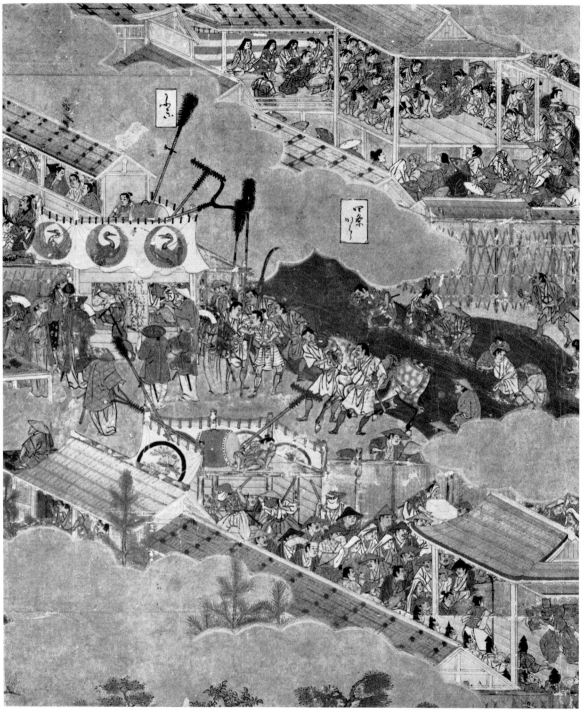

77. *Shijo riverbed; detail from* Rakuchu Rakugai Zu *(Scenes In and Around Kyoto). Pair of sixfold screens; colors and gold on paper; each screen, 162 × 352.5 cm. Early seventeenth century. Tokyo National Museum.*

78. Lady Joruri Scroll. *Handscroll; colors on paper; height, 33.9 cm. First half of seventeenth century. Atami Art Museum, Shizuoka Prefecture.*

the schools. Most of them turned out copies in large numbers, but from time to time there were painters among them who left us fine works.

Horse Racing at Kamo Shrine (Figs. 99, 133, 143) is one such compositional treat, showing a spacious riding area in the center lined with a semicircular brush fence in the front and a gentle curve of trees in the back. The composition is held together by the paddock. A large cross section of local people has gathered for the event. There is not a single stereotype in the richness of form, faces, and line. The brushwork is sensitive and supple as to line, and the power to catch attitudes is amazing. The nonchalance of the townsfolk, lolling with sleeves and kimono tucked up, is done extremely well. Could anyone have caught the common folk as perfectly before? It is a really delightful as well as wonderfully sensitive depiction of a crowd that has

come to cheer the horses. The war is over, and this great scene breathes the blissful peace and pleasant air of the good life.

The skillful composition and the handling of the trees at one time convinced some scholars they should attribute the screens to the famous seventeenth-century artist Tawaraya Sotatsu. Sotatsu was reared in the town-painter mold and painted mainly flowers, grasses, animals, and classical subjects. His genre painting is rather limited. There is some fan painting by Sotatsu himself with subject matter derived from the *Tales of the Hogen Rebellion Picture Scroll: The Cow and the Farmer* and *The Cow and the Laborer*. We also have some fan work from his studio: *Horse Racing at Kamo Shrine, Hie-Sanno Festival,* and *Kiyomizu Temple*. These are now in the Hara Collection. It is rather clear that Sotatsu and his studio were not very interested in genre, and the

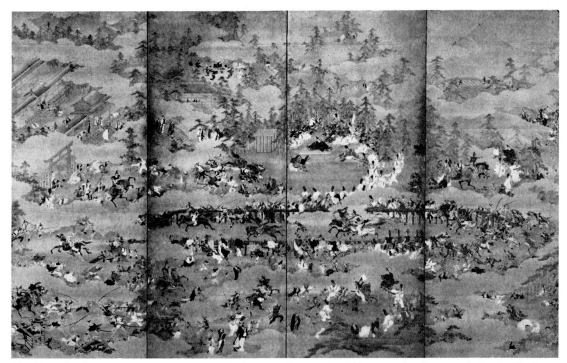

79. Horse Racing at Kamo Shrine. *Four panels from one of a pair of sixfold screens; the other screen depicts the Hie-Sanno Festival; each screen, 155 × 359 cm. First half of seventeenth century. Nishimura Collection, Shiga Prefecture.*

treatment of figures in these *Horse Racing at Kamo Shrine* screens is so different that it would be difficult to ascribe it to them. It is probably the work of an accomplished town painter who assimilated the *yamato-e* tradition in an extremely personal way, just as Sotatsu did. The style dates it around 1610, and it can be fairly described as the first masterpiece from the brush of a town painter.

Just as in the *Rakuchu Rakugai Zu* at Tokyo National Museum previously discussed priority is given to the pleasures of Women's Kabuki at the Shijo riverbed and the gay quarters at Rokujo-Misujimachi, so too, in real life they were the forms of entertainment most popular with the townspeople after about 1620. The appearance of genre works with this kind of theme was a reflection of this popular taste, and town painters took a particular fancy to them.

Okuni Kabuki (Figs. 126, 135) features the stage, seats, and entry area of the popular dance theater of Kyoto. (A woman named Okuni had begun Kabuki dance in Kyoto in 1603. In leading her troupe she made a point of adopting any popular craze into the performances. She herself took male roles, often of highly sensuous character.) It is exceptional in Kabuki painting for the performers and audience to be as wrapped up as this. The composition gracefully gravitates to Okuni; all eyes are made to fix on her as she performs. The line is restrained, the color scheme exquisite, making for a marvelous, harmonious whole. This is obviously not Kabuki coolly recorded for posterity: it is the ideal expression of a sensuous new world.

We see the Hasegawa approach to pine trees, and there are also traces of the Kaiho school's tech-

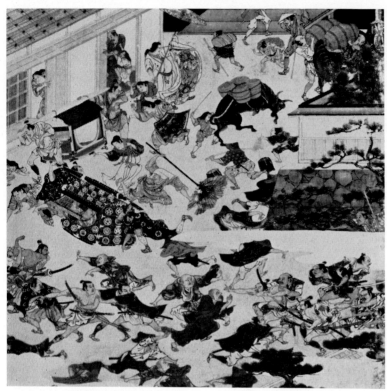

80. *Detail from* Hokoku Festival. *Pair of sixfold screens; colors and gold on paper; each screen, 167 × 352.5 cm. Early seventeenth century. Tokugawa Art Museum, Nagoya.*

81. *Detail from* tagasode bijin *screen.* ▷ *Pair of sixfold screens; colors and gold on paper; each screen, 144.5 × 342 cm. First half of seventeenth century. Nezu Art Museum, Tokyo.*

niques, but the rest is quite original, probably the excellent work of a free-lance town painter who gives the schools but a passing nod.

The *Women's Kabuki* scroll of Figure 145 shows various types of dance and raucous audiences rendered with gusto. However, it lacks the charm and elegance of *Okuni Kabuki*. Some in the brightly clad audience are brawling, and the rawness of expression is very much like that found in Matabei's paintings. The scroll is probably from a town painter who studied *kanga* and was sympathetic to the Matabei style.

Two *Shijo Riverbed* paintings (Figs. 125, 140, 142), one a pair of twofold screens and one a single twofold screen, show the bustling prosperity of the entertainment area, now even more thriving than it was at the time of Tokyo National Museum's

Rakuchu Rakugai Zu screens. The viewpoint is rather objective, but the subject matter itself outstrips anything previous as to pleasure highlights. Bright, unbridled fun is everywhere in sight. The way the Kamo River is rendered shows the hand of a town painter who was possibly first apprenticed to the Kano or Tosa schools and then struck off on his own to specialize in genre. The screen was clearly painted before 1629, when Women's Kabuki was proscribed.

The tendency toward entertainment themes became more pronounced as painters came to concentrate on indoor parties at brothels. *Merrymaking at the Brothel* (also known as the So-o-ji screens; Fig. 128) is a good example. The general disarray of the men and women is emphasized, giving the work a suggestive flavor. The peculiar pine-tree

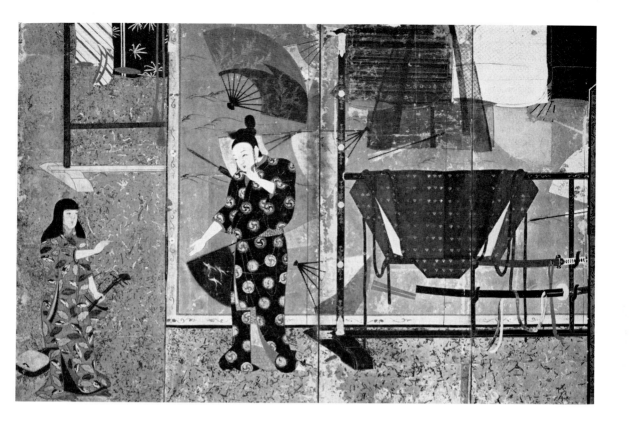

treatment would imply it to be the work of a genre specialist who had studied the Kano style, dating from after 1633.

THE HUMAN FIGURE AND COSTUME The genre painting we have discussed so far, apart from Naganobu's *Merrymaking Under the Cherry Blossoms*, has shown many men and women along with surroundings handled in rather true-to-life fashion. This realism has kept the size of the people somewhat small. A type of painting emerged, however, in which the surroundings were omitted, with the gaze turned on a group of around ten figures, mainly large-scale depictions of women. This carried Naganobu's *Merrymaking Under the Cherry Blossoms* a step further. Two factors were behind this development. First,

there was a general increase of interest in depictions of men and women in beautiful poses, a genre whose possibilities Naganobu had already noticed. This was connected with the popularity of Okuni and the prostitutes of Women's Kabuki, with their beautiful posing on stage. Second, a phenomenon seen in *kachoga* occurred in *kompeki* partition-and-wall paintings also. In the period from about 1615 to 1640, the backgrounds of these paintings came to be completely covered in gold. This was the ultimate development in the methods of composition using gold clouds and gold ground, and signified the extinction of interest in the background. The earliest instance of the picture-surface being clearly conceived of as a flat area of gold is Sotatsu's *shohekiga* of pines (1621) at the Yogen-in temple in Kyoto. On the other hand, the Kano

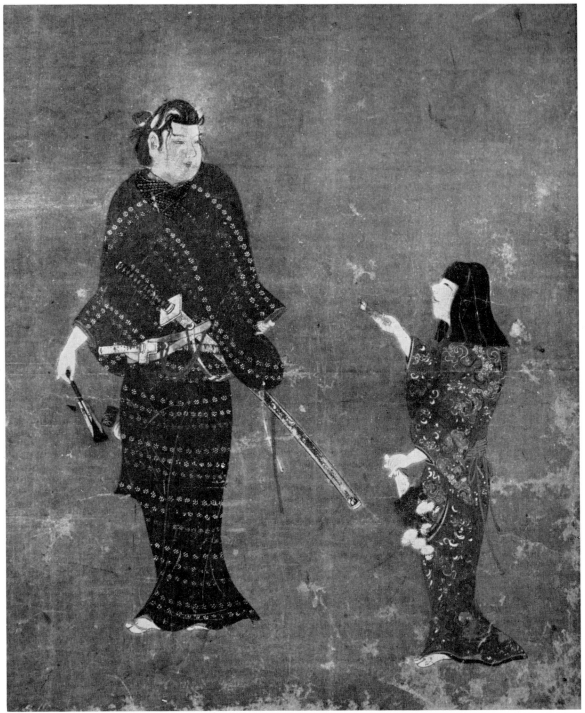

82. *Detail from* The Story of Honda Heihachiro. *Single twofold screen; colors on paper, 72.7 × 157.5 cm. First half of seventeenth century. Tokugawa Art Museum, Nagoya.*

83. Dancing Women. *Three panels of a single sixfold screen; colors and gold on paper; size of whole screen, 63.2 × 245.8 cm. First half of seventeenth century. Kyoto City Collection.*

school in its *fusuma* painting of 1633 at the Tenkyu-in, Kyoto, had not yet completely lost interest in background. Although four of the *fusuma* have all-gold backgrounds, one part retains gold clouds.

Dancing Women (Fig. 83) has six large depictions of beautiful women with fan in hand, one to each fold of the screen, dancing on a gold ground. In the forms of the figures (always two facing each other) we notice special attention paid to the play of contrasting light and shadow in the garments, and variations of movement and stillness. There are similar paintings to this, with one figure to a hanging scroll. However, originally they were aligned on a screen as a part of one close-knit composition. Thus these differ in principle from the single-figure paintings of women coming later. The full forms of the dancers' bodies and the lovely dress patterns are painted carefully in a blaze of color. This screen is probably by an artist of the orthodox Kano school who was indirectly influ-

enced by Naganobu. I would place it 1624–44, in view of the all-gold background.

The Story of Honda Heihachiro (Figs. 82, 130) employs rich colors on a ground of gold paint. It is an appealing portrayal of a dashing young paramour surrounded by several women dressed in gay-colored kimono. The noblewoman in the center of Figure 130, clad in a silk garment with a hollyhock design, has been identified as Princess Sen, daughter of Hidetada, the second Tokugawa shogun, and the man as Honda Heihachiro, a famous general in the service of Ieyasu. The scene is said to represent their mutual love. The interpretation founders, for the depiction of the lady is too demi-monde. The hair styles, the long pipes, and the shamisen spell a definitely sensuous atmosphere. The painter was a Kano-school artist, like the painter of *Dancing Women,* and he doubtless did this about the same time. Between 1624 and 1634, therefore, it was the Kano school that brought something new and

84. Women's Entertainments. *One of a pair of sixfold screens; colors and gold on paper; each screen, 153 × 363 cm. First half of seventeenth century. Yamato Bunkakan, Nara.*

different to genre through its preoccupation with the beauty of the female form and its fascination with colorful garments.

The Weavers (Fig. 134) gives us women at work, but the deeper intent, here again, is to depict the beauty of the female form. The loom and the chrysanthemums and autumn grasses are merely accessories. It is not a Kano-school work, but probably by someone influenced by Matabei. The smooth curve of the twining fingers, the hands, and the full, rounded faces are derivative of his style of painting.

Women's Entertainments (Figs. 84, 124), also known as the Matsuura screens, for many reasons stands quite alone in Momoyama genre work. The work consists of a pair of sixfold screens, with eight women on the right-hand screen and ten on the left. The background is all in gold. It is a bold arrangement

of large-scale figures, nearly 130 cm. tall. (I mentioned on page 57 that it would not have been out of character for Eitoku to attempt warrior genre of similar proportions. However, until the discovery of these screens some decades ago, no such works were extant, either by Eitoku or anyone else.) The treatment of the women is rather different from anything we have seen before. The figures have no three-dimensional feeling—they are quite flat. They seem to be arranged in such a way that the figures on each pair of adjacent screen panels form one group, but the overall impression is of a series of figures strung out along the screens. In comparison with this, even *Dancing Women* (Fig. 83), where all the figures are standing, has greater rhythmic variety. For these reasons, the work is lacking in vitality. On the other hand, the artist has achieved a powerful and colorfully detailed

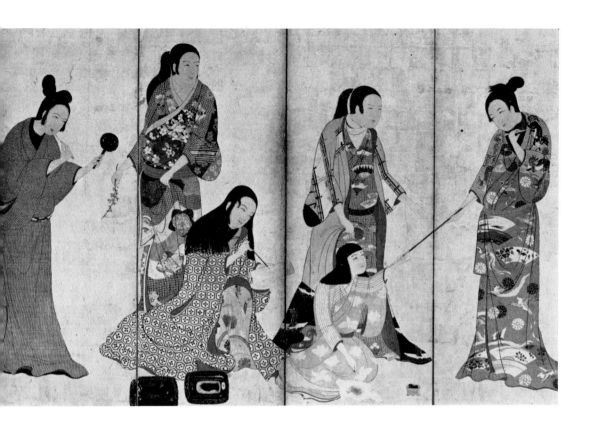

representation of many different kinds of beautiful costume.

Because of this the screens have been described as giving the impression of a fashion show. It is true that, after the manner of the "four accomplishments" genre, various properties are distributed among the figures: a shamisen, a *go* board, a writing set, playing cards, a pipe, a handmirror. But there is not much of the feeling of the women enjoying these recreational activities. We have, rather, a strong impression of a display of beautiful clothes of the latest fashion. The presence on the left-hand screen of a folded silk kimono with a vivid design of Chinese characters is significant, for it suggests that the screen represents a stage in the development from the *tagasode bijin* (garment and beauty) paintings (Fig. 81), which typically showed women with garments draped over a stand, to the orna-

mental *tagasode byobu* (garment screens), which showed only garments and stands, without the beauties.

The artist who painted *Women's Entertainments* was probably originally a designer of the gorgeous kimono then fashionable, and it is thought that the work was a special commission. Various dates are assigned, but its connection with the *tagasode byobu* (garment screen) genre and its all-gold background incline me to assign it to the years between 1624 and 1644. The appearance of a genre painting of this scale attempting a group treatment of female figures is worthy of note. Had Kano Eitoku or Tohaku with their glorious *kachoga* repertory tried something with figures of this scale, I cannot help feeling the result would have been beauty to end all beauty. That they did not, alas, is cause for real regret.

CHAPTER SIX

From Glory to Obscurity

MOMOYAMA GENRE PAINTING was born with the newly emergent military class and *machishu* merchant elite as its patrons. It was nurtured against a backdrop of their vigorous affirmation of reality, developing magnificently as an art singing the praises of the calm which had come over the land. The large paintings, partly decorative in intent, depicted every kind of life style, irrespective of class. Festivals, the fun of famous places, the dancing on the Shijo riverbed, the licensed quarter at Rokujo-Misujimachi, the foreigners from far places—wherever life and good times reigned—genre was there.

Just as the genre paintings in Nagoya Castle's Taimensho suite charmed those of the inner circle, so too, the masses enjoyed life and the times in the mirror of painting. The townsfolk, unencumbered by the demands for dignity or formality found in the military class, surely loved to decorate their shop fronts and parlors with genre screen painting. Genre was, so to speak, a public art.

Between 1615 and 1644, the organization of the country on a feudal basis was being gradually consolidated. The Shimabara Christian revolt of 1637 and the exclusion of Portuguese vessels from Japan in 1639 strengthened this tendency further. In the period between 1661 and 1672, the fourfold social stratification of samurai, farmer, artisan, and merchant was established. Moreover, the shogunate, with its Confucianist thought and politics, proscribed Women's Kabuki in 1629 and excluded puppet plays and shows from the center of town in 1632. Prostitution was limited in 1637, the pleasure quarters of Rokujo-Misujimachi were moved to Shimabara in western Kyoto in 1640, and Young Men's Kabuki was banned in 1657. This series of proscriptions was allegedly a net laid for the wicked, the "evil places" of Kabuki, and hotbeds of license. Idealism had locked the door but life still found the key. The daimyo and samurai still managed to frequent these "dens of iniquity," and the merchants especially found their paradise there. Life went on more merrily than before, the difference being that now it was a forbidden flower forced to bloom in the shade.

Between 1615 and 1644, genre painting, as previously noted, tended more and more toward pleasure themes, making its main themes those of Kabuki and prostitution. That this would not exactly please the military establishment was only to be expected. The main Kano school, led by the shogunate's official painter, Tan'yu, followed the shogunate's line, and from about 1633 concentrated on Confucian didactic painting. Their techniques and style also underwent big changes. However, there was resistance to this, both within the Kano school and among town painters who had made a specialty of genre. Moreover, as Kabuki and the pleasure quarters continued to thrive, so also genre, which sang their praises, was hard to stifle. Instead of an object of public appreciation, genre now became a private posses-

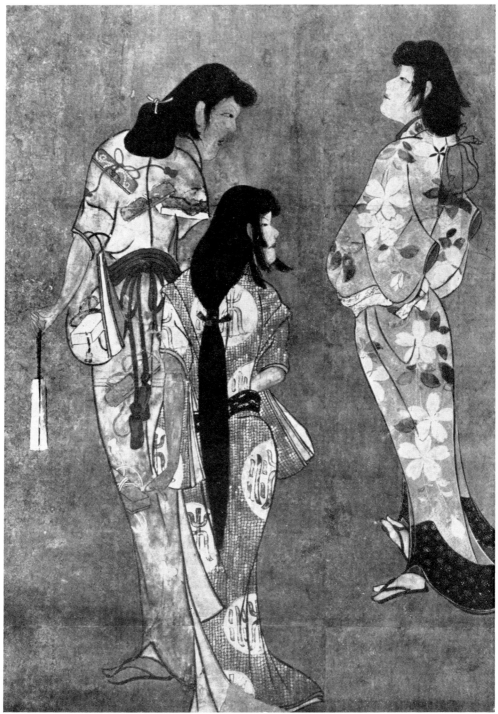

85. Detail from Yuna *(Bathhouse Girls). Hanging scroll; colors on paper, 72.6 × 80.3 cm. First half of seventeenth century. Atami Art Museum, Shizuoka Prefecture.*

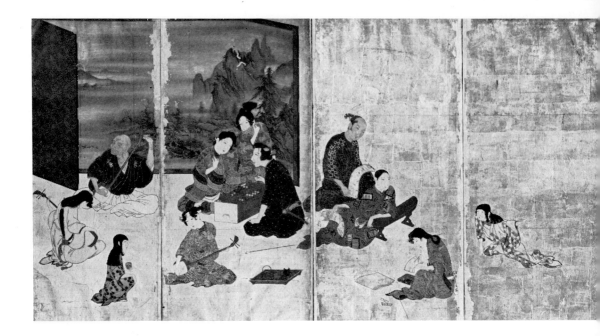

sion with a certain tinge of naughtiness. For this reason, when artists approached the medium, they were forced to take one of two positions: either continue to slum, as it were, or begin a beautification program.

THE PATHOS BEHIND PLEASURE The Hikone screen (Figs. 86, 127), so-called because it was handed down in the Ii family, daimyo of Hikone, depicts fifteen men and women clad in the latest fashions, against a gold background. Everyone is doing something: either strumming the shamisen, playing backgammon, or reading or writing love letters. Unlike the previously discussed pleasure-and-amusement paintings, however, there is no evident gaiety or stress on physical beauty. The figures are slight, frail in appearance, and the actions and gestures languid. Their facial expressions betray dark passions. What the artist has done is to distill perfectly the sheer ennui of the group. (Particularly worthy of note is the blind man with the shamisen,

his gaze directed outside the painting.) The careful draftsmanship draws a pathetic picture of the misery that lies at the bottom of pleasure.

As mentioned before, once one sacrifices background in favor of pure gold, the arrangement of subject matter and colors plays a key role. On this point, the Hikone screen is quite peerless among genre. The screen introduced on the far left, for example, indicates that it is an indoor scene, but in addition functions to draw the composition together. The old-fashioned ink landscape on it contrasts very effectively with the amusement scene it overlooks. Without such rigorous compositional technique, the work would simply be decadent.

The artist is unknown. The brushwork we see in the landscape of the screen inside the screen is precise, Muromachi-like. The elegant color scheme and adroit composition call for a truly accomplished Kano painter. Whoever he was, he loved the life and times. He was certainly a gifted and experienced genre artist, and I like to think of him as having produced the last and loveliest work in

86. *Hikone Screen; Kano school. Six panels originally in the form of a folding screen; colors and gold on paper; each panel, 94 × 48 cm. First half of seventeenth century. Ii Collection, Shiga Prefecture.*

the resistance against Tan'yu and the new movement. His realism impresses all the more for having pushed beyond the limits of previous Kano genre painting, then gone beyond genre itself to attempt portrayal of the person. The Hikone screen, then, marks the end of the development of the Kano genre-painting style, just as Sanraku's *fusuma* painting of plum and waterfowl at the Tenkyu-in temple, Kyoto, signaled as much for *kachoga*.

There are several screens called *Women's Entertainments* that seem to have been strongly influenced by the Hikone screen. They all feature voluptuous feminine charm. But whereas the Hikone screen manages to transcend the decadent beauty it handles, these screens end up with a cloying beauty in a rather loose composition.

HIGHLIGHTING While the Hikone screen de-
THE VULGAR picts women with a subtle erot-
icism, *Yuna* (Bathhouse Girls; Figs. 9, 85) is a large painting of a group of six earthy ladies of the trade boldly sauntering along.

A bevy of female beauties in the prime of life was never treated so baldly, so surcharged with strength. The shogunate's restrictions on bathhouse girls to the contrary, they had continued to increase in number, and this picture is probably true to life. The girls must have reveled in their raw vitality. This artist was the first and last to use them and their forceful vitality as subject matter. Tuned in as he was to all this, the painter must have been thoroughly enraged by the shogunate and its Confucian strictures. Indeed, his painting is full of such indignation.

Nameless though the artist is, we see clearly by the sensitivity and strength of line that his background was in *kanga*. There is also the same note we saw in the Tokyo National Museum *Rakuchu Rakugai Zu* or with Matabei: the appearance of the bathhouse girls and raw forcefulness of depiction. The composition, at first glance, does not seem to be deliberate, but upon closer examination we find considerable care has been taken. The right-to-left movement of the four girls on the right, stopped by

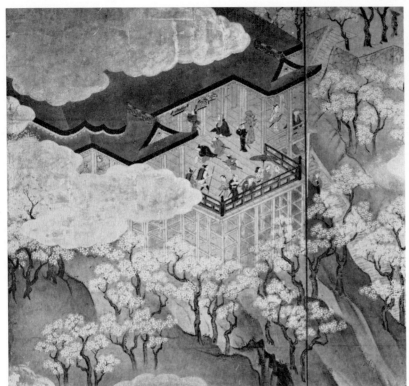

87. *Detail from* Arashiyama and Kiyomizu Temple, *by Kano Eino. Pair of sixfold screens; colors and gold on paper; each screen, 95 × 270.5 cm. Second half of seventeenth century. Okuyama Collection, Kyoto.*

88. *Detail from* Eight Scenic ▷ Spots on Lake Biwa, *attributed to Tosa Mitsuoki. Painting mounted on tokonoma wall; colors and gold on paper, 178.5 × 379 cm. Second half of seventeenth century. Kanju-ji, Kyoto.*

the two girls on the left turning back, adds considerably to the effect. As far as the depiction of vulgar vitality is concerned, this artist has earned a place at the top. *Yuna* and the Hikone screen are contrasting works, yet both are representative of the maturity of Momoyama genre painting.

Two screens called *Yujo Yuraku* (Courtesans' Entertainments) are extant, both in the tradition of *Yuna*. (Figure 139 is an illustration of one of these.) Here the improprieties of numerous ladies are laid bare without a blush. The vulgarity is carried even further, and we fail to find the strain of anti-establishment indignation we saw in *Yuna*. They are unbridled portrayals containing something dark and weary. From here the tendency to beautify and refine becomes dominant.

THE KANO SCHOOL CHANGES COURSE

As official painters to the shogunate, the mainstream of the Kano school, led by Tan'yu (1602–74), had turned to didactic painting. But this did not mean that it had given up genre painting altogether. According to the records, during the years between 1624 and 1673, Tan'yu himself did much decorative work in various imperial buildings: *Events of the Year, Sumiyoshi Shrine, Mount Yoshino, Wakanoura, Kiyomizu Temple, Horse Racing,* and others. But work by Tan'yu, to judge from the *Arashiyama and Kiyomizu Temple* screens (Fig. 87) done by Kano Eino (1634–1700) under Tan'yu's direction, is obviously watered-down genre, more a reversion to the traditional art of seasonal and famous-place paintings.

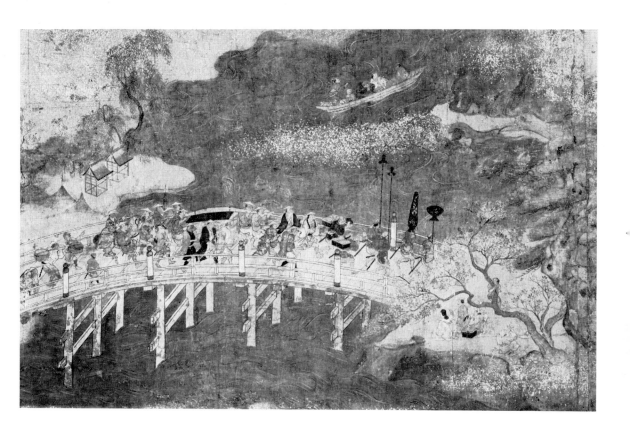

There is much more in the way of genre elements in, say, the work of his contemporary Tosa Mitsuoki (1617–91), who is reputed to have painted *Eight Scenic Spots on Lake Biwa* (Fig. 88), now in Kanju-ji temple. This indicates that the Kano school had split up the marriage of Chinese and Japanese methods and clearly plumped for the techniques of *kanga,* although it still used *yamato-e* methods for certain types of subject matter. The age when the Kano school, with its synthesis of Japanese and Chinese techniques, was active in *kachoga* and genre painting was past.

Two painters originally with the Kano school, Hanabusa Itcho (1652–1724) and Kusumi Morikage (dates unknown), worked in idioms quite different from the Kano style. For his unique genre paintings, Itcho found his subject matter in the lives of ordinary city people. Morikage, on the other hand, who is said to have been expelled from the Kano school, has given us lyrical depictions of village life, such as his famous *Enjoying the Evening Cool Under the Moonflower Trellis,* in ink monochrome, or sometimes ink with touches of color. But these artists painted in an idiom completely different from the Momoyama genre tradition.

FROM GENRE TO BIJINGA The many themes of Momoyama genre painting continued to be depicted after 1644, although in ever smaller format—from large to medium and small screens, then hanging scrolls and hand scrolls. Nearly all this work was by town painters.

Largely stereotyped paintings, they do not need to be discussed here. Of greater interest are the forms of painting after 1644 that continued to use the hedonistic treatment of figures found in paintings on the "merrymaking" theme during the years between 1615 and 1644. With the background gone, attention was focused solely on the group of people pictured. We have already noted how the artist's interest narrowed to the lady of easy virtue, and to the expression of her sensual side both in appearance and movement. Carried further, this led of necessity to the concentration of attention on one figure. And since paintings on the theme of merrymaking are susceptible to criticism as being seamy, they were the first to go "private" by slipping into a smaller, less obtrusive medium. This might well be the reason why paintings of a

single beauty, the so-called *bijinga,* caught on so quickly.

Meanwhile, the pleasure quarters, smarting under the label of "evil place" and looking for a new ideal of feminine attractiveness, began training a new kind of polished, high-class prostitute. This resulted in the kind of consummate courtesan-entertainer best typified by the *tayu.* Similar efforts were expended on the *bijinga,* and what emerged was a sensuous, elegant representation of feminine beauty using *yamato-e* painting techniques.

Beauty at the Rope Curtain (Fig. 91) shows a somewhat unyielding line. But in looking at the woman bidding her lover farewell by the dangling curtain, face so forlorn, we realize—here is good taste and stylishness that is really new. In *Dancing Girl* (Fig. 92) you have it again in the elegance of a slightly

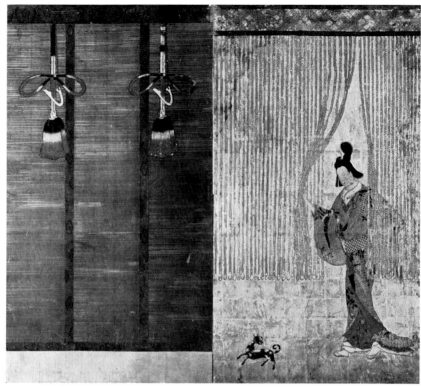

89 (opposite page, left). Beauty Looking over Her Shoulder, by Hishikawa Moronobu. Detail from hanging scroll; colors on silk, 63 × 31.2 cm. Late seventeenth century. Tokyo National Museum.

90 (opposite page, right). Detail of courtesan and attendant, from triptych of hanging scrolls. Colors on paper, 71.7 × 30.3 cm. First half of seventeenth century. Nezu Art Museum, Tokyo.

91. Single twofold screen. The right-hand panel has Beauty at the Rope Curtain; the left-hand panel shows a bamboo blind. Colors and gold on paper, 159.5 × 180.5 cm. Mid-seventeenth century. Hara Collection, Tokyo.

upturned foot or the wistfully attractive face. The *Beauty on the Veranda* (Fig. 94) type of painting proliferated between 1661 and 1673, and it typifies the *bijinga* idiom of that period. The line has lost the stiffness and flows gracefully. While the left hand is withdrawn into the sleeve, the skirt of the garment is daintily gathered up in the right. The treatment is unusually fine, showing us the female form at its most elegant. The enchanting face and figure ushers one into the world of the chic and stylish.

To sum up, genre painting, which grew out of a far-reaching affirmation of life, its contemporary manners and customs, lost touch with that life force completely about the middle of the seventeenth century. Four factors in general contributed to its decline. First, the Kano and Tosa schools reverted to seasonal landscapes and famous-place paintings, both of which have few genre elements. Second, town painters by and large mass-produced stereotyped works illustrative in nature. Interest in the female form and dress lasted longest, and in the case of outstanding town painters of the Kambun era (1661–73) it manifested itself in the *Kambun bijin zu*, or Kambun paintings of beauties. The other manifestation of this interest was in the *tagasode byobu* (garment screens), which presented the abstracted beauty of garments alone, and in the *hiinagata-cho*—catalogues of kimono designs. In the *Kambun bijin zu* a new kind of feminine beauty is to be seen, while the *tagasode* screens are interesting as a new kind of decorative painting. However, neither of them can be considered genre painting. *Beauty Looking over Her Shoulder* (Fig. 89), by

92 (left). Dancing Girl. *Detail from hanging scroll; colors on paper, 80.3 × 25.2 cm. Mid-seventeenth century. Tokyo National Museum.*

93 (right). Pilgrim Beauty. *Detail from hanging scroll; colors on paper, 37.6 × 18.8 cm.; 1668. Atami Art Museum, Shizuoka Prefecture.*

Hishikawa Moronobu (1618–94), is an extension of the *Kambun bijin zu* idiom. Moronobu, sometimes called the founder of ukiyo-e (the Edo-period genre of paintings and prints popular with the merchant class), also used the Kabuki theater as subject matter, but these paintings alone would not give him a very prominent position in Japanese art history. But in his illustrations for *kana-zoshi* and *ukiyo-zoshi,* two genres of popular literature, and his woodblock work for picture books, he managed to create a wholly original style. The black-and-white world of these monochrome prints—accurate depictions of the life and manners of the common people—had a truly popular appeal. Moronobu had succeeded brilliantly in recapturing the vital force of Momoyama genre painting. And this is the reason he is called the founder of ukiyo-e—the art of the common people.

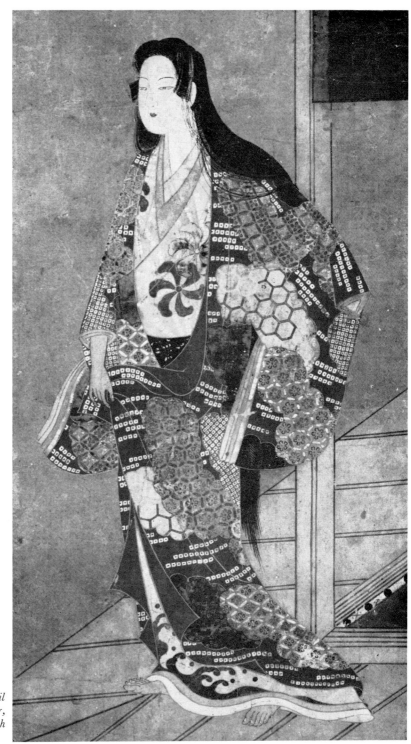

94. Beauty on the Veranda. *Detail from hanging scroll; colors on paper, 83.3 × 32.7 cm. Mid-seventeenth century. Tokyo National Museum.*

Rakuchu Rakugai Zu: An Overview

IN THE AUTUMN OF 1965 a special exhibition of *Rakuchu Rakugai Zu* was held at the Kyoto National Museum. Practically everything extant in this genre was brought together, and the exhibition served to increase the general public's interest in this form. *Rakuchu Rakugai Zu,* published by the museum on the occasion of the exhibition, stressed the value of the genre as a source of information for cultural history, and the important place occupied by it in the early history of Japanese genre painting.

First of all, *Rakuchu Rakugai Zu* provide us with a very comprehensive picture of the former capital. They give us the full spectrum of shrines and temples, courtiers' and warriors' residences, rows of merchants' houses, and the lives and customs of citizens of all stations. The genre originated on folding screens in the late Muromachi period (beginning of the sixteenth century), and was popular thereafter, from Momoyama times up to the middle of the Edo period (1603–1868). In the sixteenth century *Rakuchu Rakugai Zu* in fan format arose, followed by the picture-scroll and picture-album formats. Always, however, the main vehicle of expression was the folding screen, and extant paintings are largely in this form. Folding screens, it must be recalled, showed considerable variation; after the middle of the seventeenth century, the popularity of medium and small screens increased.

The many existing *Rakuchu Rakugai Zu* screens can be classified according to the way the artist depicts the city and according to his choice of the principal compositional elements. In the publication mentioned above, the art historian Tsuneo Takeda sets up three categories. My own classification, partly based on Takeda's, has four types.

TYPE ONE. There are three screens of this type: the Machida screens (Figs. 28, 39), a copy in the Tokyo National Museum, and the Uesugi screens (Figs. 10, 43, 44, 67). On each right-hand screen these paintings show what is usually a spring-summer scene of the Shimogyo (southern) section of Kyoto with the Higashiyama hills to the east in the background. On the left-hand screen you have the Kamigyo (northern) section of Kyoto in fall-winter, with the Nishiyama western hills in the background. Thus the right-hand screens have southern Kyoto seen from the west, whereas the left-hand screens have northern Kyoto seen from the east. The visual sweep in contrary directions is quite fascinating.

Next we notice that the main elements in all three works are the Imperial Palace, the residence of the shogun, and that of Hosokawa, the governor general. The names of each of these are indicated on the paintings on small rectangular pieces of

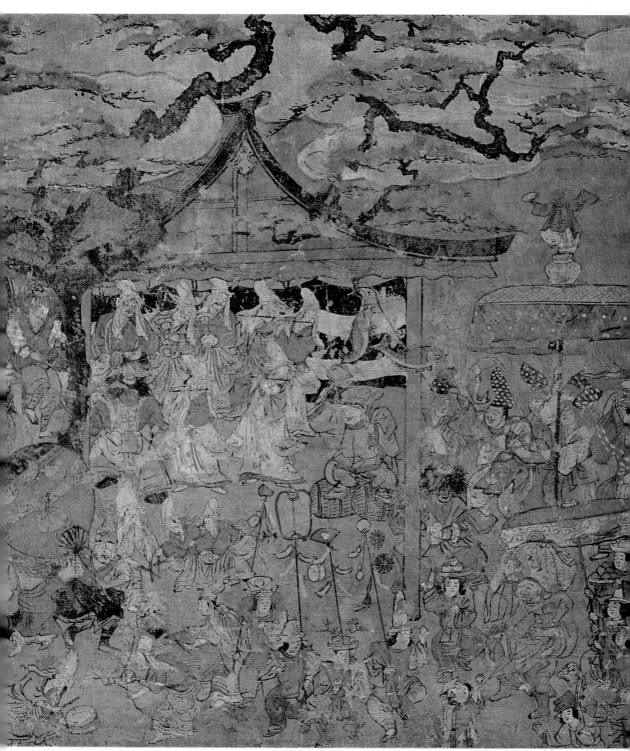

95. New Year's entertainment known as matsubayashi. *One of several miscellaneous paintings of manners and customs of the months* (tsukinami fuzoku) *mounted on a single eightfold screen. Half panel; colors on paper; size of whole panel, 61.7 × 41.7 cm. Mid-sixteenth century. Tokyo National Museum.*

96. *Detail from Gion Festival; Kano school. Pair of sixfold screens; colors and gold on paper; each screen, 153.5 × 346 cm. Early seventeenth century. Idemitsu Art Museum, Tokyo.*

97. *Detail from* Hie-Sanno Festival; *Kano school. Pair of fourfold screens; colors and gold on paper; each screen, 168.5 × 369 cm. Early seventeenth century. Danno Horin-ji, Kyoto.*

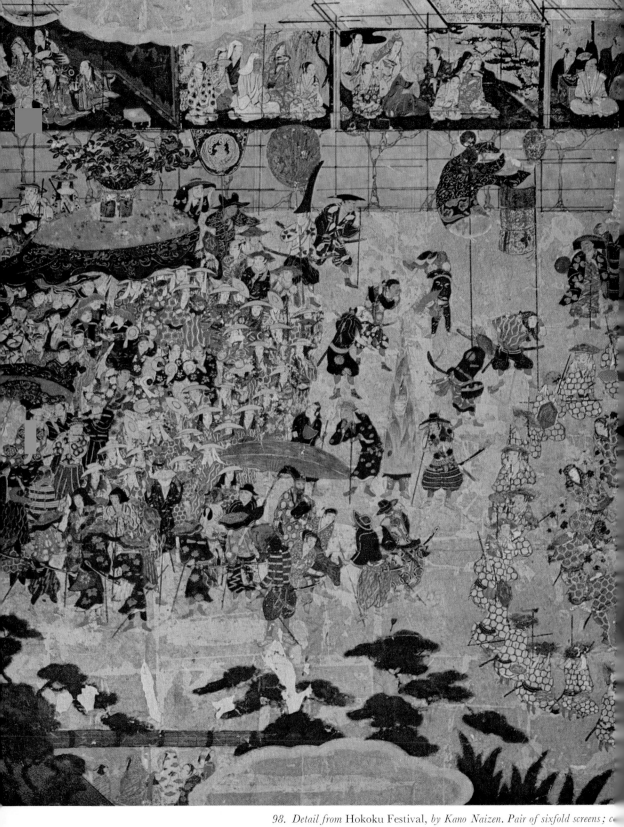

98. *Detail from* Hokoku Festival, *by Kano Naizen. Pair of sixfold screens; c*

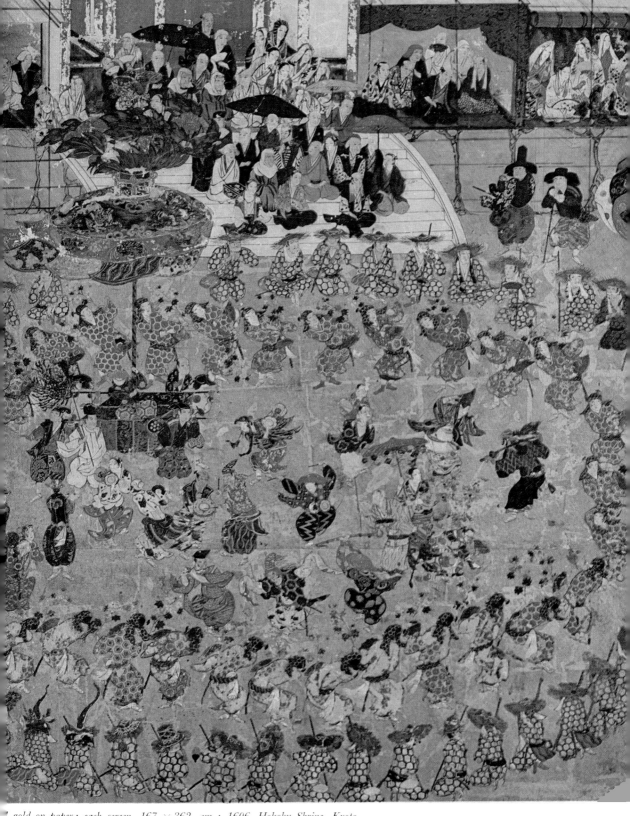

gold on paper; each screen, 167 × 362 cm.; 1606. Hokoku Shrine, Kyoto.

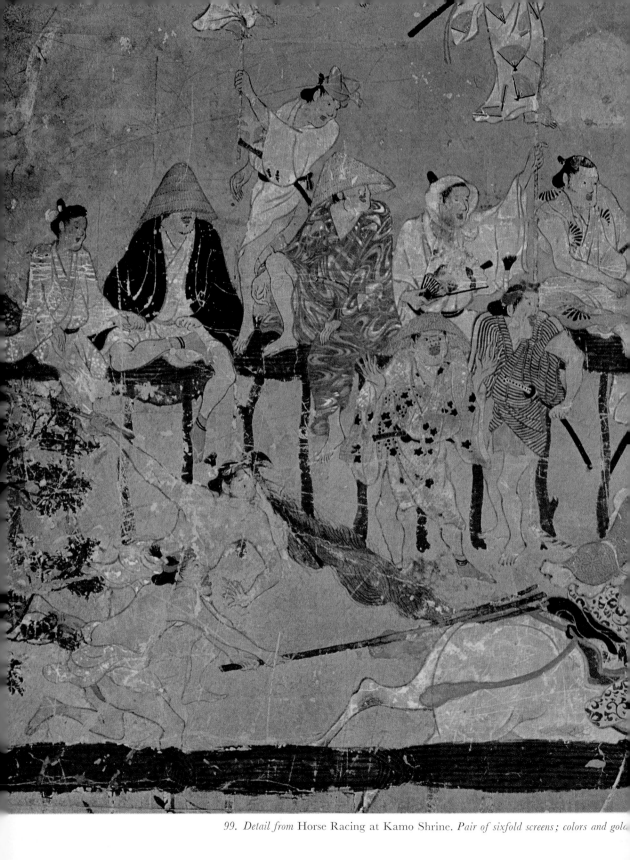

99. Detail from Horse Racing at Kamo Shrine. *Pair of sixfold screens; colors and gol*

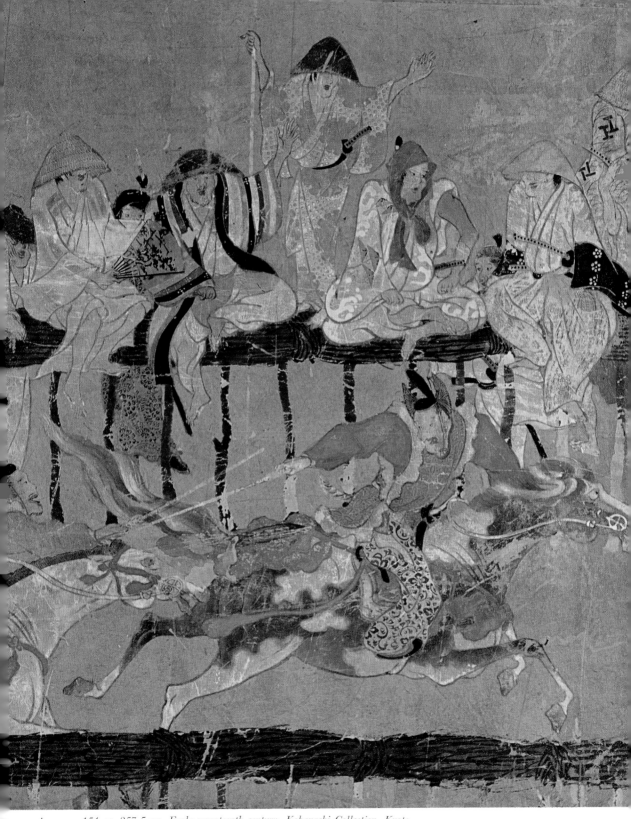

er; each screen, 154 × 357.5 cm. Early seventeenth century. Kobayashi Collection, Kyoto.

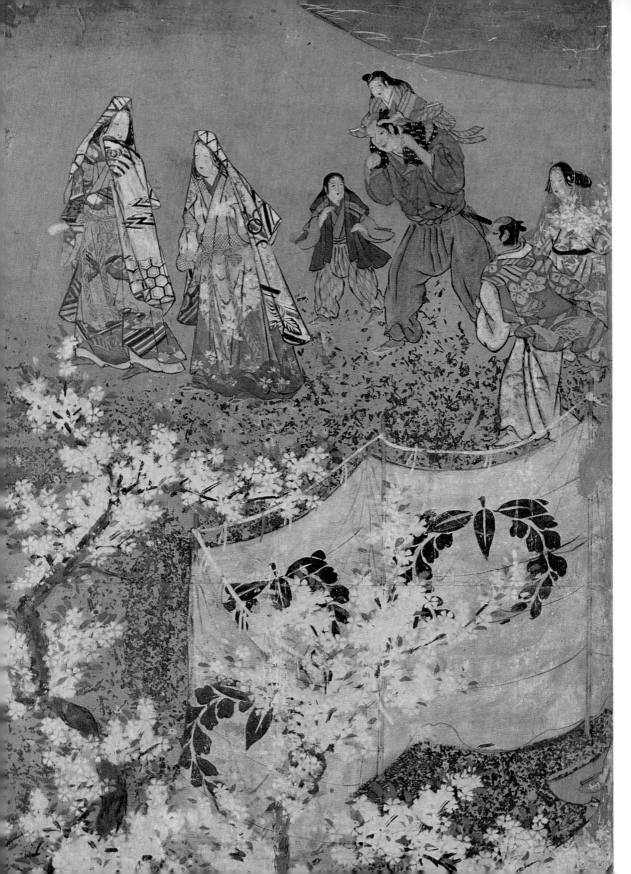

paper. The scenes we see in this first category are accordingly of Kyoto in the late Muromachi period. The three screens do not, of course, show these residences in exactly the same way or in the same locations. In fact, these very differences help us to date the views of Kyoto more accurately. With the aid of earlier historical studies on the architecture carried out by Professor Sutemi Horiguchi, Tsuneo Takeda has determined that the Machida screens show the Kyoto of the late 1520s. The scene depicted in the Tokyo National Museum copy is surmised to date from around 1540, and that of the Uesugi screens from the 1550s or early 1560s. Kyoto is represented so accurately on these screens that this kind of dating is possible.

I should point out here that there are only two or three genre paintings for which the dates of execution are known definitely. In all other cases, the dates have been surmised on the basis of style and the kind of circumstantial evidence adduced above.

On comparing the Machida screens, the Tokyo National Museum copy, and the Uesugi screens, it becomes clear that during the last decades of the Muromachi period Kyoto underwent a striking renascence, and we see the city on the road to prosperity. This is especially evident from the Gion Festival scene in each. It is intriguing to watch it gain in glory from the Machida to the Tokyo National Museum version, until in the Uesugi screens it becomes one of the centers of attention.

TYPE TWO. Nothing is extant that clearly belongs to this category, but Tsuneo Takeda advances a well-researched opinion, with which I agree. He maintains that the *Juraku-dai* screen (Figs. 45, 47) is of this type and so I place it here. It has the Juraku-dai palace built in 1587 by the military ruler Toyotomi Hideyoshi in the Uchino district of Kyoto depicted on a large scale in the center of one sixfold screen, the sixth panel of which is missing. Until now the screen has been called *Juraku-dai*, but since it takes in the scenery from Mount Hiei to Mount Atago—the Rakuhoku, or northern districts of Kyoto—Takeda concludes that it is the

left-hand screen of a pair of *Rakuchu Rakugai Zu* screens. The missing right-hand side of the pair, he conjectures, would mainly have consisted of a view of the Imperial Palace with the Higashiyama hills lying behind. This opinion rests on analogy: Oda Nobunaga commissioned Kano Eitoku to do the Mount Azuchi screen painting which has Azuchi Castle impressively rendered on one side and the center of the new town of Azuchi on the other. Since it was Hideyoshi's political scheme to make the Juraku-dai palace the center of things in Kyoto, it is easy to see him commissioning an artist to do a *Rakuchu Rakugai Zu* with a similar composition. In any case, this remaining screen, the left-hand side of the pair, showing the majestic Juraku-dai in the center, describes perfectly Hideyoshi's times, when his power brought the country unification.

Sometime around the completion of Hideyoshi's Juraku-dai in 1587, work was begun on the Great Buddha Hall of Hoko-ji temple in eastern Kyoto. Here we have a clue to what Hideyoshi's master plan for this *Rakuchu Rakugai Zu* was. The left side of the screen showed the Juraku-dai, the right would manifest the Great Buddha Hall, and in between, the center would show the city houses, with people having a great time at the Gion Festival. But before the hall was completed in September 1595, Hideyoshi had the Juraku-dai demolished; and the hall was leveled in an earthquake only a year later. This is, perhaps, why the *Rakuchu Rakugai Zu* screen Hideyoshi had dreamed of never materialized.

TYPE THREE. Only one painting of this type is known at present, a pair of sixfold screens (Figs. 64, 76, 77, 129). It is now in the Tokyo National Museum, but was formerly in the Funaki Collection. It has remarkable characteristics, and so I treat it as representative of a distinct period.

The first thing we notice is that the two screens show a single continuous scene. This is rare. In both the first and fourth types, the artist usually paints Kyoto seen from the east on the left-hand screen, and from the west on the right. (In screens of the second type, the views are thought to be from the

◁ *100. Detail from* Merrymaking Under the Cherry Blossoms; *Kano school. Pair of sixfold screens; colors on paper; each screen, 149 × 352 cm. Early seventeenth century. Kobe Municipal Museum of Namban Art.*

southeast and northwest respectively, but this is not certain.) This painting has one flowing perspective spanning both sixfold screens—Kyoto as seen from the southwest, with the Kamo River, shown running obliquely, binding the two screens closely together.

A second distinguishing feature of this screen pair is the playing off against each other of Nijo Castle of the Tokugawa family on the left and the Great Buddha Hall (and Hokoku Mausoleum) of the Toyotomi family on the right. Thus on comparing it with the Juraku-dai screen (conceived by Hideyoshi as a pair of screens with the Great Buddha Hall to be shown on the right-hand screen), we can say that in the present work Nijo Castle has replaced the Juraku-dai. Nijo Castle was completed in 1603. The Great Buddha Hall of Hoko-ji temple, destroyed by the 1596 earthquake, was ravaged again, this time by fire, while being reconstructed. Then Hideyoshi's son, Hideyori (1593-1615), undertook its rebuilding once more in 1610. By 1614 it stood ready for dedication again. Consequently, actual juxtaposition of the Buddha Hall and Nijo Castle as in this pair of screens would only have been feasible in 1614 or after. But the *Hokoku Festival* screens of 1606 (Figs. 55, 98, 110) show the hall as though it had all the reason in the world to be there. Thus it seems reasonable to say that this third type of *Rakuchu Rakugai Zu*, in which the rivalry between the Tokugawa and Toyotomi families is alluded to through architectural symbolism, was popular between about 1605 and 1615.

To come back to the pair of screens at the Tokyo National Museum, another outstanding characteristic is the close-up of the busy town the artist provides between the castle and the Great Buddha Hall. In the large space between them we encounter the great excitement of Kyoto—the prospering merchants from Nijo to Shichijo avenues, the Gion Festival in progress, Women's Kabuki at Shijo riverbed, puppetry, the prostitution at Rokujo—the old capital is celebrated in style. The result is a scene of large, compelling contrasts, an expression of tension and roaring life: the Tokugawa family's castle on the left, the Toyotomi family's Great Buddha Hall on the right, and the center teeming with townsfolk, the aristocracy, and their entertainments. I would date the pair of screens at about 1610.

TYPE FOUR. Over half our extant *Rakuchu Rakugai Zu* belong to this category. Since they were produced over a rather long period one meets considerable differences in content and handling, but the following points are common to all.

1) Abura-Koji street, running from north to south, is seen to divide Kyoto into east and west. The left-hand screen gives us the west, with the Nishiyama hills rising in the background; the right-hand screen shows the east and the Higashiyama hills behind. Hence the different perspective in each.

2) The left-hand sixfold screen has Nijo Castle in the center and the right-hand screen has the Imperial Palace and Great Buddha Hall of Hoko-ji temple. The latter two are fairly large, but the heart of the painting is the Gion Festival.

Screens of this category first appeared in 1603, when Nijo Castle was erected, and continued to be painted for a long time thereafter. (It is hasty to conclude that because smaller place is accorded to the Hoko-ji in this as compared to the third type of *Rakuchu Rakugai Zu*, they must date from after 1615, when Osaka Castle fell and Hideyoshi's son Hideyori was finally defeated by Ieyasu. It is quite possible that the importance of the Toyotomi family, as symbolized by the Hoko-ji, was played down as early as 1605.) In fact it is the appearance of Nijo Castle that allows us to date these works. It was renovated for the visit of Emperor Gomizuno-o in 1626. The premises were greatly enlarged, the huge donjon of Fushimi Castle in southeast Kyoto was brought in, and Nijo Castle's own, smaller tower transferred to Yodo Castle, further south. New buildings, including special quarters for the emperor, were also constructed for the occasion. Thus, when the scene shows the donjon behind the Ninomaru Palace (the shogun's residence), it is pre-1627; if the larger donjon is shown on the enlarged Hommaru, or principal compound, side, it is post-1627. Nijo Castle was no longer a bustling place after the third Tokugawa shogun, Iemitsu (1604-

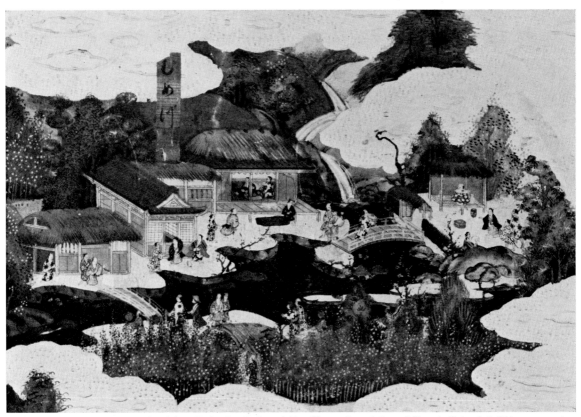

101. Katsura Imperial Villa; detail from Rakuchu Rakugai Zu *(Scenes In and Around Kyoto). Pair of sixfold screens; colors and gold on paper; each screen, 159.1 × 362.8 cm. Mid-seventeenth century. Okayama Art Museum, Okayama Prefecture.*

51), marched into Kyoto in a show of strength in 1634. And in *Rakuchu Rakugai Zu*, too, the castle's role on the left-hand screen gradually lost importance.

A great number of paintings of very stereotyped composition, brushwork, or treatment are included in this fourth category. I take them to be mass-produced "practice paintings" (*shikomi-e*) that appeared in profusion after about 1650.

Best of the category are the screens at Shoko-ji temple and Okayama Art Museum. The former seem to be a work of about 1615. They stand out for the emphasis on Nijo Castle on the left-hand screen, and the fine treatment of the prospering town as seen on the right-hand screen. The Oka-

yama screens show Nijo Castle a bit smaller but compensate by concentrating on the town, its business district and the merriment at Shijo riverbed. They are quite valuable as a source on customs and life in general. It is interesting to note the inclusion of Katsura Imperial Villa (Katsura Rikyu; literally, "Katsura Detached Palace"; Fig. 101) as it was in its early days.

I HAVE DIVIDED *Rakuchu Rakugai Zu* into the four foregoing types based on the way Kyoto is treated and the main elements introduced into the paintings. The types are also roughly chronological categories. That is, the first type consists of works up to the close of the Muromachi period; the second

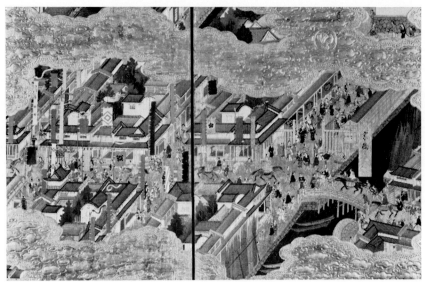

102. Detail from Scenes in Edo. *Pair of sixfold screens; colors and gold on paper; each screen, 162.5 × 363.4 cm. First half of seventeenth century. Hayashi Collection, Tokyo.*

of work of circa 1590; the third of paintings of around 1610; and the fourth type, of work beginning around 1605 and continuing to appear well into the middle of the Edo period (1603–1868). These four types of *Rakuchu Rakugai Zu* provide a penetrating comparison and insight into the government of Kyoto in each period, the gradual revitalization of the city, and the developing life style and customs of the populace. However, from about 1644, *Rakuchu Rakugai Zu* begin to lose their life and their important role as a record of the changing times.

PAINTINGS OF It is reasonable that paint-
OSAKA AND EDO ings similar to *Rakuchu Raku-*
 gai Zu, but of cities other than Kyoto (especially Osaka and Edo), should have been produced. I have already discussed Kano Eitoku's Azuchi Castle screen, commissioned by its builder Oda Nobunaga. Similarly, Toyotomi Hideyoshi may have had Eitoku paint his own Osaka Castle and its surrounding city. But no such Osaka painting has come down to us from Hideyoshi's day. A painting of Osaka in the Haya-

shi Collection gives us a large-scale execution of the castle as restored by Tokugawa Iemitsu in 1624; it takes up the center of one of a pair of sixfold screens. The surroundings show the bubbling city life. The missing right-hand screen probably had a Shitenno-ji temple scene in the center of the composition.

One Edo painting has finally turned up. It is a pair of sixfold screens in *kompeki* style (Fig. 102) with a very detailed depiction of the fabulous castle of Edo (present-day Tokyo), mansions of the daimyo before the great fire of 1657, and the gay customs and life of the people. Again, a very valuable source of information.

The *Rakuchu Rakugai Zu* and related kinds of painting discussed above contain in themselves a variety of genre motifs. And depending on one's point of view, the types of painting we shall discuss next—courtiers' and warriors' genre, paintings of the trades and crafts, festivals, famous places, and entertainments—can all be interpreted as works in which individual scenes of the *Rakuchu Rakugai Zu* have been enlarged and made the principal themes of independent paintings.

CHAPTER EIGHT

Aristocratic and Samurai Genre: An Overview

EVERY RAKUCHU RAKUGAI ZU shows the Imperial Palace and residences of the nobility, such as the Konoe mansion, giving us a certain glimpse of the public and private lives of the nobility. However, these do not receive top billing. This is clearly brought out when we look almost in vain for a large-scale treatment of court customs and manners, compared with the many dealing with commoners.

At Koen-ji temple in Kyoto there is a pair of screens in the "events-of-the-months" (*tsukinami-e*) genre that have two dozen fan paintings mounted on them in "scattered" (*chirashi*) fashion. The work is of the late Muromachi period and bears the seal of Kano Motonobu, though it may very well be the product of his assistants. Five of the fan paintings can be classified as court genre work: the imperial New Year's banquet at Shishin-den hall (Fig. 30); the Sagicho ceremony (a kind of exorcism ritual carried out at the Seiryo-den hall in January); the first archery of the year; the cockfights of March (Fig. 29); and *kemari* (a kind of football). All of them are genre paintings of events with a long-standing tradition. However, in a *tsukinami* (events-of-the-months) genre album of the kind done in the Momoyama period, only two of twelve paintings—the *uguisu* (bush warbler) contest (February) and the *furyu* dance (July)—are shown taking place in noble residences. The cockfights of March are

shown conducted in the mansions of the samurai class, and with the Muromachi period the *furyu* dance became a public affair. The dance only happens to take place in a nobleman's residence in this particular fan painting.

From late Muromachi up into early Momoyama times, the courtiers' residences and the Imperial Palace saw performances of not only the *furyu* dance but also Noh, *onna-mai* (a type of dance performed by professional women dancers), and even Okuni Kabuki. The screen called *Tax-Exemption Dance* (Fig. 60; see also page 70) shows nobles and samurai lining a garden and veranda of a courtier's residence in the city; all watch the swirling circle of dancers. The nobles sit on the porch, the samurai squat in the garden. No paintings depicting *onna-mai* or Women's Kabuki being performed in a courtier's mansion are extant. Kobe Municipal Museum of Namban Art, however, has a single six-fold screen called *Watching Noh* (Fig. 103), which is believed to depict a Noh performance on a temporary stage erected in a garden of the Imperial Palace. Sitting in the garden are a group of Europeans puffing on pipes. The scene is not necessarily true to life but it points out one facet of court life in those times.

A kind of football called *kemari* was the favorite court sport, and at the Nezu Art Museum there is

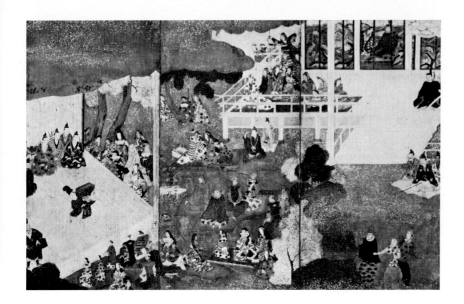

a pair of sixfold screens (Fig. 105) dedicated to it. The traditional game is awarded the novel decorative treatment and large-scale handling of the Sotatsu school. Not surprisingly, it is low in genre elements.

The gala events for the courtiers of the day were: the visit of Emperor Goyozei to the Juraku-dai in 1588; the entry of Kazuko, daughter of the second Tokugawa shogun Hidetada, into court service as a consort to Emperor Gomizuno-o in 1620; and Gomizuno-o's visit to Nijo Castle in 1626. No screen showing the imperial visit to the Juraku-dai is extant; the sixfold screen showing the bridal party's ceremonial entrance, handed down in the Ii family, was destroyed by fire, but we have a pair of fourfold screens (Fig. 104) of it in the Mitsui Collection. It is indeed a faithful depiction of an unforgettable moment for the Tokugawa: the long entourage with its luggage is seen wending its way along the avenue from Nijo Castle to the Imperial Palace before many onlookers. The emperor's visit to Nijo Castle was also commemorated in an album —The Imperial Visit to Nijo Castle—painted by Hinaya Rippo (1599–1669).

Recently, a pair of sixfold screens (Fig. 106) show-ing court ceremonies, apparently by the Tosa school of early Edo, was uncovered. They reflect the resurgence of court ceremonial during the reign of Emperor Gomizuno-o (1611–29). The presence of common people among the spectators is interesting.

STABLES, HORSES IN PASTURES, HORSE TRAINING

Themes intimately connected with the daily lives of samurai—stables, horses in pastures, horse training—are prominent among samurai genre paintings. Stable paintings were to be seen earlier in picture scrolls, as part of the depiction of samurai residences. For example, the *Chronicle of Seiko-ji Temple Scroll* (1487; Fig. 107) by Tosa Mitsunobu shows a stable with a wooden floor forming part of a samurai residence, and two horses and a groom. But here we are concerned with screen paintings having stables as their main theme, and works of this type were being produced from the late Muromachi to the early Edo period. These are divided into two types according to the approach and handling of subject matter. One type is genre and the other is not; but I will make a few comments on the non-genre category also.

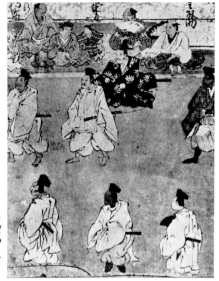

103. Watching Noh. *Three panels of a single sixfold screen; colors and gold on paper; size of whole screen, 106.7 × 426.8 cm. First half of seventeenth century. Kobe Municipal Museum of Namban Art.*

104. *Detail of bridal entry of Empress Tofukumon-in (Tokugawa Kazuko). From a pair of fourfold screens; colors on paper; each screen, 168.5 × 372 cm. First half of seventeenth century. Mitsui Collection, Tokyo.*

Paintings of the non-genre type have a large-drawn stable that covers the whole length of the screen, with a horse on each panel. There is a pair of sixfold screens of this type in the Imperial Household Collection (Fig. 113), another in the Uesugi Collection, and another in the Taga Shrine, Shiga Prefecture (Fig. 117; only the left-hand screen shows a stable scene, the right-hand one showing horse training). If no people are in sight, the paintings cannot qualify as genre. There was a tradition of "portraits" (*nise-e*) of famous horses and oxen, and these screens are probably in the same tradition, transferred to the larger format of the folding screen. They are characterized by a careful depiction of fine steeds tethered to their stalls, in a variety of individual, dynamic poses. Full of movement, they are just the kind of decorative painting to appeal to the samurai taste. We should note here that the twelve horses shown in the Imperial Household and Uesugi screens are almost identical in appearance and arrangement, and the six horses of the Taga Shrine screen correspond in the same way to the left-hand screens of these works. The three differ only in details like the coloring of the horses, the treatment of the bamboo in the background,

and the distribution of the gold clouds. The screen in the Imperial Household Collection is the finest of these. We do not know whether it is an original or a copy, but judging from the antique elegance of its gold and silver mists and the two-dimensional arrangement of the bolt-upright bamboos, the work dates from the late Muromachi or early Momoyama period, and is by an artist of the *yamato-e* tradition. The Uesugi and Taga screens, with plentiful gold clouds, are probably Kano work done between 1596 and 1623. At any rate, these non-genre paintings have a stereotyped composition showing no development whatsoever.

The genre-type stable paintings show, over and above the beautifully executed horses, a stable having a room with *tatami* (rush floor mats) and an adjoining veranda where guests can enjoy *go*, chess, or backgammon. This is genre, then, centered on a stable, so to speak. The type is represented by the pair of sixfold screens in the Tokyo National Museum (formerly in the Okazaki Collection; Figs. 49, 114); the Honkoku-ji temple pair of twofold screens (Fig. 115); and a pair of sixfold screens in the Cleveland Museum, among others. While the non-genre stable screens were almost identical, nearly

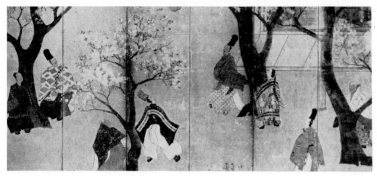

105. *Court football. Detail from a pair of sixfold screens; colors and gold on paper; each screen, 159.5 × 356 cm. First half of seventeenth century. Nezu Art Museum, Tokyo.*

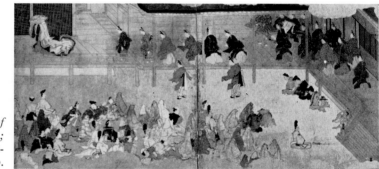

106. *Court ceremony. Detail from a pair of sixfold screens; colors and gold on paper; each screen, 110 × 279.4 cm. Mid-seventeenth century. Yabumoto Collection, Tokyo.*

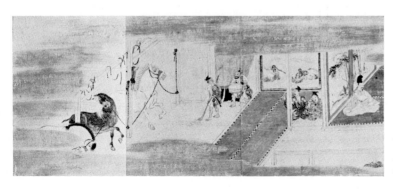

107. *Detail from* Chronicle of Seiko-ji Temple Scroll, *by Tosa Mitsunobu. Handscroll; colors on paper; height, 33 cm.; 1487. Tokyo National Museum.*

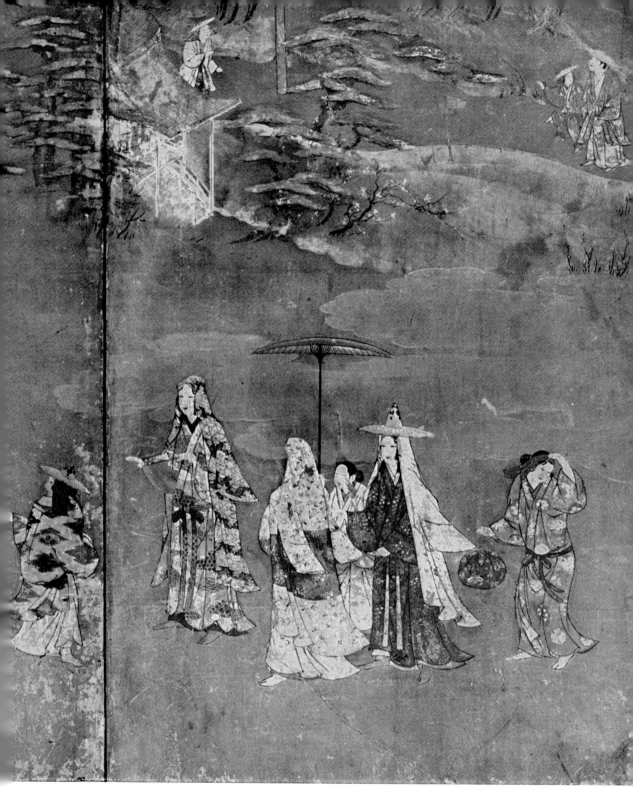

108. Detail from Hie-Sanno Shrine; *Kano school. Pair of sixfold screens; colors on paper; each screen, 93.2 × 275 cm. Early seventeenth century. Domoto Collection, Kyoto.*

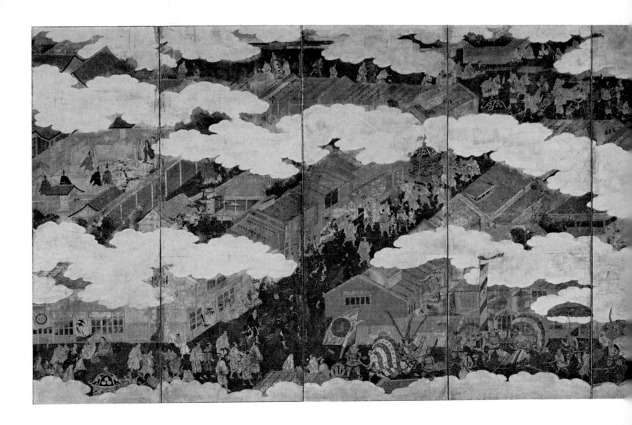

109. Gion Festival; *Kano school. Pair of sixfold screens; colors and gold on paper; each screen, 153.5 × 346 cm. Early seventeenth century. Idemitsu Art Museum, Tokyo.*

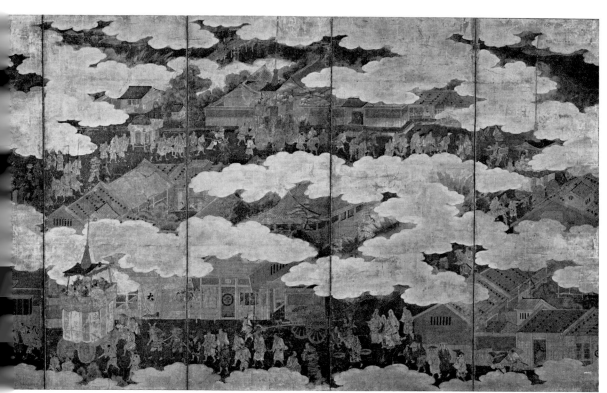

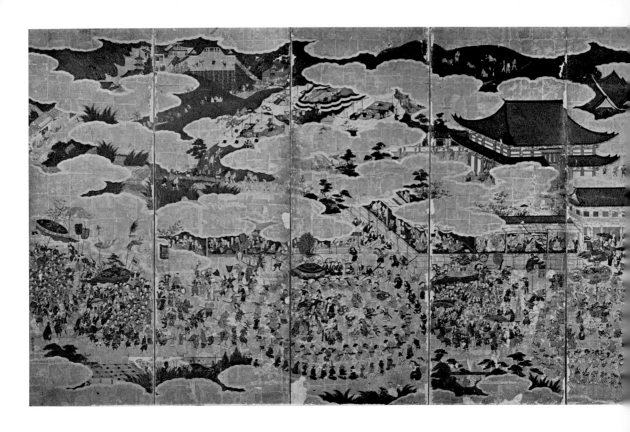

110. Hokoku Festival, *by Kano Naizen. Pair of sixfold screens; colors and gold on paper; each screen, 167 × 362 cm.; 1606. Hokoku Shrine, Kyoto.*

111 (overleaf). Battle of Sekigahara; *Tosa school. Pair of eightfold* ▷ *screens; colors and gold on paper; each screen, 194 × 594 cm. Early seventeenth century. Maeda Collection, Osaka.*

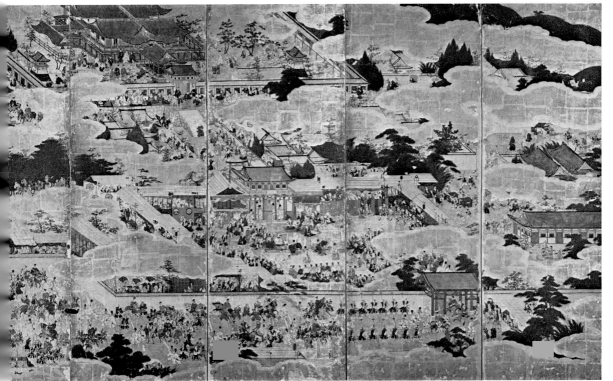

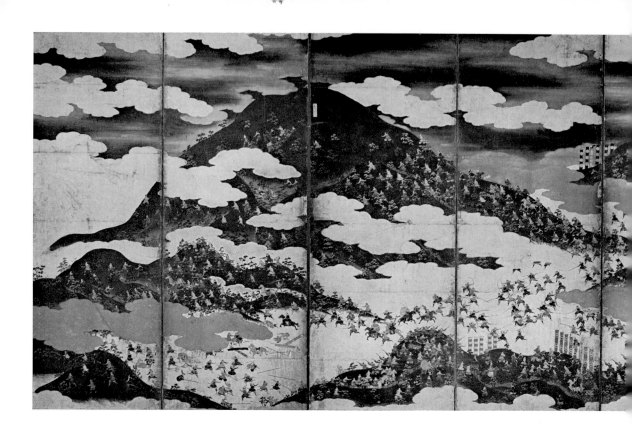

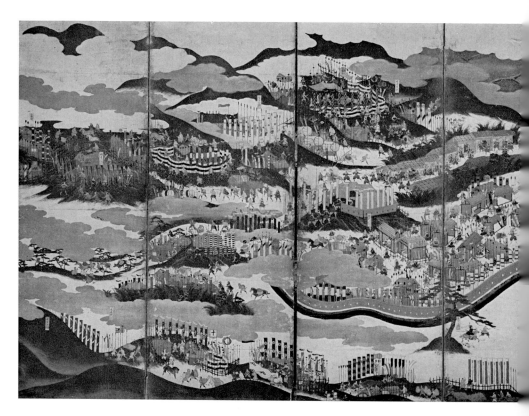

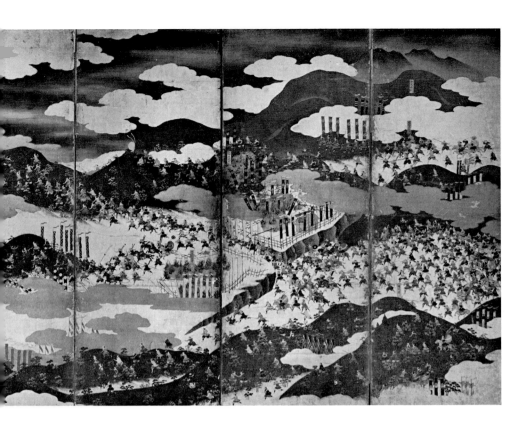

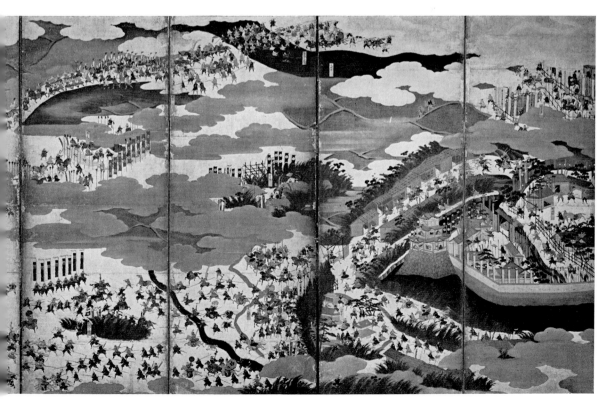

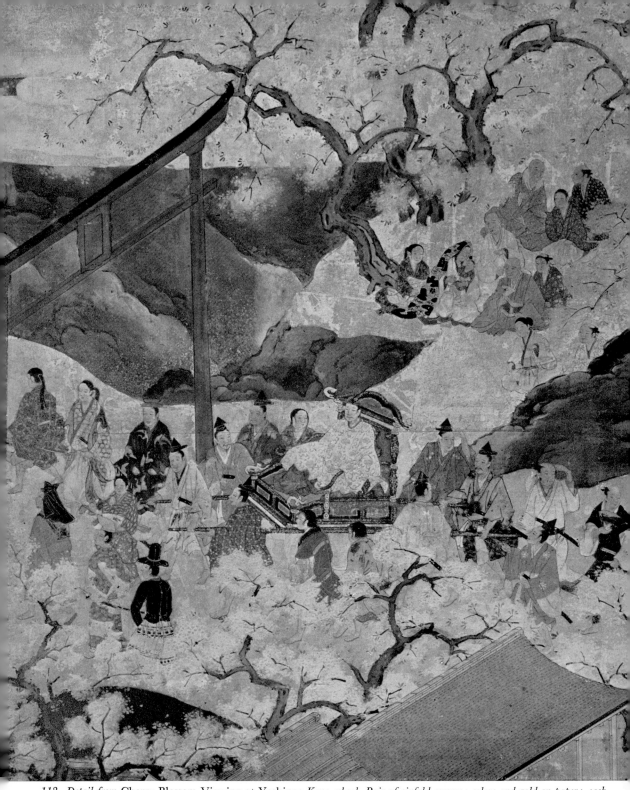

112. *Detail from* Cherry-Blossom Viewing at Yoshino; *Kano school. Pair of sixfold screens; colors and gold on paper; each screen, 155 × 363.5 cm. Early seventeenth century. Hosomi Collection, Osaka.*

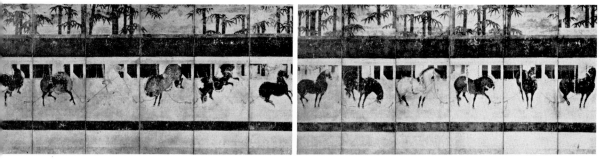

113. Stable. *Pair of sixfold screens; colors on paper, each screen, 145.4 ×*
309 cm. Second half of sixteenth century. Imperial Household Collection.

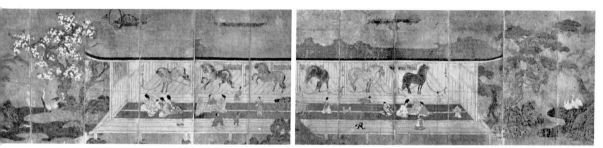

114. Stable; *Kano school. Pair of sixfold screens; colors on paper; each screen,*
149.5 × 354 cm. Second half of sixteenth century. Tokyo National Museum.

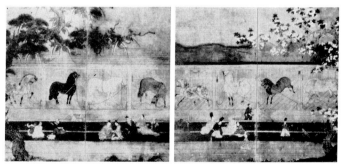

115. Stable; *Kano school. Pair of twofold screens; colors on paper, 155.1*
× 339.6 cm. Second half of sixteenth century. Honkoku-ji, Kyoto.

pastiche in subject matter and composition, these three are decidedly different. The Tokyo screen shows people at a stable surrounded by a garden (six horses, twenty people); the one at Honkoku-ji merely suggests a garden in front of the stable (eight horses, seventeen people); and the Cleveland screen focuses on the stalls (twelve horses, twenty-six people). On closer investigation, however, we discover many common elements among them, indicating a close connection among the three. The conclusion is that the Tokyo screen is either the original or a close copy, the Honkoku-ji a reworked version of it with its own additions (the three horses in it are almost as they are in the Tokyo screen; two face in a different direction and three more are added). The Cleveland screen adds to the latter a hawk, a falconer, and four horses, in addition to rearranging the motifs. This means we have considerable development with each of the three in this second category of stable paintings. And the Cleveland work, in particular,

boasts an accumulation of many genuine genre elements.

The dates are not certain. The Tokyo screen approaches the synthesis of *kanga* and *yamato-e* techniques we saw with Hideyori's *Maple Viewing at Mount Takao*, thus dating itself roughly somewhere from the end of Muromachi to early Momoyama. We can find no special trace of a direct connection between the genre and non-genre types that might have affected the composition of the Cleveland Museum screen.

As we saw much earlier, the Azuchi Castle donjon has a twenty-mat room on the third floor with a painting of horses in a pasture. One could describe it as a warrior genre painting garnished with grooms and grazing horses. Its model was *Horses in a Pasture*, a pair of sixfold screens in the Tokyo National Museum (Figs. 38, 48), painted by Hasegawa Tohaku sometime around 1570. It shows eighteen horses, fifteen mounted samurai, and six grooms. The ground, figures, and horses are in

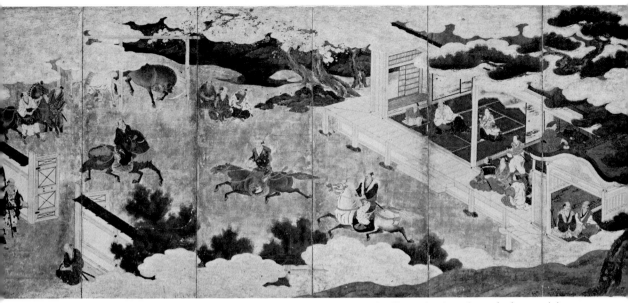

117. Horse Training and Stable; *Kano school. Pair of sixfold screens; the illustration here shows the horse-training screen. Colors and gold on paper; each screen, 155 × 354 cm. Early seventeenth century. Taga Shrine, Shiga Prefecture.*

yamato-e style, the rocks and trees in *kanga*, but at this stage we do not yet see the harmonious whole that was to come. The figures are really excellent, however, and it is a valuable work of warrior genre painting. I might mention that horses-in-pastures genre includes such works as the painting by Hasegawa Sakon (Tohaku's son, according to one tradition), now in the Boston Museum of Fine Arts, having only grazing horses.

Next comes genre work dealing with the equestrian arts: the paintings of horse training. Horsemanship, naturally enough, was paramount among the martial arts. Day in and day out the training of horses took place on special grounds set up for the purpose or in the open countryside, and it became the theme of many screens. Three have come down to us: the Daigo-ji temple pair of sixfold screens (Figs. 73, 118); the single sixfold screen belonging to the Domoto family (Fig. 119); and the pair of sixfold screens at the Taga Shrine (Figs. 36, 117). All are the work of the Momoyama-period Kano

school. There is no copying or reworking among them as we saw with the horses-in-a-pasture type. The subject matter is the same in all; but both the overall composition and the individual motifs vary. First, let us compare the composition.

The Daigo-ji painting extends as one unit across the entire twelve panels: nineteen horses and riders gallop across gold ground and, here and there, blue and green grass. Other than this there are only the two spare horses and three grooms on the far right. The theme is plainly horse training, but the Domoto screen is another matter. Here, eighteen mounted pages cavort on a single sixfold screen; on the far left, we see three spare mounts and four grooms, a grove of trees and a pond; then, on the far right is a sprawling carpet laid for a lord on his stool and a retinue of twenty-two, with a few trees beyond. The complete composition seems to be present on the one sixfold; what the other screen showed is not known. Here, in addition to horse training there is a genre motif—the onlooking

samurai. The Taga work is a pair of screens, but the horse-training scene is on one—the right. (The left-hand screen is a separate stable painting. See page 127.) It has cherries blooming by a pool, and in the center three samurai train their steeds in the garden of a samurai residence. Three tethered horses and six samurai stand nearby. The master and his household watch from a room of the residence where a tea ceremony is in progress, the teamaster making tea and pages serving it. At the gates of the residence we see a gatekeeper and two other figures. The location of both the training and the spectators is within the grounds of the residence; moreover, there is the notable addition here of the tea ceremony—inseparable from military life in those days. Thus this work is richest in samurai-genre elements. The right-hand (horse-training) and left-hand (stable) screens of this pair are by one and the same artist.

Thus, we note a progression in the composition of these horse-training paintings, a certain development from the Daigo-ji to the Domoto and Taga screens, and a growing number of genre elements appearing in the process. It is fair to say that the horse-training genre began to be combined with other forms of samurai genre. (We will see later that similar developments occurred in the case of *namban* screens.) Still, it does not necessarily follow that the three screens were painted chronologically in the order of development. That is another problem.

DOG-CHASING CONTESTS Archery is an important martial art on a par with horsemanship. The dog-chasing contests and archery meets in genre painting command attention. We have as many as a dozen or more extant examples of the dog-chasing type, dating from the period from the end of Muromachi to the early days of Edo.

In the dogchase, the animals are shot at from horseback with arrows tipped with blunt wooden heads to avoid wounding the dogs. This and two other forms of horseback archery (*yabusame* and *kasagake*) formed the "great trio" of riding sports. The practice began in the Kamakura period (1185–1336) as a means of encouraging proficiency in mounted archery. It was generally thought that the dogchases ceased to be held with the Onin Civil War (1467–77) and were revived by the Shimazu family in 1622. Research by the art historian Kazuo Mochimaru, however, points out that Hosokawa Masamoto held one on a grand scale in Kyoto in 1489. (He was governor general of Kyoto at the time.) Another was held by the Asakura daimyo family of Echizen Province (modern Fukui Prefecture). The Machida *Rakuchu Rakugai Zu* screens, which depict the Kyoto of the 1520s, also include a dogchase scene. Thus it seems certain that dogchases were held at least up to the end of Muro-machi times. They may have been abolished after that, since no mention is made of them in Momoyama records. Moreover, the one held by the Shimazus was not in 1622, as popularly believed, but rather in 1646.

The procedure for a full, formal dogchase was as follows. A circular enclosure some forty meters in circumference was marked off with a rope within a walled-off contest area. This enclosure was called *o-nawa,* or "great rope." Then inside it, another, smaller circle was formed; into this an attendant would release the dogs, one by one, upon a referee's signal. The mounted archers lining the larger circle would then shoot their blunted arrows just at the moment when a dog, having left the smaller circle, was about to leave the big circle. When the arrows missed the mark, the chase was on. Each contestant was allowed three shots only, and a penalty was exacted for striking the head or legs. The shooting of each archer was judged by the referees on a points basis; a caller (*yobitsugi*) and signaler (*heifuri*) relayed the points scored to the scorer (*nikizuke*) for totaling. There were thirty-six archers divided into three groups of twelve each, and one hundred and fifty dogs per contest. Ten dogs were released for one round, the contest lasting fifteen rounds in all.

Extant dogchase paintings produced from the end of the Muromachi period until the dawn of the Edo period may be divided on the basis of composition into three broad categories with five subdivisions.

FIRST CATEGORY. One *tsukinami* genre painting, mounted with other paintings on a folding screen, in Tokyo National Museum; one copy of a painting by Tosa Mitsumochi for Kannon-ji Castle.

The Kannon-ji Castle painting is reproduced in *Kokushi Daijiten* (Dictionary of Japanese History), published by Fuzambo. According to this dictionary, Tosa Mitsumochi was commissioned by Lord Sasaki Yoshihide to do the (original) painting for the Hommaru, or principal compound, of Kannon-ji Castle in Omi Province (modern Shiga Prefecture) in May, 1550. At the upper left, in the contest area we see a scorer, caller, signaler, and a

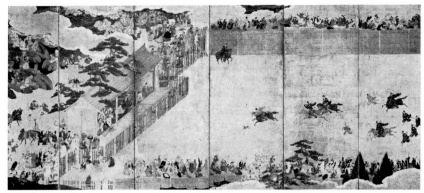

120. Dogchase; *Kano school. Single sixfold screen; colors and gold on paper, 154 × 362 cm. First half of seventeenth century. Tokyo National Museum.*

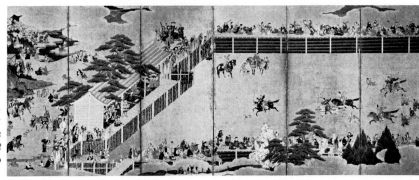

121. Dogchase; *Kano school. One of a pair of sixfold screens; colors and gold on paper; each screen, 153.5 × 366 cm. First half of seventeenth century. Tokyo National Museum.*

few onlookers. In the bottom left and upper right, respectively, are twelve and eight archers, and in the middle of the game area is a dog that has escaped from the large rope circle, three horsemen hot in pursuit. The dogman is about to release another dog into the large circle. Tosa Mitsumochi most likely saw one of these meets firsthand and the Tosa family probably had at least one painting of the sport for reference. It is a comparatively faithful depiction of an official contest. But besides the referees in and outside the circle there are thirteen archers on horseback and the smaller ring is not shown—which might be because it is only a copy.

The Tokyo National Museum work is part of a screen mounted with various *tsukinami* (events-of-the-months) genre paintings which are, to all intents and purposes, done in Yamato style, dating from the end of Muromachi. The dogchase scene we see mounted thereon is akin in composition to the Kannon-ji Castle painting, but there are only eight bowmen, and the dog is depicted just as it is leaving the larger circle.

In any case, this first category is of dogchase scenes painted in the late Muromachi period and the works in it are notable for documenting the sport, but it casts only an occasional glance in the direction of the spectators.

SECOND CATEGORY. 1) One pair of sixfold screens in the Tokiwayama Library (Fig. 71); one pair of sixfold screens in the John Powers Collection (America). 2) One sixfold screen in the Tokyo National Museum (formerly in the Imperial Household Collection; Fig. 120); one pair of sixfold screens in the

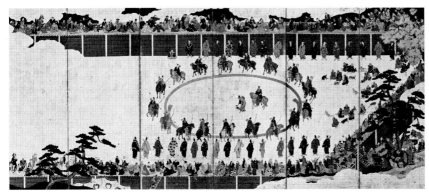

122. Dogchase; Kano school. One of a pair of sixfold screens; colors and gold on paper; each screen, 151.5 × 357.5 cm. First half of seventeenth century. Akagi Collection, Okayama Prefecture.

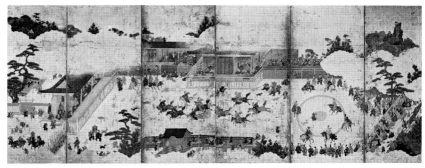

123. Dogchase. One of a pair of sixfold screens; colors and gold on paper; each screen, 129.5 × 353 cm. Mid-seventeenth century. Hosomi Collection, Osaka.

Tokyo National Museum (Figs. 33, 121); one pair of sixfold screens in Nezu Art Museum; one pair of sixfold screens in the Akagi Collection (Fig. 122); one pair of sixfold screens in the Fujioka Collection.

At first glance the paintings in each of the two subdivisions of this category seem to be almost identical to one another in composition. And indeed, there is also a close relationship between the two types. This is true of the techniques used, too, and there seems to be no doubt that these dogchase paintings were executed by artists of the same tradition and stem from one model.

The paintings of both subdivisions are sixfold screens with gold ground and have a large depiction of a horse paddock in the center. The right-hand screen shows the archers, mounted with bows at the ready around the large rope circle, and the

dogman about to release the dog; the left-hand screen has the dog outside the large circle, being chased by a mounted group of aiming archers. There is another common feature. In addition to the seventeen mounted archers, there are two groups of seventeen archers each, on foot, lined up along the contest-area walls at the top and bottom, respectively, awaiting their turn.

There is, however, a difference between the first and second subdivisions in the numbers and appearance of the archers on the left-hand screens. But the most noticeable difference between the two types is that in the first there are small groups of onlookers watching here and there from the top of the wall or over the fence, whereas in the second we have a crowd of five hundred or more spectators. Moreover, the far left on the left-hand screen has

the added interest of the bustling activities outside the actual contest grounds. Thus, the paintings of the first type place priority on the samurai participants while those of the second also show an interest in the appearance and behavior of the spectators of all classes. For this reason, the second type can be regarded as a kind of "samurai and ladies' amusements" painting borrowing from the dog-chasing theme.

The Tokiwayama screens (Fig. 71) emerge as having the best technique of either group. The unique handling of the pines and other trees, the figures, especially the rich expressions of the old men in the scorer's stand on the far left, make it much like Kano Sanraku's *Battle of the Carriages* (Fig. 72). The similarity as well as allusions to it in records make a strong case for Sanraku's having painted the Tokiwayama dogchase screens. Sasaki Gen'yu's biography of Sanraku in the Kano *History of Japanese Painting* states that the artist first heard of the sport from old men; and in the same history the Tokiwayama work is called the first of his paintings of dogchases. The likelihood is that the meets had been stopped during Momoyama as noted above, since Sanraku had to rely on old men for his information. This is why, though the authentic rules call for three groups of a dozen contestants for a total of thirty-six, the first and second subdivision paintings have seventeen to a group for a total of fifty-one participants in all. Aside from this, they adhere to the standard rules and regulations for dogchases.

As for the dating of the Tokiwayama screens, the Sanraku style suggests the period roughly between 1610 and 1624. The screens in the John Powers Collection of the same subdivision are almost a perfect copy, only diverging from the model in changes of color and design of people's garments. The strong stylization of trees and shrubs and the gold clouds intersected by many horizontal lines at the extreme upper left make it seem likely that the work is by a Sanraku student who probably painted it somewhere between 1633 and 1644.

Among the five screens in the second subdivision, the Tokyo National Museum painting (single six-fold screen, right screen missing; formerly in the Imperial Household Collection; Fig. 120) is the most outstanding and was produced the earliest. It is a fresh departure from the Tokiwayama screens, even while using them as a model, and includes a milling crowd of over five hundred spectators (with a sprinkling of Europeans). The execution of the trees and so on is reminiscent of Sanraku and I would date the work around 1615 to 1630. The Akagi (Fig. 122) and Nezu screens agree extraordinarily even in minute details and must, therefore, be from the same brush. The left-hand screens have nearly the same composition as we saw in Figure 120. But there is a smaller number of people, brighter clothing, and more pronounced tree stylization. The Akagi screens have two mounted referees (without bows or arrows), while in the Nezu work the referees have been turned into archers—probably an oversight in the copying. These latter two may have been modeled after the Tokyo screen of Figure 120 and are possibly from the Sanraku school, dating from the Kan'ei era (1624–44). A pilgrim in the Fujioka screen wears a straw hat with the characters for Kan'ei written on it, from which it is surmised that this work, too, was executed between 1624 and 1644.

The next screen (Figs. 33, 121) of the second subdivision is also in the Tokyo National Museum and is based on the screen shown in Figure 120. Here the number of people is reduced even more. (The number of people on the wall at the top of the left-hand screen is sixty-five for the painting of Figure 120, sixty-six for the Akagi screens, and fifty-one for the present work.) The artist has made a considerable effort to tidy up the composition. (Note the treatment of the pond area, the mountains in the distance, the addition of gold clouds.) The left-hand screen has no referee in the contest area (they have been turned into archers with bows and arrows), and there is a horse being watered also. This would seem to indicate the artist never saw the real thing, and was in fact simply using the dogchase theme as a vehicle for a genre painting. So we can reasonably date it the latest of the five in the second subdivision.

124. Detail from Women's Entertainments. *Pair of sixfold screens; colors and gold on paper; each screen, 153 × 363 cm. First half of seventeenth century. Yamato Bunkakan, Nara.* ▷

the work. One samurai sits on a scarlet carpet with his left shoulder and torso bared, about to release an arrow. Near him we see attendants whose function is to hand arrows and spare bows to the contestant. A samurai in a *jimbaori* campaign vest is motioning with his fan to the target area. A large gathering watches intently from vantage points on the lawn and in the building. The painting can be regarded as a kind of famous-place painting with the Sanjusangen-do as the main attraction. But it is a single sixfold screen, so it may be one of a pair of samurai genre screens, the missing one possibly having scenes of horse training or other martial arts. It appears to have been painted by a Tosa artist around 1615.

Among samurai genre paintings, the most popular were those that combined horsemanship and archery, such as hunting. The only work that survives —*Grand Hunt at Mount Fuji* (Fig. 15)—is one among several paintings fixed to a single screen now in the Tokyo National Museum. Here we see the scene with the famous samurai Nita Shiro riding a boar backward, so the work is probably based on the traditional composition of historical genre painting. Although we have no hunt paintings showing Japanese contemporary customs, this theme in an exotic setting was quite often depicted on screens and *fusuma,* for instance *Tartars Hunting* (Figs. 50, 51; one screen of this pair shows a hunt, while the other shows polo). These screens are thought to be the work of Kano Soshu (?–1601). Another like it comes down to us with the seal of Genshu (probably Soshu's son Jinnojo). The samurai of the period must have felt a kind of closeness to these paintings of Tartars hunting. The fact that artists did not produce paintings with the Tartars replaced by samurai in contemporary attire was probably because hunting of this sort did not exist in the Momoyama period.

The hunting enjoyed by Nobunaga, Hideyoshi, Ieyasu, and other generals was falconry. The scale of Nobunaga's falcon hunt at Mikawakira rivaled that of the grand hunt held by Minamoto Yoritomo (1147–99) at the foot of Mount Fuji. And in 1577, before a hunt in the Higashiyama hills, Nobunaga is said to have mesmerized all Kyoto by the magnificence of the party he led in dazzling garments to the Imperial Palace. But no painting of such a large-scale falcon hunt is extant. About all we have of falconry paintings is one sixfold screen forming a pair with *Cherry-Blossom Viewing* (Fig. 132) by the Unkoku school, and another pair of sixfold screens by Kusumi Morikage in the collection of Eiichi Kuroda, Tokyo. Both of them depict the simple falcon hunts of provincial samurai.

The diary of the poet-courtier Nakanoin Michimura records that shortly after the summer siege of Osaka Castle in 1615, Michimura was presented with a screen painting of the siege of Osaka Castle by Kano Koi (who was Mitsunobu's greatest pupil). There are also extant similar screens of various battles of the day—*Battle of Nagashino, Battle of Nagakute, Battle of Sekigahara,* and *Osaka Campaign.*

Scrolls bearing war scenes were being produced as far back as the Heian period (794–1185), and at the end of the Kamakura period (1185–1336) we find such documentary-type work as the *Mongol Invasion Picture Scroll.* Moreover, at the close of the Muromachi period (1336–1568), large historical paintings of famous battles of old, based on the composition of the scroll versions, often decorated screens and sliding partitions. Extant examples are the *Hogen-Heiji Battle Screen* (Metropolitan Museum of Art, New York), *Battle of Ichinotani* (Chishaku-in temple, Kyoto), and *Battle of the Gempei War* (originally a *fusuma* painting, but now mounted as a hanging scroll at the Akama Shrine, Shimonoseki City), among others. The *Battle of Sekigahara* screen and others mentioned above are not altogether outside this tradition, but now contemporary battles are depicted on large surfaces. Which is to say they were probably appreciated not only as pictorial records of war but also as samurai genre.

Of the extant works, the *Battle of Nagashino* screen, featuring horses and firearms, and *Battle of Nagakute,* depicting the famous battle between Hideyoshi and Ieyasu, were probably produced in the Edo period, judging from the style. The Tokugawa family was proud of these battles, and a whole series of copies of the original paintings must have

The paintings of this subdivision thus would appear to have had their origin with Sanraku, who investigated the by then long-discontinued sport of dogchasing and produced a genre painting on a pair of sixfold gold screens, which his disciples in the Kyoto Kano school adopted as a theme for the genre painting that was their special province.

THIRD CATEGORY. 1) One sixfold screen in the Tokyo National Museum (formerly Imperial Household Collection); one sixfold screen in the Ogihara Collection. 2) One pair of sixfold screens in the Hosomi Collection (Fig. 123); one pair of sixfold screens in the Amagasaki Collection.

The two screens of the first subdivision have only one side of a pair. One dog is running in the open and another is seen scampering about the circle in the contest area. The Tokyo National Museum screen of the two dates from the eighteenth century (mid-Edo period). It seems to be the product of an artist unversed in what actually went on at a dog-chase and unfamiliar with the old paintings on the subject. The next of this category, the single Ogihara sixfold screen, is the older of the two, dating from the middle of the seventeenth century. It is by a town painter connected with the *kanga* tradition, and concentrates more on the representation of the watching crowd than the ostensible theme of the dogchase, thus carrying even further the tendency we saw in the painting of Figure 121. What was depicted on the missing screen of the pair is not known.

Just as with the screens of the first subdivision, the left-hand sixfold screen of the two screens of the second subdivision has one dog in the circle and another running away outside it; the right-hand screen of the pair shows archers and dogs entering the contest area. The Hosomi screen (Fig. 123), in particular, gives a detailed picture of many samurai watching the contest from a building in a style reminiscent of a daimyo's residence. This may reflect some connection with the Shimazu family's revival of the sport in Edo in 1646. The clear class separation of the watching samurai and commoners is interesting.

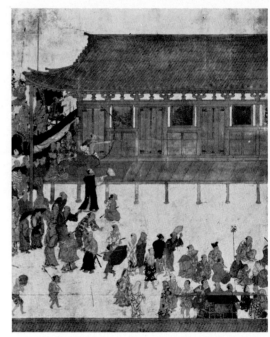

131. *Detail from* Toshiya at the Sanjusangen-do. *Single sixfold screen; colors and gold on paper, 161.5 × 364 cm. First half of seventeenth century. Itsuo Art Museum, Osaka.*

TOSHIYA, HUNT, AND BATTLE PAINTINGS The next type of samurai genre also has archery as its theme. *Toshiya* is a form of archery competition in which the participants have to shoot arrows a predetermined distance, and the winner is decided by the number of arrows that reach this distance. *Toshiya at the Sanjusangen-do* (Fig. 131; single sixfold screen) is an example of a *toshiya* genre painting. The competition held at the Sanjusangen-do hall in Rengeo-in temple, Kyoto, became famous after 1606. Throughout the Edo period, archers from all over Japan came to try their skill. The Sanjusangen-do also appears in the *Rakuchu Rakugai Zu* screens at the Tokyo National Museum (Fig. 64), and these, too, show a *toshiya* competition in progress. But in the present painting we see the full length of the hall from the side, and the *toshiya* is the central motif of

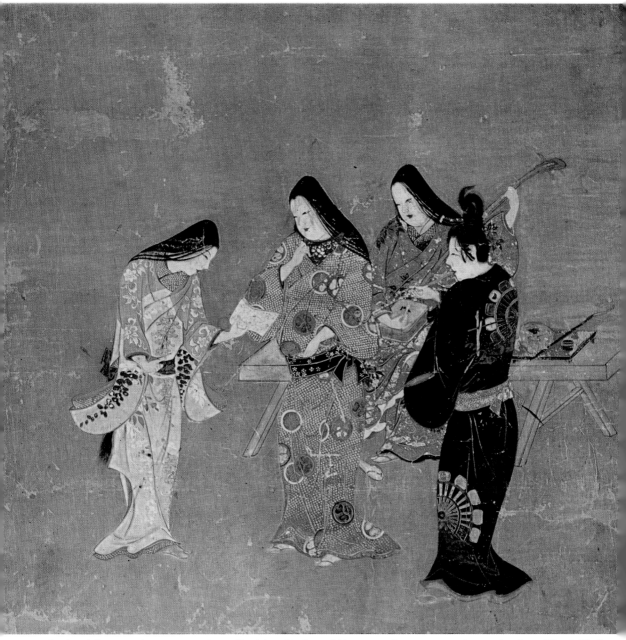

130. Detail from The Story of Honda Heihachiro. *Single twofold screen; colors on paper, 72.7 × 157.5 cm. First half of seventeenth century. Tokugawa Art Museum, Nagoya.*

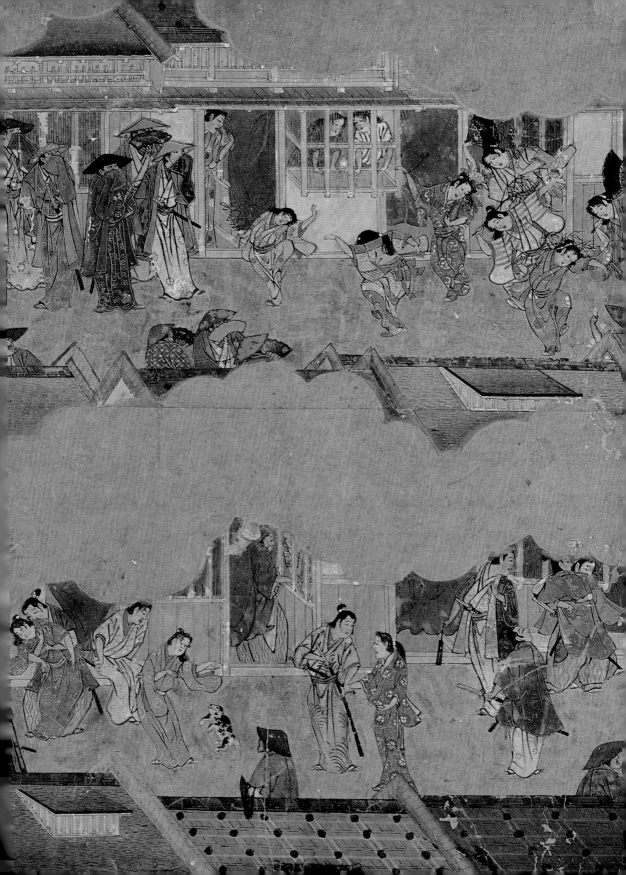

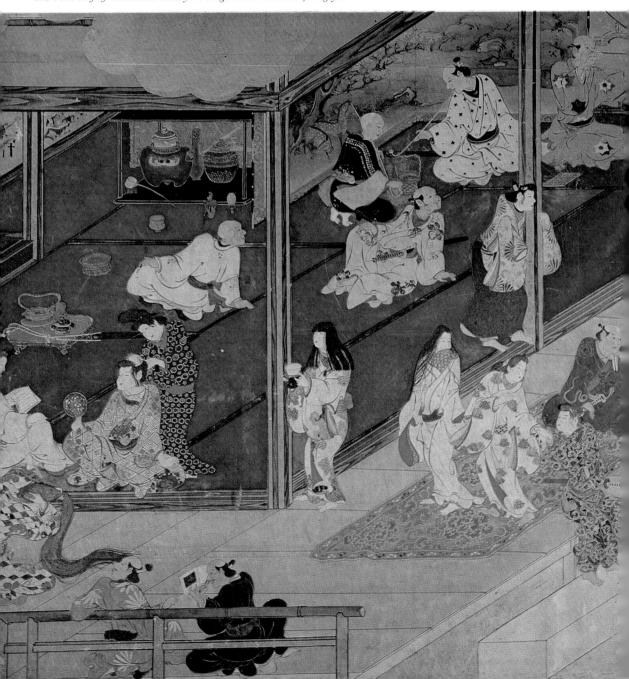

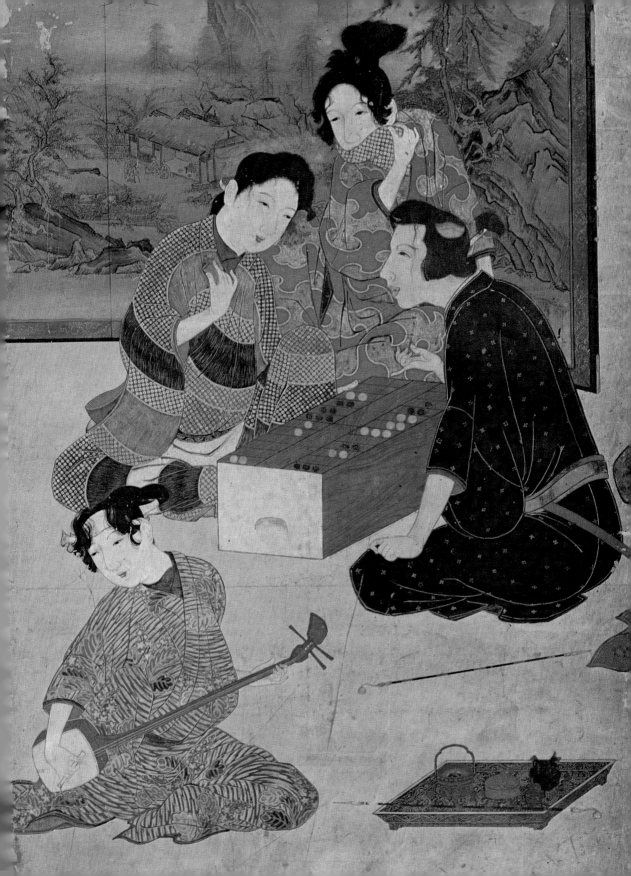

127. Detail from Hikone Screen; Kano school. Six panels originally in the form of a folding screen; colors and gold on paper; each panel, 94 × 48 cm. First half of seventeenth century. Ii Collection, Shiga Prefecture.

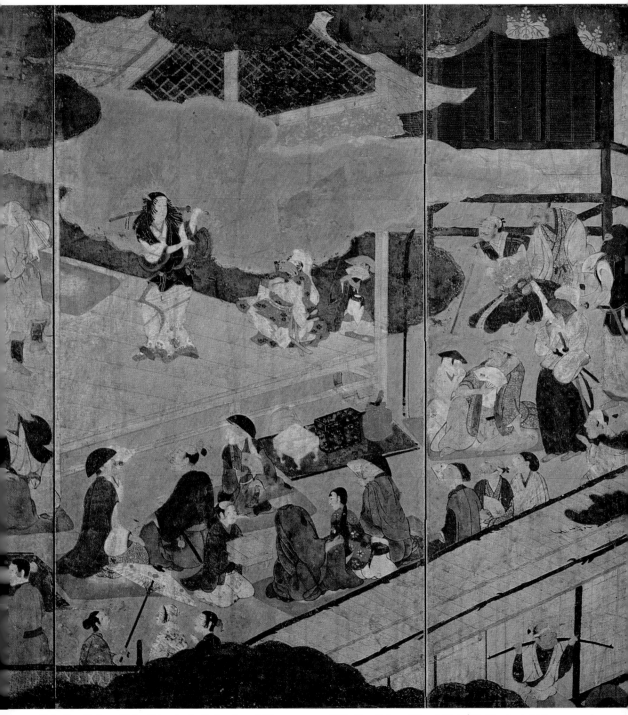

◁ 125. *Detail from* Shijo Riverbed. *Pair of twofold screens;
colors and gold on paper; each screen, 164.5 × 172 cm. First
half of seventeenth century. Seikado Library, Tokyo.*

126. *Detail from* Okuni Kabuki. *Single sixfold screen; colors
and gold on paper, 87.8 × 268 cm. Early seventeenth century.
Yamamoto Collection, Hyogo Prefecture.*

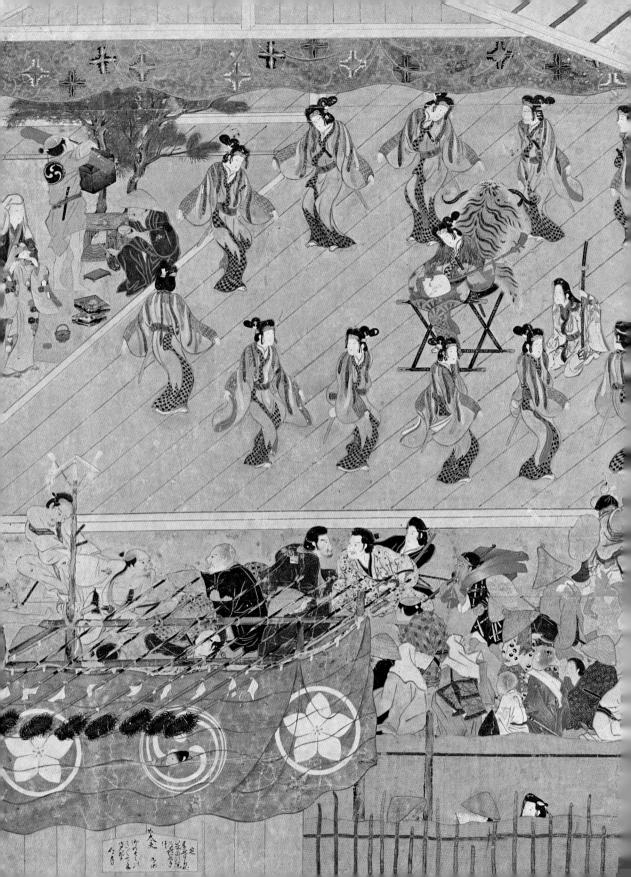

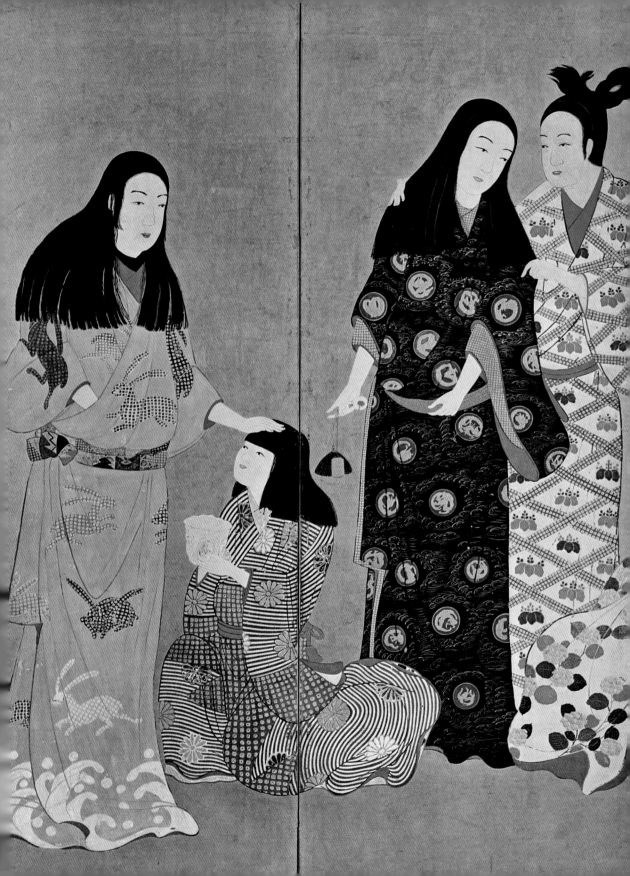

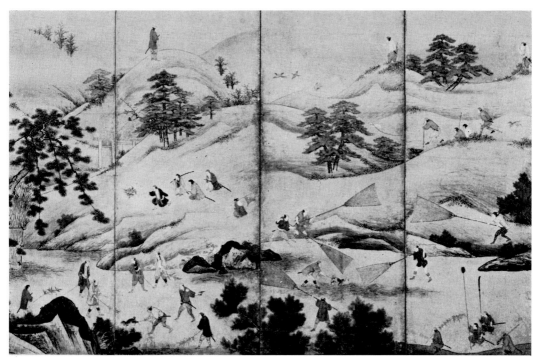

132. *Detail from* Cherry-Blossom Viewing and Falconry; *Unkoku school. Pair of sixfold screens; the illustration here is from the falconry screen, the other screen (Fig. 138) shows the cherry-blossom viewing scene. Colors on paper; each screen, 142.7 × 345.4 cm. First half of seventeenth century. Atami Art Museum, Shizuoka Prefecture.*

been made. (Figure 116 shows a detail of one such copy.)

The painting of the fateful battle of Sekigahara between Tokugawa Ieyasu and Ishida Mitsunari (Figs. 37, 56, 111), once lost, has been rediscovered recently. It is a pair of eightfold screens and shows the historic battle of the fourteenth and fifteenth of September, 1600, from the Tokugawa point of view. The right-hand screen shows, on the right, Ogaki Castle, in which part of Mitsunari's army was, and on the left, the area from Mount Kokuzo to Akasaka, where the Tokugawa army was encamped. The center shows a skirmish between parts of the two armies. The left-hand screen of the pair shows the decisive battle on the fifteenth. From the lower right, where the Shimazu camp is shown in flames, to Mount Ibuki on the upper left, where

Ishida Mitsunari was captured, the Tokugawa army is shown winning the day. But the painting gives the impression not so much of a realistic overall representation of the fierce battle as of a collection of meticulously detailed, beautifully colored men and horses, gorgeously deployed over the whole painting. Thus the work could be interpreted as using the theme of the battle as an excuse for a samurai genre painting, rather than as a documentary painting of war. The distinctive style tells us it is the work of Tosa Mitsuyoshi (1539–1613) or his associates.

The *Siege of Osaka Castle* screens (Figs. 35, 57) feature the summer siege of 1615 on both the right- and the left-hand sixfold screens. The extreme right of the former catches well the overwhelming strength of the Tokugawa forces as they come

swarming into the castle. The left-hand screen shows the fighting in the city, the opposing forces in flight, with here and there, faithfully represented, townspeople fleeing with their children and a few belongings. Whereas the right-hand screen could be called a record of war, the left-hand one presents us with a graphic genre scene of the great confusion of those caught up in the conflict (Fig. 57). The two screens of the pair seem to have been painted by different artists, but the peculiar brushwork of either suggests painters not affiliated to any of the established schools. (The Kuroda family owned the screens for a long time, and there is a tradition in the family that Kuroda Nagamasa, who took part in the battle, commissioned an artist by the name of Hachirobei or Kyuzaemon to do the painting.) The screens date from around the second to fourth decades of the seventeenth century. I should mention here that there was another famous screen painting of the siege of Osaka Castle, at one time in the possession of the Mogami family, which was painted by an artist of the Kano school.

HIDEYOSHI'S BLOSSOM VIEWING

Toyotomi Hideyoshi sponsored many magnificent events, such as the grand tea ceremony at Kitano (October, 1587), the imperial visit to the Juraku-dai (April, 1588), the cherry-blossom viewing at Yoshino (February, 1594), and a similar event at Daigo (March, 1598). Always ready to engage in self-propaganda, Hideyoshi had five Noh plays composed in 1594 with himself as the hero. From this it seems likely that paintings of the events he held would also have been commissioned of certain painters so as to commemorate the man and the occasion for future generations. The paintings of the first two historic events do not survive, but we do have *Cherry-Blossom Viewing at Yoshino* and *Cherry-Blossom Viewing at Daigo*.

Cherry-Blossom Viewing at Yoshino (Figs. 54, 112) is a pair of sixfold screens with one scene carried through on all twelve panels. The subject is Hideyoshi's visit to the Zao-do temple with Hidetsugu (chief adviser to the emperor), nobles, and generals in train. The flowery mists of cherry blossoms envelop the mountain, and we see Hideyoshi in his splendid palanquin, wearing brilliant garments and headdress, around him his colorful entourage (Fig. 112); also included are numerous onlookers, people dancing happily beneath the blossoms, and rows of busy shops on either side of the road (Fig. 54). The screen is a veritable mine of genre motifs. One opinion holds it to be a work of Kano Mitsunobu. If so, it is quite possible he was in the company making the trip to Yoshino. But the attribution should not be made prematurely.

The *Cherry-Blossom Viewing at Daigo* (Figs. 32, 53) painting makes a pair with a sixfold depiction from *The Tale of Genji,* and shows Hideyoshi—wives and concubines trailing—visiting tea houses set up by the generals. Samurai stand guard on the fringes of the scene. Hideyoshi has aged markedly now; this party is one of his last flings and it appears to have been held under heavy protection: samurai carrying firearms and bows. It has been described, therefore, as a rather overorchestrated, forced bit of funmaking, and that is exactly the impression one receives. The brilliance and bumptious merriment of the Yoshino screen are missing. The figure of Hideyoshi is symbolic—tottering along in his gorgeously colorful costume. The *sumi*-ink treatment rounding off the rocks shows the influence of Kaiho Yusho; perhaps the artist was an eclectic town painter who drew from the styles of many schools in developing a unique style of his own. It is unlikely, however, that Hideyoshi would have commissioned any painter to record the Daigo event. It is interesting to note that the screen was appreciated paired with a *Tale of Genji* painting.

The Maekawa screen antedates the Kita-in work and shows something of the older Tosa style. But in the Kita-in work, the artist has completely reworked the composition so as to conform to the Kano style. The Suntory screen seems to be a copy of it. Thus this type of genre painting immediately became stereotyped and its popularity spread.

What I find fascinating about the Kita-in work is that a house with a tile roof turns up in eight of the twenty-four pictures: the armorer, arrowmaker, gold lacquerer, furrier, weaver, spinner, dyer, and fanmaker. This means that these craftsmen were the most prosperous ones.

RICE PLANTING AND DRAPERS

Among the miscellaneous paintings mounted on the eightfold screen mentioned on page 154 in connection with hunt paintings are two works dealing with the everyday life of common people. One is *Transplanting Rice* (Fig. 11), and the other is *Draper's Store* (Fig. 63). We can say that these two symbolize rural and urban prosperity, respectively. *Transplanting Rice* shows a gay scene, with a large number of girls working in the paddies, and nearby, men performing the ritual *dengaku* dance to the accompaniment of drum and flute. Like scenes had sometimes appeared before on scrolls, but here, as the main theme of the painting, the scale is larger, and we can see how interest in genre themes had grown by the end of the Muromachi period, when these paintings are thought to have been produced.

However in the following Momoyama period no rice-planting scenes turn up as the main theme on screen paintings. We have only marginal treatment on *Rakuchu Rakugai Zu* screens, and a somewhat larger treatment in the *fusuma* genre painting in the Taimensho reception suite of Nagoya Castle (Fig. 2). This may be because interest in genre began to be concentrated on town scenes about then.

But even with paintings of draper's stores, which are town scenes, the lively bustle that we have in the late-Muromachi *Draper's Store* (Fig. 63) is not to be found in the *Rakuchu Rakugai Zu* at Tokyo National Museum (dating from the Momoyama or early Edo period), although this also shows many draper's shops. Furthermore, no screen paintings having a draper's shop as their main theme were produced in the Momoyama period.

On balance, it would seem that Momoyama-period artists either enthusiastically introduced motifs taken from the everyday lives of all kinds of common people into *Rakuchu Rakugai Zu* screens or contented themselves with having created the *shokunin-zukushi* genre. For the rest, they simply followed the earlier compositional schemes.

Farmwork of the Four Seasons (Daijo-ji temple, Ishikawa Prefecture) is a screen painting by an artist of the Kano school, and dates from about 1596–1615. This work does include a rice-transplanting scene, but it is a Chinese-style painting in the *kanga* tradition of the Muromachi period. The brilliant colors on gold and introduction of a Japanese farming landscape are innovative, but the peasants are after all Chinese in appearance. It was not until Kusumi Morikage of the early Edo period that we encounter seasonal farmwork screens that are genuinely Japanese. Morikage is known for paintings like *Enjoying the Evening Cool Under the Moonflower Trellis* and *Tea Harvesting at Uji*, which are superb genre screens of the "farming village" type, entitling him to be called the originator of the Japanese seasonal-farmwork genre. But at the same time, Morikage was still doing Chinese-style traditional seasonal-farmwork screens, and we must not overlook the fact that the idea of a Japanese version of this genre was derived from these.

A tradition in subject matter is surprisingly stubborn. Painters pry themselves away from an old one and create a new one only with great difficulty.

The *Weavers* screen at the Atami Art Museum (Fig. 134) is an early-Edo work. The main theme is ordinary people at work. This is rare for works other than *shokunin-zukushi* paintings. The women are, it is true, hard at work weaving. But the accent is on the women, not the work. The beautiful feminine form claims the spotlight, as in the famous Hikone screen (Figs. 86, 127), where the traditional theme of the four accomplishments is used as a foil for female beauty. The original aim of paintings deal-

nobu), differences in occupation are symbolized only in what the figures have in their hands. This is in the portraiture tradition of the "major poets" genre. What is epoch-making is the exclusive depiction of a great number of common people and trades, but it must be faulted for excessive allegiance to the "major poets" tradition and to the *uta-awase* form. In the end what we have, instead of an action view of the workaday world, is a concatenation of stereotypes. The people treated only in passing in the earlier scrolls had more individuality.

COMMON PEOPLE IN RAKUCHU RAKUGAI ZU

The *Rakuchu Rakugai Zu* screen painting formerly in the Machida family dates from about the same time as *Poetry Competition in Seventy-one Rounds*. But unlike the latter with its many people of varied occupations who appear only within the limited framework of the competition, the Machida work is shot through with the life of people going busily about their actual work in the hubbub of downtown Kyoto. I pointed out earlier how this kind of painting brought together in a large synthesis the earlier forms of seasonal, *tsukinami*, famous-place, and professions painting, adding a fresh input of subject matter that made for a remarkable difference. The depiction of real life was picked up and expanded upon next in the Uesugi screens (Figs. 10, 67), then carried even further in the Tokyo National Museum screens (Figs. 64, 129) of the late Keicho era (1596–1615), where it reached its zenith.

The *shohekiga* genre paintings of the Hommaru Goten (master's residence) at Nagoya Castle are considered to be a development from *Rakuchu Rakugai Zu*. Included in these paintings were prominent scenes of carpenters, plasterers, drapers, a bathhouse (Fig. 3), itinerant entertainers, and street vendors (Fig. 62), and others. As we can see in the *shohekiga* of the Emman-in, paintings of the festival, famous place, and amusements genres also frequently had lively depictions of the everyday life of common people. Nevertheless, even when these had contemporary life as their main theme, their subject matter was by no means restricted to this.

SHOKUNIN-ZUKUSHI

In contrast, there is a form of genre painting called *shokunin-zukushi* (roughly, "all the professions"). This genre consists of sets of paintings depicting members of various professions at work, mounted on folding screens or framed. Long famous among them is the screen at the Kita-in temple in Kawagoe City, Saitama Prefecture. The paintings are mounted on a pair of sixfold screens, two to a panel, making a total of twenty-four. The professions represented are all taken from the manual trades. The sword grinder (Fig. 66) and textile printer (Fig. 65) are typical examples. Roughly about the middle of the sixteenth century, handicraft specialization advanced and *shokunin* came to signify exclusively those who plied the manual trades; and the choice of professions on these screens are a reflection of this. Whereas the *shokunin uta-awase* paintings were portraits of individual members of various professions, here we have detailed representation of activities in a small workshop, centered on the master. It is interesting that men, women, and even children are shown working together. It is as if the artisans had been lifted out of *Rakuchu Rakugai Zu* screens and given a more concrete treatment.

The reason why these artisan paintings emerged is that the trades were developing and craftsmen of various types began to attract attention. On the other hand, as the genre itself grew it was not uninfluenced by the earlier poetry-competition tradition. The very idea of a set of depictions of craftsmen was derived from the poetry-competition paintings. And the fact that nearly all the *shokunin-zukushi* paintings extant from this period have the same composition is also related to this.

Besides the Kita-in paintings, in the screen category we also have a painting in the Suntory Art Museum, and another one formerly in the possession of the Maekawa family. Among framed pictures there is that of the Okazoe family, and a few others. Each picture of the Kita-in screen carries the seal "Yoshinobu." This is believed to be the signature of Kano Yoshinobu Shoan (1552–1640).

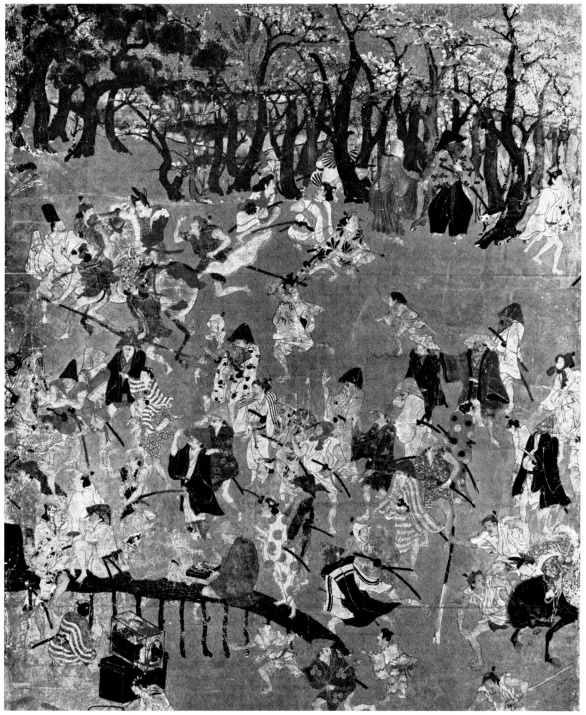

133. Detail from Horse Racing at Kamo Shrine. *Pair of sixfold screens; colors and gold on paper; each screen, 154 × 357.5 cm. Early seventeenth century. Kobayashi Collection, Kyoto.*

CHAPTER NINE

The Lives of the Common People in Genre Painting

POETRY CONTESTS OF ARTISANS As far back as the Heian period, glimpses of people working were to be found now and then on scrolls, sliding partitions, and folding screens. We see farmers and fishermen at work in many such paintings, for example, added as a touch of atmosphere to a pastoral scene; and artists included itinerant monks strumming lutes, peddlers of every sort, and small shops selling their wares along the way as foils to the traveling heroes of their scrolls. The *Pictorial Life of Saint Ippen* scroll (Fig. 17) of 1299 at the Kankiko-ji temple is renowned for the milling market crowd and the pathetic beggars thereabout. And scrolls illustrating the origins of shrines and temples often show carpenters, foundry men, and coppersmiths at work. But all these scenes are no more than a fraction of the whole. (An exception is the fish-shop scene on the late Heian-period sutra fan shown in Figure 19.)

In the Northern and Southern Courts period (1336–92), however, the *shokunin uta-awase* picture scrolls began to appear. These showed members of various professions (*shokunin*) and poems purported to have been written by them in poetry competitions (*uta-awase*). The occupations represented cover a wide range—from craftsmen, physicians, fortune-tellers, prostitutes, and itinerant entertainers to bean-curd and rice vendors. In fact, however, the *uta-awase* scrolls were an extension of the court tradition of poetry competitions, and the poems were written by courtiers. Nevertheless, the fact that the occupations of commoners were used as subject matter for *uta-awase* indicates how interested the courtiers were in the increasing social importance of commoners. The following are examples of *uta-awase* scrolls (see also foldout facing p. 56): A. *Tohoku-in Shokunin Uta-awase* (Poetry Competition at Tohoku-in Temple among Members of Various Professions); B. *Tsurugaoka Hosho-e Shokunin Uta-awase* (Poetry Competition at Hosho-e Festival at Tsurugaoka Shrine); C. *Sanjuni-ban Shokunin Uta-awase* (Poetry Competition in Thirty-two Rounds); D. *Nanajuichi-ban Shokunin Uta-awase* (Poetry Competition in Seventy-one Rounds). As we proceed from scroll A, through B and C, to D, we notice more and more people appearing and a richer selection of occupations. D is an early sixteenth-century scroll of a contest showing a spectrum of as many as 142 occupations, half of which are manual trades. This is an indication of industrial development, and in particular reflects the trend toward diversification of manual trades and toward independence of artisans in Muromachi times. Unfortunately, in all these scrolls (even D, which is traditionally attributed to Tosa Mitsu-

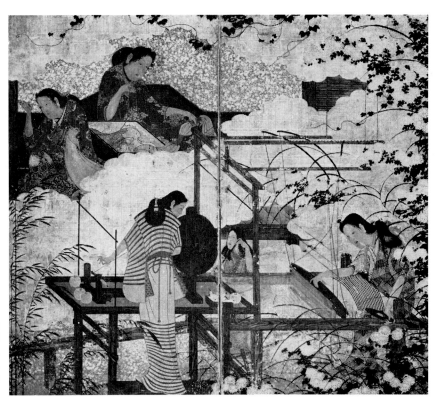

134. The Weavers. *Single twofold screen; colors and gold on paper, 151.2 × 171.2 cm. First half of seventeenth century. Atami Art Museum, Shizuoka Prefecture.*

ing with farming and weaving was didactic rather than aesthetic; and the same themes are found in the *kanga* tradition of Muromachi Japan. This surely influenced the choice of weaving from all the trades as a peg, so to speak, on which to hang feminine beauty.

VOTIVE PAINTINGS OF "RED-SEAL" VESSELS

Many of the so-called *namban* screens showing ships from abroad in Japanese harbors are extant (see Chapter Eleven), but only the four genre paintings at Kiyomizu Temple in Kyoto explicitly deal with the previously mentioned Japanese "red-seal" trade. These works were offered in thanksgiving for the safe voyages of the ships of the Sueyoshi family of merchants in 1632, 1633, and 1634, and for the 1634 voyage of the Suminokura family. All had come back safely from Tonkin (the present Hanoi, Vietnam), and the merchants aboard commissioned and presented the paintings upon their return to Japan.

These licensed vessels traded with Indochina, Luzon in the Philippines, Macao, Taiwan, and elsewhere between 1604 and 1635. Travel to foreign countries was banned in 1635. About 350 of these permits for trade and travel were granted in the space of thirty-two years. Over one hundred persons conducted this trade—daimyo, shogunate officials and samurai, powerful merchants, and others. It was the Sueyoshi merchant family of Osaka and the Suminokura family of Kyoto who

135. Okuni Kabuki. Four panels from single sixfold screen; colors and gold on paper, 87.8 × 268 cm. Early seventeenth century. Yamamoto Collection, Hyogo Prefecture.

undertook the most voyages. And so it is not surprising that their votive pictures remain.

The four votive paintings at Kiyomizu Temple have much the same composition, but the Sueyoshi ship painting (Fig. 61) is easily the best. At the top there is an inscription that reads as follows: "Yea, all our aims were attained. We were most blessed and satisfied. Upon return we gratefully offer this picture before the Buddha in the year 1632, this twenty-first day of December. Accepted by the temple authorities." Written on the hull of the ship

in the actual painting is the phrase: "From some of the passengers who sailed on the Sueyoshi ship." The picture depicts the ship at sea and shows the scene on deck. The captain is seen in a small deckroom gabled in Chinese style. The Westerners, sailors, and merchants in front of him are drinking, dancing, and playing backgammon. (The Suminokura painting shows people playing the shamisen and a game of cards.) The seal on the Sueyoshi painting (dating from 1634) identifies it as the work of the town painter Kitamura Chubei.

Festival, Famous-Place, and Entertainments Genre: An Overview

FESTIVAL PAINTINGS Festivals were the great joy of both town and country people, and it is only natural that such events were depicted in large numbers during the heyday of genre. The genre paintings on the partitions and walls of the Taimensho reception suite at Nagoya Castle have festival scenes, such as horse racing at Kamo Shrine, rituals at Yoshida Shrine, and the Sumiyoshi Shrine's Boat Festival. But it was the four types of festival paintings in particular—the Gion, Kamo, Hokoku, and Hie festival paintings—that gave the form a separate identity of its own in the large format of the folding screen. These broke new ground as well as setting the pattern for many subsequent paintings.

The Gion Festival is a festival of Kyoto's Yasaka Shrine. It goes by two names: *Gion-e*, or *Gion Goryo-e*, the latter signifying a ritual for placating the spirits of the dead. The festival originated in the Heian period, around 870, when a plague ravaged the town; the people invoked divine help through the use of Shinto festival floats called *hoko*. The *hoko* became more decorative each year, eventually turning into the famed *yamaboko* floats, and the

festival became very popular with the common people. The prototypes of the floats in use today existed even before the Onin Civil War (1467–77) and as many as fifty-eight are said to have been used in the festival. The event was discontinued during the war but revived in 1500 mainly through the energies of the emerging *machishu*, the *nouveaux riches* of Kyoto, who lavished all they could on the *yamaboko*. As symbols of *machishu* prosperity, the *yamaboko* decorations grew more gorgeous every year, and the procession of *yamaboko* came to be associated with the *machishu* almost more than with the shrine. A view of the festival right after its resumption comes down to us in the form of a reproduction of a *tsukinami* festival painting by Tosa Mitsunobu (Tokyo National Museum). And the great success of the event is clearly underscored by its inclusion in many *Rakuchu Rakugai Zu* screens.

Screen paintings with this festival as their main theme emerge in the Momoyama period. The earliest example is a pair of sixfold screens with a Gion Festival painting (Figs. 96, 109), now in the Idemitsu Art Museum. It can be taken for a Kano work from about 1596–1615. The right-hand screen shows the stream of huge floats of June 7; the

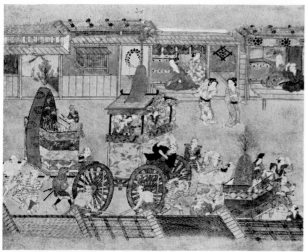

136. Detail from Gion Festival, *attributed to Hasegawa Kyuzo. Hanging scroll; colors on paper, 26.6 × 33.6 cm. First half of seventeenth century.*

137. Detail from Gion Festival, *by Kaiho Yusetsu. Single* ▷ *sixfold screen; colors and gold on paper, 116.4 × 316.2 cm. Mid-seventeenth century. Hachimanyama Preservation Society, Kyoto.*

left-hand screen depicts the second stage of the festival, on June 14, when the palanquin of the deity is returned. The picture gives us an excellent view of the town and the many customs and manners of the watchers along the route. It is as if it were a screen-size enlargement of a festival depiction in a *Rakuchu Rakugai Zu* painting. It is precise work with the spirit of gaiety surrounding the event wonderfully captured.

The dividing of the depiction into the two phases of the festival, one on either side, would be repeated in subsequent screens on the same theme. But this compositional approach of the Idemitsu work, giving us the festival parade and floats in the context of a larger backdrop of the *Rakuchu Rakugai Zu* type, would eventually bow out in favor of a narrower, sharper focus on the *yamaboko* floats and procession alone. We might find a good example of it in the Gion Festival painting by the early Edo artist Kaiho Yusetsu (1598–1677) that is in the Hachimanyama Preservation Society Collection (Fig. 137; left-hand screen of a pair of sixfold screens). Clouds divide the painting into upper and lower parts, with the upper section giving us the second phase of the festival from left to right—its famous parade of the mammoth *yamaboko;* the lower sec-

tion shows the procession of the palanquin of the deity. Along the same lines as this there is a pair of sixfold screens in the Omichi Collection that deals very minutely, even documentarily, with the movements of the *yamaboko* and palanquin of the deity.

There are also two scrolls in the Hosokawa Collection, early Edo works, that contain pictures of the Gion Festival. The festival painting (Fig. 136) attributed to Hasegawa Kyuzo (1568–93) was originally a scroll. Moreover, we have the cedar-door paintings (Fig. 150) at the Shoren-in temple, Kyoto, and one of the buildings at the Shugaku-in villa. Both are ascribed to Sumiyoshi Gukei (1631–1705). But by this time much of the genre interest has disappeared.

From ancient times, the horse race was one of the famous Kamo Festival events. It took place on the fifth of May and was looked forward to as one of the most popular events on the Kyoto calendar. There is also the Aoi (Hollyhock) Festival, a Shinto ceremony at Kamo Shrine that was also revived after the Onin Civil War, but not until 1695. The horse races, on the other hand, bounced back much earlier; they had broader-based support among the ordinary populace. Even Nobunaga and Hideyoshi

lent an enthusiastic hand to restart this event. The Kamo race is occasionally found in sections of *Rakuchu Rakugai Zu,* but it is thought that only from the Momoyama period on was it regularly adopted as a central theme. As mentioned earlier, *Horse Racing at Kamo Shrine* (Figs. 99, 133, 143) was probably done by a gifted town painter in the late sixteenth or early seventeenth century. This pair of sixfold screens, now in the Kobayashi Collection, has large-scale depictions of the sanctuary and inner precincts of Upper Kamo Shrine on the left side and the horse-racing grounds in the center of the right. We seem to savor the rousing enthusiasm of the race crowd as it wildly cheers the two galloping horses: the painting communicates marvelously. In addition to this screen, there is another like it in the Ohara Collection, which was done sometime between 1624 and 1644. It also shows the shrine sanctuary and precincts on the left-hand screen and the horse race on the right, but viewed from the opposite direction. The Ohara screens form one continuous view. The same thing can be said of the *Horse Racing at Kamo Shrine* (Fig. 8) we saw in the Taimensho suite at Nagoya Castle, which implies that the typical Kano approach to Kamo-horse-race paintings derives from the Ohara prototype.

And the Kobayashi work, diverging from the usual right-hand-screen perspective, achieves thereby a compositional freshness.

The Nishimura screen (Fig. 79) fits both the sanctuary and horse-race scenes of the Ohara screens onto one screen, leaving the other one for a Hie-Sanno Festival painting. I will devote a few remarks later to the Hie-Sanno scene, but here it is interesting to note this new development of mixing two festivals on one pair of screens. We have seen an instance of the method with the Taga Shrine screens combining a stable scene with one of horse training (Fig. 117).

The Hosomi family screen is similar to the Nishimura work in devoting one side to the Kamo horse race (the theme of the other side is unknown), but the sanctuary of the shrine is not seen. Here the race is everything.

These Kamo horse-race works developed like the Gion depictions, gradually cutting out environment and losing genre elements as time passed.

As explained earlier, the Hokoku Festival was a memorial festival for Toyotomi Hideyoshi held at his mausoleum in the Hokoku Shrine. Thus it was a relatively new festival, compared to the long-

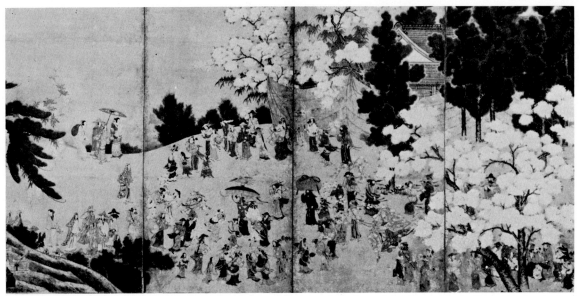

138. *Detail from* Cherry-Blossom Viewing and Falconry; *Unkoku school. Pair of sixfold screens; the illustration here is from the cherry-blossom viewing screen, the other screen (Fig. 132) shows the falconry scene. Colors on paper; each screen, 142.7 × 345.4 cm. First half of seventeenth century. Atami Art Museum, Shizuoka Prefecture.*

standing Gion Festival or Kamo horse-race events. Two pairs of screens deal with this event. One is now preserved at the Hokoku Shrine itself; the other is in the collection of the Tokugawa Art Museum. Another sixfold screen, formerly at the Chokokan Museum in Mie Prefecture, was destroyed in a fire. Both extant screens depict the huge swell of people participating in the special festival on the occasion of the seventh anniversary of the death of Hideyoshi (died August 18, 1598). This was probably the first pictorial record of the Hokoku Festival.

The screens in the possession of the shrine (Figs. 55, 98, 110) were commissioned of Kano Naizen (1570–1616) by Toyotomi Hideyori in commemoration of the great event, and were presented to the shrine. The right-hand screen has the mausoleum as a background to the festive cavalcade streaming in on August 14. The left-hand screen shows the Great Buddha Hall of Hoko-ji temple behind and two groups of dancers from north and south Kyoto respectively, performing the Hokoku Festival

Dance on August 15. In the inner precincts the artist includes some beggars and outcasts and an oblation ritual that takes place on the sixteenth. Both screens have rows of seats for spectators, and many are in their places, watching the goings-on.

The arrangement is almost the same in the Tokugawa Art Museum screens (Fig. 80), but the shrill quality and peculiar treatment are a near-startling contrast with the screens at the shrine. I have already discussed them at some length, so I will just summarize here. Whereas the work in the shrine is an objective, slightly removed overview of the festival, the Tokugawa Art Museum screens are a highly charged melee of people, horses, and frenetic dancing. They were painted somewhat after the shrine screens, possibly between 1615 and 1624.

The no longer extant Chokokan Museum painting had a Hokoku Dance scene on the left-hand screen, but it added various outdoor recreations in and outside the precincts of the Great Buddha Hall that are quite irrelevant to the festival itself. The tendency was to divorce themes from the festival, a

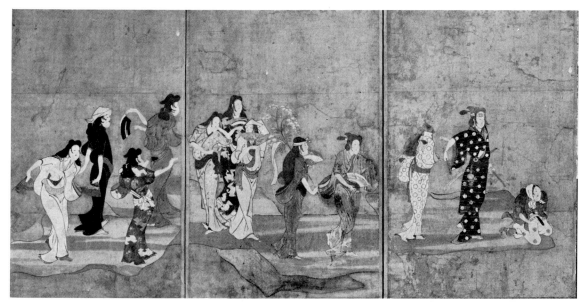

139. Three panels from Courtesans' Entertainments. *Single sixfold screen; colors and gold on paper; size of whole screen, 95.8 × 342.4 cm. Mid-seventeenth century.*

tendency inextricably connected to the downfall of the Toyotomi family in 1615, which must have been a big factor in the discontinuation of the festival itself, too.

Hie Shrine is the residence of the tutelary deity of Enryaku-ji temple on Mount Hiei. Faith in this deity grew as the Tendai sect of esoteric Buddhism flourished, and the devoted followers ranged through all classes—from the court to the common people. When the monks of Enryaku-ji made their appeals by force to the court (tenth to twelfth centuries), they bore the portable shrines (*mikoshi*) of Hie Shrine. Hie Festival (also called Sanno Festival; one name for the deity was Sanno Gongen) was held in April. Its popularity was on a par with the Gion Festival. Oda Nobunaga attacked and burned Enryaku-ji, putting a stop to the Hie-Sanno Festival for a time, but it was revived in 1591.

The oldest large-scale depiction of the festival is the pair of fourfold screens (formerly a *fusuma*

painting) now in the Danno Horin-ji temple (Figs. 58, 97). They are thought to be a work of the 1600s, and as mentioned earlier, are attributed to the orthodox Kano school. The portrayal is precise and the composition adept. The right-hand screen (Fig. 58) shows a group of sanctuaries within the precincts and a ritual procession bearing a sacred *sakaki* tree, suggestive of ancient traditions. The painting on the left-hand screen (Fig. 97) shows the boat festival and spectacular ferrying of portable shrines that was the festival's climax. Bearers brought these enshrined deities down from seven different shrines, struggling for precedence en route and finally swooping to shore to transfer the sacred burdens into boats for the crossing.

A pair of sixfold screens (Fig. 151) in the Konchi-in temple, Kyoto, pursues the same general theme. The boats and onlookers are seen approaching the shrine in the painting on the right-hand screen, while the left-hand one has the boats making off after receiving the *mikoshi*. As mentioned earlier, the Nishimura work has combined both of the

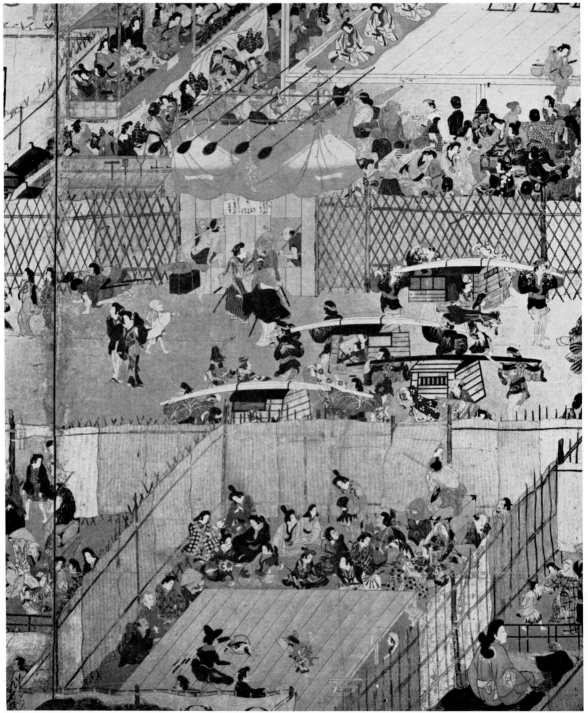

140. Detail from Shijo Riverbed. *Pair of twofold screens; colors and gold on paper; each screen, 164.5 × 172 cm. First half of seventeenth century. Seikado Library, Tokyo.*

above views on one screen and put a Kamo horse race on the other. I alluded to the excitement and dynamic impression generated by the whole; it is conceivably by the Iwasa Matabei school between 1624 and 1644. Finally, there is a pair of screens in the Suntory Art Museum that brings two scenes over to one side, as in the Nishimura screens. The screen is paired with a Gion Festival screen.

In conclusion, we can say that the focus in festival paintings of the Momoyama and early Edo periods began with an overall view of the festivities in general, narrowed to the festival climax, and eventually descended into rather lifeless documentary painting.

FAMOUS-PLACE AND ENTERTAINMENTS PAINTINGS

Famous places of Kyoto all received a certain coverage in *Rakuchu Rakugai Zu*, but Hideyori's *Maple Viewing at Mount Takao* (Figs. 12, 41, 42) is an example of a screen painting devoted to one famous place in particular. As the title suggests, the main motif of the screen is Mount Takao in autumn, but Mount Atago in winter is also shown. This suggests that the screen was originally one of a pair of screens of the "famous places in the four seasons" genre. The other screen would probably have shown the Higashiyama hills in spring and summer, with cherry-blossom viewing as the principal motif.

Famous Places of Higashiyama is a pair of sixfold screens in the Tsuruki Collection. It is thought to date from the late Momoyama period and shows, on one screen, the Kiyomizu Temple and Gion (i.e., Yasaka) Shrine in spring time, and on the other, entertainments at the Hokoku mausoleum and Great Buddha Hall in autumn. The seasons of seasonal painting have now shrunk to spring and autumn, and the famous places of the famous-place genre have been reduced to the Higashiyama hills. Again, in the *Toshiya at the Sanjusangen-do* of Figure 131 we have only spring and a single site—the grounds of Rengeo-in temple at the foot of the Higashiyama hills. And in *Kiyomizu Temple* (Fig. 147) at the Atami Art Museum there is only the temple in springtime and a Kabuki troupe. Of

course, each of the latter two screens is only one of a pair. There might have been views of Higashiyama in autumn on the missing companion screens.

In the Momoyama period the season was apparently always springtime, and the screens of this period combined cherry viewing and famous places. A pair of sixfold screens in the Hasegawa Collection showing Kyoto famous places has Kiyomizu Temple and Gion Shrine on the right and Kitano Shrine (Fig. 148) on the left. *Amusements at Higashiyama*, a pair of sixfold screens in the Kozu Collection, has Kiyomizu Temple and Yasaka Pagoda to the right and Gion Shrine to the left. It seems legitimate to describe these types as springtime outdoor-amusement painting with famous places for a backdrop. The movement in this direction gathers momentum with two pairs of screens called *Merrymaking Under the Cherry Blossoms*. One is in the Kobe Municipal Museum of Namban Art (Figs. 69, 100), the other in the Suntory Art Museum (Fig. 149). As I pointed out earlier, the composition is identical: the right-hand screen of both include the Gion Shrine, the left-hand one the Upper Kamo Shrine, as foils. The main motifs are the folk dance with many people in a ring and the sakè parties under the fluttering petals of cherry blossoms. The *furyu* dance of the right side includes some figures dressed as the gods of fortune, while the dancers in the circle of the left-hand screen include some figures prancing about in foreign costumes (Figs. 69, 149). Both these scenes are depicted on a large scale in the center and with brilliant effect. The fact that screens of identical composition are extant implies that this type of *Merrymaking Under the Cherry Blossoms* was very popular.

The *Dengaku Dance* of the Hosomi Collection (Fig. 70), a single sixfold screen, also has a dance under blooming cherries in the center foreground. But our famous place is nowhere to be had; it is all an outdoor-amusement scene now. Into this stream of famous-place genre turning into outdoor-amusements painting came Kano Naganobu's masterpiece—*Merrymaking Under the Cherry Blossoms* (Figs. 14, 68). Next, the *Cherry-Blossom Viewing and Falconry* pair of screens (Figs. 132, 138), which is at the Atami Art Museum, combined the merry-

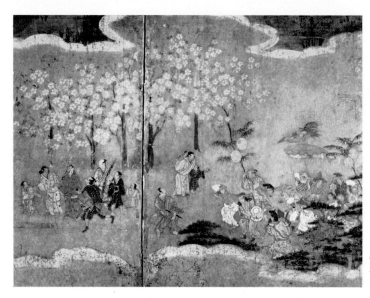

141. Detail from Dengaku Dance. *Single sixfold screen; colors on paper, 105 × 291 cm. Early seventeenth century. Hosomi Collection, Osaka.*

making-under-the-cherry-blossoms and falconry genres.

On the other hand, we have the early-Edo pair of sixfold screens in the Okuyama Collection (Fig. 87) by Kano Eino (1631–97)—*Arashiyama and Kiyomizu Temple*—which reverts to depiction of two famous spots in spring; but the genre elements are markedly few, and we have backpedaled into work of the famous-place or seasonal-landscape categories once more.

The Shijo riverbed, so bleak and barren in the Uesugi *Rakuchu Rakugai Zu* (Type one; late Muromachi), had come full circle by the end of the Keicho era (1596–1615). In the Tokyo National Museum *Rakuchu Rakugai Zu* (Type three) there is a cluster of stalls and stands, a great amusement zone of Courtesans' Kabuki, puppet drama, and Noh, all occupying an important position in the painting. By late Keicho the quiet riverbed had been radically transformed into the popular recreational hub of Kyoto. As a new famous place, so to speak, it became the main subject matter for

a number of screens, several of which are extant.

The pair of twofold screens in the Seikado Collection (Figs. 125, 140) has large executions of Courtesans' Kabuki—the "Sadoshima Grand Kabuki" in the upper right of the right-hand screen and the "Doki Kabuki" in the upper left of the left-hand screen. In the lower foreground are a "Giant Lady," and trained dogs are being put through their paces—dancing or jumping through a hoop—by a master dressed in exotic foreign costume. There are stalls for stunt performers, *shakuhachi* (bamboo flute) ensembles, and others, with all kinds of archery ranges and a number of tea stalls, too. Originally these twofold screens probably had further panels on either side and included much more. The single twofold screen in the Domoto Collection (Fig. 142) seems to have been first done as part of a *fusuma*. It shows stalls with an armless wonder—a woman who shoots arrows with her feet—peacocks, two puppets being manipulated, and a form of Courtesans' Kabuki called "Mataichi Kabuki." The Seikado and Domoto screens were painted around 1630, when Shijo riverbed was at

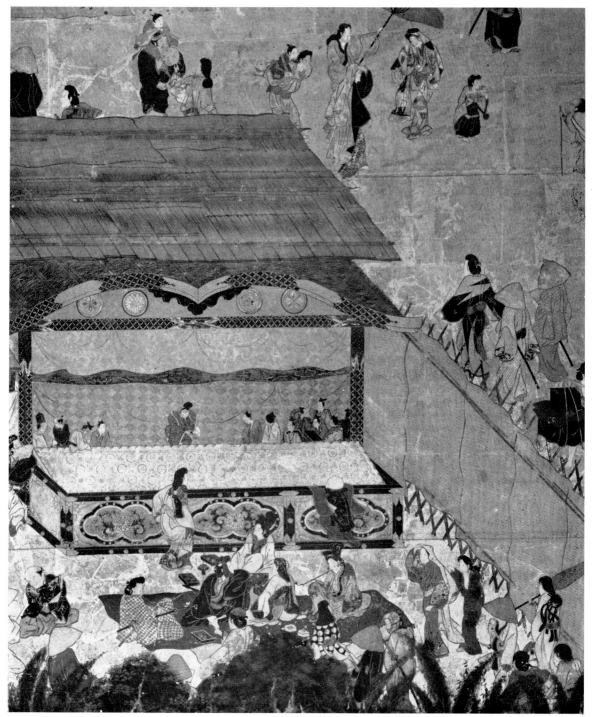

142. *Detail from* Shijo Riverbed. *Single twofold screen; colors on paper,* 152.2 × 157.2 *cm. First half of seventeenth century. Domoto Collection, Kyoto.*

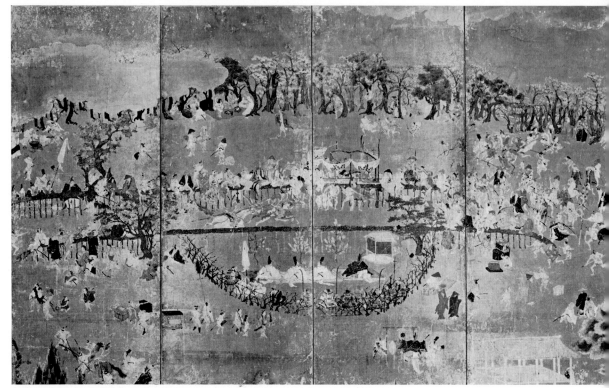

143. Horse Racing at Kamo Shrine. *Four panels from one of a pair of sixfold screens; colors and gold on paper; each screen, 154 × 357.5 cm. Early seventeenth century. Kobayashi Collection, Kyoto.*

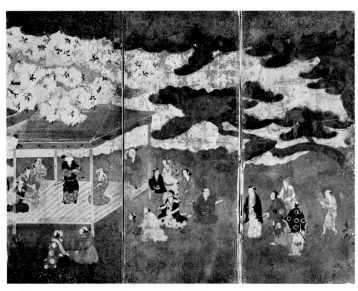

145 (opposite page). Detail from Women's ▷ Kabuki. *Handscroll; colors on paper; height, 37 cm. First half of seventeenth century. Tokugawa Art Museum, Nagoya.*

144. Detail from Okuni Kabuki. *Pair of sixfold screens; colors and gold on paper; each screen, 148.5 × 332 cm. First half of seventeenth century. Idemitsu Art Museum, Tokyo.*

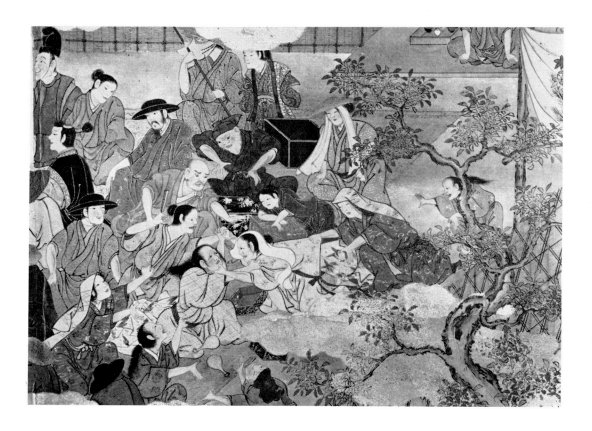

the height of its prosperity. As I reflected before, they are outstanding in their superb communication of an atmosphere of fun and enjoyment.

The Boston Museum of Fine Arts has a Shijo riverbed sixfold screen that contains an amazing range of action—acrobatics, tricks, exhibits, *sumo* wrestling, Noh, puppetry, Courtesans' Kabuki, and other entertainments. But the treatment is stereotyped and merely illustrative. It would seem to be by a town painter of around 1640. The trend to the explanatory, also seen with Gion Festival work, hastened the advent of picture scrolls treating this subject. There soon came Shijo-riverbed scroll paintings like that in the Kaneda Collection (c. 1700) or the one in the Suntory Art Museum.

Kabuki began in the spring of 1603 when a priestess from Izumo Grand Shrine, a certain Okuni, staged a "Kabuki Dance" at the Kitano Shrine in Kyoto.

Okuni Kabuki created a sensation in Kyoto with its titillating performance of women seductively cast in male roles, flirting with "tea-shop girls." By 1608 Okuni Kabuki had been staged even in Edo Castle. In its wake, the very similar Courtesans' Kabuki came to enliven the stalls along the Shijo riverbed (1615). This flourished until the shogunate proscribed it for reasons of public morality in 1629. The Kabuki seen depicted so generously in the Shijo-riverbed screens above is Courtesans' Kabuki. The entertainers are prostitutes from the gay quarters of Rokujo-Misujimachi whose gimmick was the use of the shamisen, newly introduced into Japan, for accompaniment.

Okuni Kabuki did not use the shamisen but only flutes and drums. It is portrayed in a *Rakuchu Rakugai Zu* screen owned by the Yamaoka family and also in a Kyoto famous-place painting of the Hasegawa family (Fig. 148), both of which seem to be of

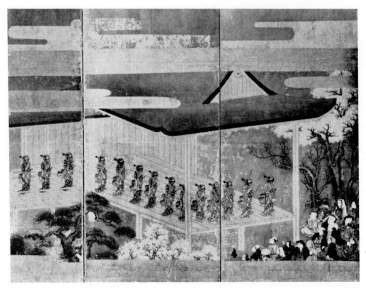

146. Detail from Men's Kabuki. *Pair of sixfold screens; colors on paper; each screen, 155 × 343 cm. Mid-seventeenth century. Otsuga Collection, Toyama Prefecture.*

around 1606. The Okuni Kabuki appears to take place in the precincts of the Kitano Shrine, the most famous spot of the several sites at which it is recorded to have been staged. The sixfold screen in the Uji Collection in Tokyo also has a large Okuni Kabuki scene on it, and Kitano Shrine, seen at the far left, is apparently the locale. The Idemitsu Art Museum has a single sixfold screen with an Okuni Kabuki painting (Fig. 144), which forms a pair with a screen showing a blossom-viewing scene probably in the Higashiyama hills in spring. This Kabuki painting is also thought to have been conceived as a genre depiction of Kitano in springtime.

But even apart from the seasons or setting—Takao or Shijo riverbed—Kabuki itself was a novel and fascinating field for an artist. Moreover, there was a growing tendency for the part to divorce itself from the whole: we saw before how outdoor amusements split from the famous places of the famous-place genre to stake claim to independence. So it would be no surprise if the Yamamoto sixfold screen (Fig. 135), with its Okuni Kabuki and spec-

tators as the only theme, had been painted as early as around 1606. There is a review of the forms and variations of Okuni's Kabuki dance in pictures with accompanying narrative (*e-kotoba*) now in the Kyoto University Library. It has striking similarities with the remnant of an Okuni Kabuki scroll in the Yamato Bunkakan. The Tokugawa Art Museum preserves a Women's Kabuki scroll (Fig. 145) with highly animated depictions of Uneme Kabuki dances and their enthusiastic audiences. (Uneme Kabuki was the successor to Okuni Kabuki.)

Courtesans' Kabuki was banned by the Shogunate in 1629 and Kabuki performed by young men (*wakashu*) emerged to replace it. But this too had its untoward side and was forbidden in 1652. Men's Kabuki (Yaro Kabuki) sprang to the rescue, bringing the dance to a new beginning as a drama form. One screen of the pair in the Otsuga Collection (Fig. 146) shows this new situation in Kabuki; the other screen has a *Courtesans' Entertainments.*

The most famous of Kyoto's gay quarters were at the old Gion-machi and Kitano's Kami-Shichiken,

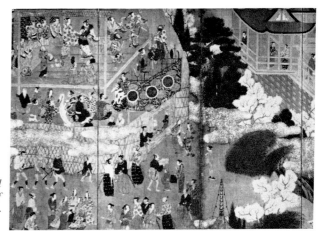

147. Detail from Kiyomizu Temple. *Single sixfold screen; colors on paper, 152.4 × 361.2 cm. First half of seventeenth century. Atami Art Museum, Shizuoka Prefecture.*

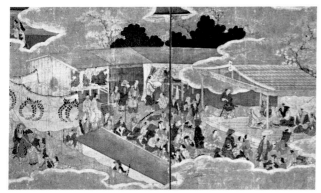

148. Detail from Famous Places of Kyoto. *Pair of sixfold screens; colors and gold on paper; each screen, 149 × 330.5 cm. First half of seventeenth century. Hasegawa Collection, Aomori Prefecture.*

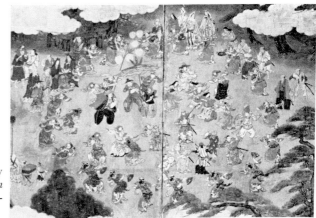

149. Detail from Merrymaking Under the Cherry Blossoms. *Pair of sixfold screens; colors and gold on paper; each screen, 151 × 352 cm. First half of seventeenth century. Suntory Art Museum, Tokyo.*

150. *Detail from* Gion Festival, *attributed to Sumiyoshi Gukei. Painting on cedar door; colors on wood, 170.5 × 84 cm. Second half of seventeenth century. Shoren-in, Kyoto.*

both situated on the fringes of the respective shrines, and the Shimabara area to the south of the city. But whereas the gaiety of Gion and Kitano began with the tea-shop girls of the sacred precincts, Shimabara, like Edo's Yoshiwara, was a district designed from the start for that purpose. Hideyoshi was the architect of the first gay quarters in the Kyogokumadeno-Koji section of Nijo-Yanagi. When the Nijo Castle was completed in 1602, the quarters were transfered south to Rokujo-Muromachi. The latter district was called Rokujo-Misujimachi up as far as Rokujo-Yanagimachi. But in 1640, everything was moved out—lock, stock, and barrel—to Shimabara, then called Shujakuno, in southern Kyoto. The Rokujo-Misujimachi period covered forty years from 1603 on, and it was a long and lively chapter in the history of Kyoto's licensed quarters. The *Rakuchu Rakugai Zu* in the Okayama Art Museum and that in Tokyo National Museum illustrate this chapter in detail. The Tokyo work especially is a spirited treatment of the openly fraternizing men and women at Rokujo-Misujimachi (Fig. 129). It was the prostitutes from these pleasure quarters who succeeded Okuni to perform what was known as Courtesans' Kabuki at Shijo riverbed.

In the two decades from 1624 to 1644, depiction of these pleasures ceased to be just a part of *Rakuchu Rakugai Zu*. They were given screens all to themselves. The *Banquet in a Brothel* screens in the Boston Museum of Fine Arts shows on one side the excitement in front of several latticed storefronts where trade is being drummed up, while on the other there is a banquet inside a huge brothel where the

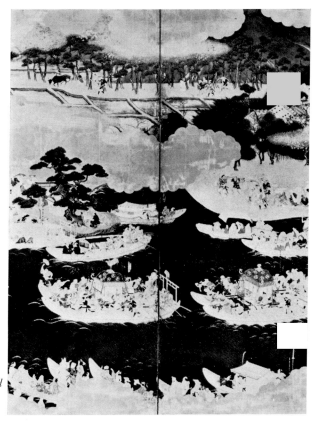

151. Detail from Hie-Sanno Festival. *Pair of sixfold screens; colors and gold on paper; each screen, 155.4 × 358.8 cm. Mid-seventeenth century. Konchi-in, Kyoto.*

fun is well under way. We wondered earlier where this took place—is it a Kyoto or an Edo scene? At any rate, pleasures are gradually coming in off the streets and are now depicted indoors in the manner of these banquet scenes. The so-called So-o-ji screens (Fig. 128) in the Tokugawa Art Museum have a fancy two-story brothel on the side. It discloses the rooms of the upper and lower levels, the separate bath facilities, and a patio where sakè, song, and dance hold sway. The other half departs from the brothel, showing instead an amusement-type scene of Kabuki, tea shops, and cherry-blossom viewing. A sixfold screen belonging to the Domoto Collection is like the So-o-ji work in that one side shows a luxurious two-story brothel of much the same proportions and type, but only the inside is seen. The screen shows the bathhouse

women sloshing down customers in the bath and the entertainment in the various rooms of the building. It is not clear whether such palatial two-story affairs actually existed during the Kan'ei era, but the image sought was that of a valhalla of pleasures for everyman.

The Kan'ei era also saw paintings different from the gay-quarters and banquet-in-a-brothel sort. We have the famous Hikone screen, where scenic background is dropped in favor of focus on the pleasures of the banquet alone; or paintings like the *Bathhouse Girls* in the Atami Art Museum, where only women are to be seen.

The artist was thus reducing subject matter and concentrating more and more on the figures of men and women, and the beauty of fine clothes (as in Fig. 124).

CHAPTER ELEVEN

Namban Screens:
An Overview

REFLECTING THE FLOURISHING relations between Japan and Europe in Momoyama times, there are many screens featuring *nambanjin*—Western traders, Catholic missionaries, and the like—and these are generally called *namban* screens. Because they treat foreign manners and customs they are sometimes grouped together with Western-style painting (*yoga*: painting of Christian themes or Western manners using Western painting techniques) and referred to as *namban* art. However, the technique and style of *namban* screens are the same as those of genre painting. They always include Japanese customs and manners also, and so should be taken as a special form within Momoyama genre painting. In other types of genre painting, too, here and there we notice Westerners, or Japanese adopting their ways, but *namban* screens can be said to deal with such themes specifically.

Namban screens present the largest number of extant genre paintings. Over fifty are authenticated, and this suggests the great popularity of the form.

Namban work is usually divided into the following three types according to compositional arrangement and subject matter. The first type are sixfold screens and have a *namban* ship docking in a Japanese port on the left-hand screen and a party of Europeans led by a captain-major proceeding to Namban-ji (the Jesuit church in Kyoto) on the right-hand one. In other words, the setting of both

is Japan and the composition unfolds from left to right—the landing and procession to the church. There are approximately twenty-eight extant samples of this type, including that in the Imperial Household Collection (Fig. 152).

Paintings of the second type show the *namban* ship at anchor on the right-hand screen along with the group going up to Namban-ji; the left-hand screen has the boat leaving a foreign port. This makes for two locales, but the artist manages to achieve a certain compositional continuity. There are about nine works in this category, the most representative being preserved in the Kobe Municipal Museum of Namban Art (Fig. 153).

With the third type, the right-hand screen has subject matter identical to the screens of the second type—the ship at anchor and the procession to Namban-ji—but the left-hand screen has only a depiction of foreigners on foreign soil. The harbor and ships have been supplanted by scenes from abroad, very often horse-training depictions. For the sake of convenience, we can also include here those screens which have the same in a Japanese setting on the left-hand screen. But generally the result is two paintings arbitrarily combined. No effort, it seems, was made to unify the composition or contents; the two simply go their own way. Seventeen of this type are extant, among them the Suntory Art Museum screens (Fig. 154).

152. *Pair of sixfold* namban *screens. (Top) Party of Europeans proceeding to Namban-ji. (Bottom) European ship in Japanese harbor. Colors and gold on paper; each screen, 155.8 × 334.5 cm. Early seventeenth century. Imperial Household Collection.*

In the past, emphasis has been laid almost exclusively on the above three types and the similarity of composition to be found among screens in each category. But recent research has unveiled not only further subdivisions within each category but also an organic development in all three. The oldest screen of the group—that in the Imperial Household Collection—for example, with the ship anchored on the left and the Namban-ji procession on the right, would appear to be the prototype upon which many subsequent variations were based. Some of these brought together both scenes

from the above model on one screen. The problem then was what to put on the other one. The dilemma was brilliantly solved by the artist of the screens of the second type in the Kobe Municipal Museum of Namban Art (Fig. 153). He struck on the idea of flanking the boat and procession on the right-hand screen with a scene of the ship's departure from a foreign port on the left-hand one. But artists had never seen foreign lands, much less foreign landscapes, and they were scarcely acquainted with foreign customs. This paucity of materials meant the artist had to scrounge for this and that to form

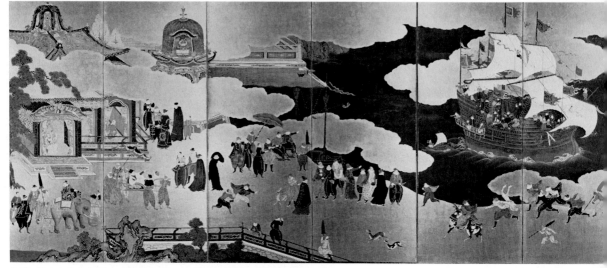

153. Pair of sixfold namban screens; Kano school. (Left) European
ship leaving a foreign port. (Right) European ship entering Japanese port
and Europeans proceeding to Namban-ji. Colors and gold on paper; each
screen, 155.6 × 364.6 cm. First half of seventeenth century. Kobe Munic-
ipal Museum of Namban Art.

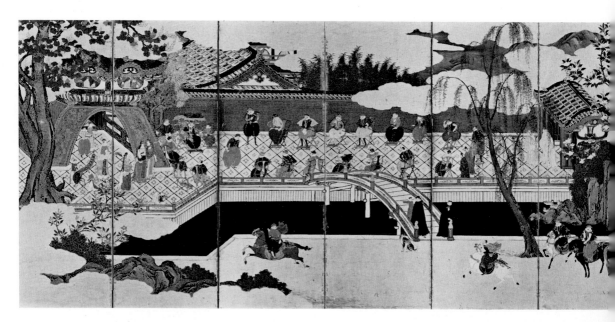

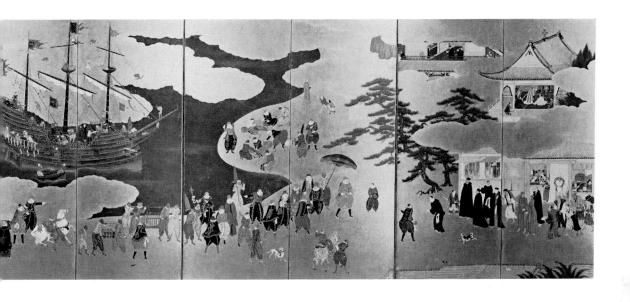

154. *Pair of sixfold* namban *screens; Kano school. (Left) Europeans in a foreign land. (Right) European ship entering a Japanese harbor. Colors and gold on paper; each screen, 156 × 358 cm. First half of seventeenth century. Suntory Art Museum, Tokyo.*

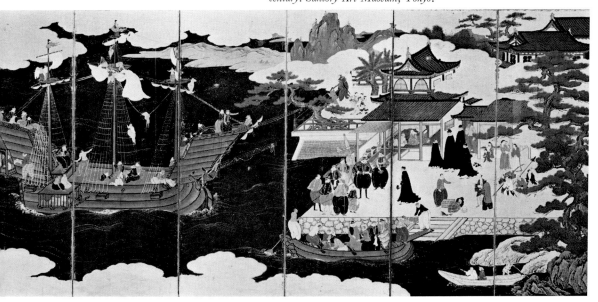

a compositional whole. This brought considerable variation but also invited many mere copies. The themes chosen most for the purpose were foreigners on horseback or sitting on chairs. (We also find foreigners seated on chairs on right-hand screens that have a Japanese locale.) From the point of view of the main theme of a ship's departure, these were merely secondary motifs, but in the third category they assume the central role on the left-hand screen, and the ship disappears. In the Suntory Art Museum screen (Fig. 154) of the third category the seated figures have a more important role than riders, but in the Tokyo National Museum work (Fig. 75) of the same type, the mounted foreigner has regained the spotlight, so much so that we are tempted to set up a new genre and call it "Horse Training Abroad." The third-category paintings at this juncture have attained no small degree of independence. As such we should locate them in the context of the Japanese samurai-genre painting we looked at earlier, especially that of the horse-training variety. In the *Horse Training* in the Itsuo Art Museum, a variation in the third category, the horse training has been removed from a foreign to a Japanese setting. The screen in the Okazaki Library has dropped the horse-training theme on the left in favor of a scene of many foreigners dancing in a Japanese setting. Obviously it was an imaginary scene. Yet the theme is frequent in Momoyama genre and may be regarded as a variation on the group-dance motif.

This means we have a definite progressive development from the first to the third categories of *namban* screens. This does not mean, however, that this classification can be used as a criterion for dating the extant works. As I mentioned earlier, *namban* screens were extremely popular. It is quite thinkable that works of the first type were still being painted even when the second and third types had already appeared. For this reason, style and many other factors have to be given due consideration before ascribing any dates.

It was once firmly held that so many similar *namban* screens with so few signed or sealed ones among them could only indicate town-painter production. The fact is, unsigned screen paintings at this time were the rule and many did not bear a seal either. As regards volume, we noted earlier how many facsimiles and formula paintings existed in other genres also. If *namban* screens were so popular, obviously there would be more stereotypes. The truth is, the main works of the *namban* screen idiom, like the main works of other genres, were by Kano artists. The screen of the first type in the Imperial Household Collection (Fig. 152), for instance, is easily recognizable as the product of a disciple of Kano Eitoku. And in the third category, with the Suntory Art Museum screen, the rock and tree brushwork clearly approximate those of Sanraku. Again, in the same category, there is the Tokyo National Museum work bearing the "Tomonobu" seal. Its style evinces Kano Mitsunobu lineage. Moreover, one can doubt the signature and seal of Kano Naizen (of the Hokoku Festival painting) on the Kobe *namban* screen (Fig. 153) of the second category. But it is certain that the left-hand screen, with its foreign landscape so indebted for its treatment of architecture and women to the Chinese historical and legendary figure-painting idiom of the Kano school, and its telltale stylistic peculiarities, is a work executed by an artist of the Kano school.

Thus, I would see the development within the first, second, and third categories also as the handiwork of Kano genre specialists. Let us go along with the credentials that are said to be mandatory for the first artist ever to paint a *namban* screen—he must have lived in Nagasaki or thereabouts and been well acquainted with foreign life and customs. We have Ichiun, a disciple of Kano Eitoku, who lived in Nagasaki, and there is a Kano Gennosuke listed in Jesuit annals who would also appear to have the right qualifications.

It is undeniable that many *namban* screens seem to be town-painters' practice paintings or "commercial" paintings produced for sale. The great popularity of the form is why there are over fifty extant paintings, more than of any other genre, so a larger number of inferior works would be only natural. But the principal *namban* screens in each category are most certainly from the brush of Kano artists.

TITLES IN THE SERIES

Although the individual books in the series are designed as self-contained units, so that readers may choose subjects according to their personal interests, the series itself constitutes a full survey of Japanese art and will be of increasing reference value as it progresses. The following titles are listed in the same order, roughly chronological, as those of the original Japanese editions. Those marked with an asterisk (*) have already been published or will appear shortly. It is planned to publish the remaining titles at about the rate of eight a year, so that the English-language series will be complete in 1975.

The "weathermark" identifies this book as having been planned, designed, and produced at the Tokyo offices of John Weatherhill, Inc., 7-6-13 Roppongi, Minato-ku, Tokyo 106. Book design and typography by Meredith Weatherby and Ronald V. Bell. Layout of photographs by Sigrid Nikovskis and Ronald V. Bell. Composition by General Printing Co., Yokohama. Color plates engraved and printed by Nissha Printing Co., Kyoto, and Mitsumura Printing Co., Tokyo. Monochrome letterpress platemaking and printing and text printing by Toyo Printing Co., Tokyo. Bound at the Makoto Binderies, Tokyo. Text is set in 10-pt. Monotype Baskerville with hand-set Optima for display.